Outdoor
Action and Adventure
Photography

Outdoor
Action and Adventure
Photography

Dan Bailey

Focal Press
Taylor & Francis Group

NEW YORK AND LONDON

First published 2015
by Focal Press
70 Blanchard Road, Suite 402, Burlington, MA 01803

and by Focal Press
2 Park Square, Milton Park, Abingdon, Oxon OX14 4RN

Focal Press is an imprint of the Taylor & Francis Group, an informa business

Notices
Knowledge and best practice in this field are constantly changing.
As new research and experience broaden our understanding,
changes in research methods, professional practices, or medical
treatment may become necessary.

Practitioners and researchers must always rely on their own
experience and knowledge in evaluating and using any
information, methods, compounds, or experiments described
herein. In using such information or methods they should be
mindful of their own safety and the safety of others, including
parties for whom they have a professional responsibility.

Product or corporate names may be trademarks or registered
trademarks, and are used only for identification and explanation
without intent to infringe.

Library of Congress Cataloging in Publication Data
Bailey, Dan (Outdoor sports journalist)
Outdoor action and adventure photography/by Dan Bailey.
 pages cm
 ISBN 978-0-415-73424-0 (pbk)—ISBN 978-1-315-83264-7
 (ebk) 1. Outdoor photography. 2. Travel photography. I. Title.
 TR659.5.B35 2015
 778.7'1—dc23 2014032974

ISBN: 978 0 415 73424 0 (pbk)
ISBN: 978 1 315 83264 7 (ebk)

Typeset in Helvetica 45
by Florence Production Ltd, Stoodleigh, Devon, UK

Printed and bound in India by Replika Press Pvt. Ltd.

Contents

1 On Being an Adventure Photographer 1

2 The Gear 7

3 Technical Concerns 67

4 Creativity 129

5 Lighting 217

6 Going Pro 249

7 Photographer Profiles 271

 Index 297

Acknowledgements

I had a whiteboard in my old office in Colorado where I kept my "to do" list. The first word on the list was "book," and it had been there for so many years that when I finally moved, the marker ink had permanently stained the board and had to be scrubbed off with considerable elbow grease. Ten years later it's no longer just an idea on the whiteboard, it's a reality. You're holding it in your hands: my first printed book.

Completing a project of this scope certainly ranks as a huge milestone for me so I'd like to acknowledge a number of people who have influenced, aided and supported me during the months it took to see this book from start to finish.

First of all, Cara, who in March of 2011, said to me, "I'll get you to write for us someday." She's the one who got the ball rolling on this project. Kimberly, who helped me refine my ideas into a workable format and provided helpful advice, direction and overall project management, and Alison, Mary, Deirdre, Denise and all the other awesome Focal Press people, both present and former, who held my hand along the way. Also, to Colin for doing an excellent and thorough job on the technical edit.

Then, to the late Galen Rowell, who made me want to be outdoor photographer/author. He has influenced me since the beginning and motivated while I was writing this book. Sometimes when I felt stuck, I'd pick up *Mountain Light*, read a few pages and then come back fresh, with renewed energy.

My grandmother Elsie who inspired the adventure and travel bug in me. When I was little, she sent me postcards from all over the world. I never could read her flowing scribbly cursive, but nonetheless her gesture stuck. I actually still have the entire stack of cards; most of them are over 40 years old.

To Amy, for her unending patience, nurturing care, yummy snacks, and regular motivation to go out and get some much needed exercise during marathon weeks of writing and editing. And for being ok with postponing a really cool bike trip so that I could finish my manuscript on time. We'll go on that trip, and many more . . . I promise!

Finally, thanks to my friend Eric, and all my adventure partners over the years and anyone else who's ever heard me say the word "AGAIN!" This book is dedicated to you, because without your willingness and cooperation, many of these photos wouldn't even exist.

On Being an Adventure Photographer

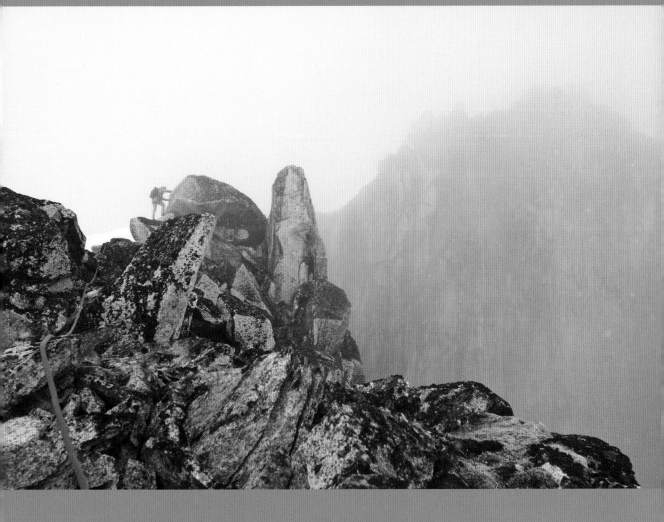

The Why

Imagine yourself pulling over a tiny lip in the middle of a thousand vertical feet of granite, or skirting along a knife-edge ridge as you look down upon a remote valley full of broad, broken glaciers and majestic high peaks. Riding your boards through waist-deep powder, pedaling your bike through a stand of yellow aspens on a crisp fall day, or waiting for your friends just downstream of the Class V rapids. It doesn't matter, as long as you're outside.

Your backpack isn't as light as it could be; it rarely is. Your ultramodern outdoor gear doesn't weigh very much, but all that metal and glass definitely pulls on the shoulder straps. You're OK with it though, because you simply cannot imagine heading off on an adventure without your camera.

Just then a band of pink clouds forms at the horizon, causing your adrenaline to rise. Spotting an ideal vantage point, you break off from your companions and head for a tiny ledge that offers the best view. Your heart beats faster as you survey the scene in front of you. Your creative mind goes into overdrive and you're already thinking about how cool these shots are going to look on the screen when you get home.

After swapping out lenses with well-practiced efficiency, you verify your camera settings. You check them again, because you know that once the action starts to unfold, you won't have time to fiddle with dials and menus. You won't even have time to think. At that point, you'll have to be on autopilot, because you may only have one chance to capture a fleeting moment that will likely go by in the blink of an eye.

You've been waiting all day for this moment. Maybe all week. Perhaps even all year. This could be a once-in-a-lifetime commercial assignment on the other side of the world that required you to research remote locations, travel thousands of miles, hump loads of heavy gear, and work around coordinating schedules with professional athletes. Or maybe you're just hiking or riding through the wilderness in your own backyard with a friend and creating memorable experiences, not just as a photographer, but also as a participant in the adventure as well. Even if you didn't have your camera with you, this is exactly where you'd want to be.

A few seconds later, the sky opens up and delivers golden rays of afternoon sunlight that splash onto the scene with intense color and drama. You look towards your models and yell "GO!" Then you take a deep breath and you bring the camera up to your eye . . .

Are you ready for the action that's about to explode in front of your lens? I mean REALLY ready? You'd better be, because there is no second chance in this game. When the light fades and your model drops that line, your moment is gone. You'll either nail it or you won't. Simple as that.

True love, fierce challenges, and endless rewards

Adventure and action photography is not just a job, it's a way of life, where the lines are blurred between vocation and vacation; where trips can potentially become tax write-offs; and where nearly every aspect of your life revolves around your photography. It can take you to the most magnificent places in the world, and it can become a vehicle that lets you do things that others only dream about.

This is true even if you're not a full-time pro. Adventure bloggers and camera-toting outdoor enthusiasts take note: even if you have a day job, I'll wager that you possess the same passion for your craft. When you're not out shooting, you live a life that revolves around your love of photography. You're constantly working to improve your skills. Your main expenditures in life usually break down into gear and trips, trips and gear; and you work hard to stay in shape, because keeping up with pro athletes and your hardcore friends while lugging a pack full of heavy camera gear is no easy task.

Cameras were practically made for adventure. Ever since Frank Hurley first dragged a full-sized 8 x10 view camera all the way to Antarctica in 1911, cameras have accompanied explorers to nearly every corner of the globe. Of course, Frank shot his photos on glass plates, and it took years for anyone to see his imagery from the trip. Today, we document our adventures and send images around the world in almost real time.

Few styles of shooting bust your photography chops like adventure and action photography. Consequently, this kind of shooting makes you a better photographer. Imagine trying to grab a shot while trying not to be plowed over by a mountain biker who's blasting down a rocky hillside at 30 miles per hour. You have to be on top of your game, because you might only have one chance to get it right. This kind of shooting requires skill, focus, and confidence, because in a span of split seconds you can do one of three things: miss the shot, get the shot, or actually nail the shot. Which one would you rather do?

Outdoor adventure photography requires you to effectively gauge your scene and pull together all of the elements that will make for a breathtaking shot, oftentimes in the harshest light you can imagine, all while being immersed within the scene yourself. It requires you to think quickly and see geometrically, because the world doesn't stop and wait for you. It doesn't even slow down. In fact sometimes it feels like it's speeding up!

For the pro, shooting adventure sports and high-action subjects brings both income and recognition. The potential client base for adventure imagery goes well beyond just magazines and outdoor companies; nearly every type of client uses this kind of imagery in their projects at some point. To step up into this realm, your imagery has to be top notch, because competition is fierce in this industry.

This type of photography can also open up many doors in today's media-driven world, especially for the emerging or aspiring pro. Create jaw-dropping imagery and you're more likely to get more followers, which can contribute to revenue by way of workshops, blogging, writing, and self-publishing. High visibility can also lead to opportunities for taking your career to the next level, as well as the chance to work with camera manufacturers and other companies in the photography industry.

However, not everyone aspires to make money with their camera, so let's explore the other side of The Why. Professional shooting aside, we all share a similar passion for photography, whether we do it for a living or not. We're all driven by the image and immersing ourselves in the scene; wrangling with bold light and experimenting with new techniques and equipment is what pushes our creativity.

As artists, we strive to say something, to communicate our vision, to share the experiences that move us, shape us, and bring us to the edges of our world. And, of course, we hope to come out the other side with imagery that whacks our viewers on the side of the head and transports them to a whole new place. That's why we do this.

How to

This practical reference manual is written especially for aspiring and emerging photographers, as well as pro and semi-pro shooters who want to master their craft and take their game to the next level. The techniques and insight I present in this book were pulled directly from nearly 18 years working as a full-time pro and teaching other photographers. From selecting

the right equipment to refining your eye and technique, I'll show you how to capture motion, emotion, and moments that convey the true sense of adventure for whatever sport you like to shoot.

I've included a wide variety of subject matter and equipment, partly because it reflects the diversity of what I shoot, but also because I recognize that everyone has a unique style of dealing with their gear, working within their scene, directing their models, and yes, living the outdoor life. What works for one person may be totally impractical for another. As far as you're concerned, so long as you possess the technical skills and creative methods that allow you to get the shots you want, there is no right way; there is only your way. Ultimately, it doesn't matter if you're a top pro on assignment in a remote location or an enthusiast shooting on your local trails, once you put that camera up to your eye, it feels the same for everyone.

In addition to the technical and creative chapters, I've included a section on going pro. In it, I detail approaches and ideas that can help you turn your passion into a business, and I profile a handful of other adventure photographers who have each found their own success in this fiercely competitive field. It's true that this is a tough industry. The very same thing could have been said when I first started, but I got my foot in the door. There is always room for new talent, and if you work hard and shoot great imagery there's no reason that you can't get yours in as well.

Let's get started!

The Gear

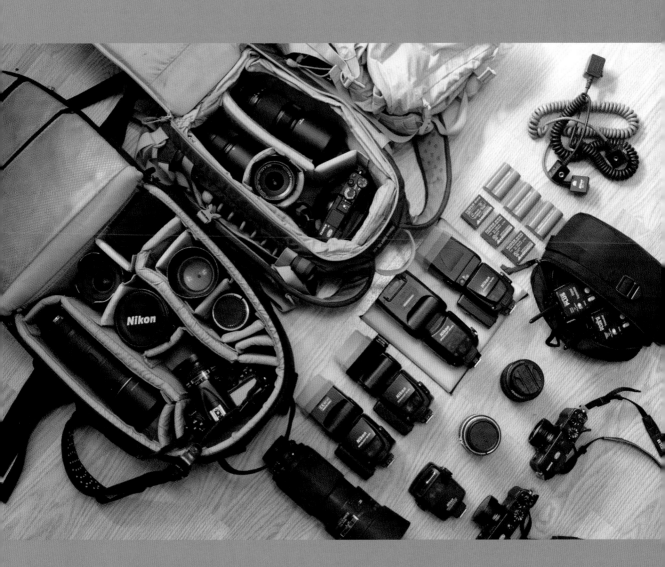

Adventure photography equipment

Let's consider the early adventure photographers. In 1924, mountain photographer Captain John Noel hauled 14 cameras to the base of Mt. Everest to document a British climbing expedition. His kit included a 40 lb. cinematograph, a glass-plate camera, a number of small Kodak Vest Pocket cameras, and all the necessary equipment to set up a darkroom at basecamp. His "film" would have been emulsion-coated glass plates that were probably packed into wooden crates for the long journey, and he would, no doubt, have required numerous Sherpas to carry all of his gear.

Fast forward to the late sixties, when a young rock climber named Galen Rowell, who many consider to be the father of modern-day adventure photography, started documenting the vertical world of Yosemite with manual Nikon cameras. He had no idea how his pictures would turn out until he returned from his outings and sent his film off to the nearest Kodachrome lab. Although Galen's 35 mm film canisters were certainly less cumbersome than Captain Noel's glass plates, he had his own challenges, like making sure not to drop any off the sides of 3,000-foot-high granite walls like El Capitan and Half Dome.

What about all those nineties ski photographers like the late Carl Skoog who changed countless rolls of film without gloves in the cold on deep powder slopes? Forget about frozen hands; drop a roll in the snow and it's gone forever.

Having started shooting back in the days of film myself, I can't ever imagine going back. Early photographers aside, compared to the gear that was available even just a decade ago, we've got it pretty darn easy.

Today, photographers can choose from a wide selection of highly advanced and easily portable camera systems that allow us to go lighter and faster through the world than ever before. And instead of waiting until after a long trip is over to see what we shot, we can view and share our images in real time, which gives us the opportunity to learn, correct, and compensate right there on the spot.

Each year, camera manufacturers give us quicker autofocus, faster frame rates, and smaller cameras that produce even higher resolution than the generation before. It almost seems as if all of the advances in modern photography gear are designed with sports and action photographers in mind. Lucky us!

Given all the tools that we have at our disposal these days, there's almost no excuse for you not to be a great adventure photographer. Keep in mind, though, that gear isn't everything. Without comprehensive technical know-how and a strong creative style, a kit full of expensive, high-tech gizmos won't get the job done. However, it makes our job much easier, and for that we can be thankful, even if it does make us a little bit softer than the legends who came before us.

Pro gear vs. amateur gear

In a large sense, photography is a money game. The more you spend, the better your images can be. Please take note, I said "can," and not "will," because gear alone doesn't make the image. More on that later.

High-end camera gear offers superior optics, unmatched image resolution, tonal range and color rendition, better low-light sensitivity, and increased frame rates. Pro gear takes much more of a beating than amateur-class gear. Like anything else in life, you get what you pay for. If you want to create the best imagery, and if you want your cameras to withstand the rigors of being dragged through the outdoors year after year, then you'll probably want to shell out decent money for high-quality gear.

That said, nearly every single piece of modern photo equipment you'll find on shelves today will produce acceptable quality imagery. Especially when you consider that most images in today's marketplace are viewed on the web at 1/4 screen or smaller. Even if it's destined for full-screen on a high-resolution display, an image shot on a 3-megapixel camera is more than adequate.

In theory, unless you're printing larger than 8 x 10, you really don't need image file sizes larger than 6 megapixels. However, most digital cameras today (even point and shoots) fall somewhere in the 16–24MP range, which is what you should aim for.

From an image-quality standpoint, most amateur gear is often good enough for pro work. I've sold a number of photos from my $600 compact camera, and many of today's modern journalists and bloggers rely on gear that wouldn't be considered "pro quality" by any stretch of the imagination. These days, high-end clients are even starting to use iPhone photos in their projects. Bottom line, if an art director likes a photo, most likely they don't care what camera was used to make it.

That's not to say that the gear doesn't matter at all, because it does. High-end cameras let you shoot in a wider variety of light levels and situations, and they do give you better image quality. Under critical comparison, a high-end camera and lens will give you wider tonal range, more accurate colors, and lower noise. However, depending on how you output the final processed image, the difference may be negligible.

For most of my adventure work I've used Nikon DSLRs and pro grade lenses. Recently, I've come to rely on lightweight Fujifilm cameras that let me shoot more easily on the go and that offer different creative options. I try to use a similar approach with all of my cameras, because my goal is to make the process transparent. I want to the images to stand on their own, regardless of what gear I used.

Choosing your gear

So, how do you choose the right gear and put together a kit that gives you the best options? You start by understanding what advantages and disadvantages each type of gear offers, and how it can help you create the kind of imagery you want to make.

More than anything else, your gear selection should revolve around your shooting style. Every single piece of equipment in your camera bag should let you freely explore your creativity in the way that makes YOU feel good, regardless of what anyone else says or thinks about it. Your camera should fit seamlessly within your personal vision, your creative methods, and your general approach towards photography. Does it fit in your hands and make you WANT to use it? Then it's the right camera for you.

It's good to read reviews, but take some reviews with a grain of salt. Remember, your particular gear needs and concerns might be wildly different from another shooter, even if they're an accomplished photographer.

Think about it: the typical portrait shooter or photojournalist might know absolutely nothing about what's required to capture fast action sports images in the middle of winter on the side of a mountain. Even within the genre, a dedicated ski photographer might have vastly different needs than someone who shoots climbing or trail running full time.

During a recent conversation on Twitter, one of my favorite people photographers made the following statement: "*To me, follow focus ability is not a consideration for camera choice.*" This illustrates just how different photographers can be, because that's pretty much the number one thing

I look for in a camera body. When searching for advice, look for photographers who work in a similar style or who produce the kind of imagery that you'd like to make and see what they use.

Eventually, you'll form your own opinions about gear and figure out what things you can't live without. In the end, however, you'll realize that what ultimately matters more than the gear itself is HOW YOU USE IT.

Cameras

The camera is the hub of your photography system. It's the device that converts the three-dimensional beauty and the fluid motion of life into the series of ones and zeroes that make up a digital image. Ultimately, the camera is what determines the overall look and quality of your photograph, and depending on its size, weight and capabilities, it can actually dictate and define how you take photos.

You'd better love your camera. You'd better have a special fondness for how it feels when the thing is cupped into your grasp, because it's going to spend a great deal of time there. Imagine the thousands of hours you'll devote to cradling that little metal, plastic, and glass contraption. Shoot enough photos and you'll develop an intimate connection with your camera. It will cease to become just a tool and will become an extension of your creative self, so you'll want to get one that fits your needs and style.

Today's cameras offer tremendous power and versatility for adventure and outdoor shooters. For one thing, the gear keeps getting smarter. Camera exposure meters and image-processing software have reached a point where I often leave my cameras in auto mode. For a guy who cut his teeth in manual mode with film, this feels like freedom.

The other main advance that we've seen in recent years is the stunning evolution of the compact camera. In the past, DSLRs have been the mainstay of the camera world and the no-brainer choice of any serious photographer. Now, with the advent of mirrorless camera systems and even the improvement of modern point-and-shoots, photographers are experiencing a whole new level of mobility and creative liberation with lighter, smaller camera systems.

Where it used to be common for a person to own but a single camera system, in today's market many photographers find it beneficial to have a couple of different systems at their disposal.

Let's look at what kinds of camera options are offered these days and see how to build a system that's right for you and your style of adventuring.

DSLRs

The pro Digital Single Lens Reflex (DSLR) is still the diehard tool of most sports and action photographers, at least for now. DSLRs are practically made for shooting action because they offer the best performance, excellent image quality, rugged construction, and the widest combination of features that any photographer needs to produce high caliber imagery in the outdoors.

Keep in mind that it's not so much what a single DSLR itself offers, it's that when you get a DSLR camera, you're actually buying into an entire world of lenses, flashes, and accessories that go with that camera. In other words, the spokes. Companies like Nikon and Canon offer an enormous selection of pro-quality optics, lighting tools, and other accessories that can let you take your photography to whatever level your creative brain and technical skills can imagine.

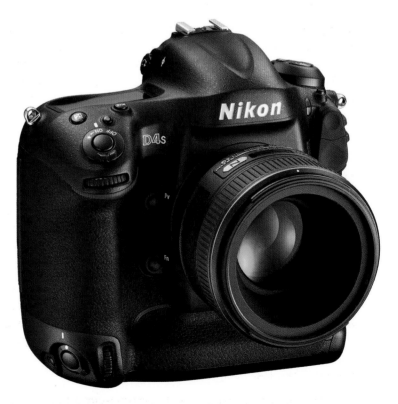

The Nikon D4S. To date, the baddest, most powerful DSLR ever created.

In my mind, there are a few very simple reasons why most adventure and action photographers regularly use DSLRs in their work and why you should consider one for yourself.

1 **Highest resolution and quality**: Even today's consumer-grade DSLRs are built with sensors in the 16–24MP range; pro cameras like the Nikon D810 go even higher. That's more than enough pixels for any kind of professional-quality publication, no matter what subjects you're shooting. In addition, DSLRs with full-frame sensors generally offer better high ISO performance and lower noise when shooting in low light conditions.

2 **Fast autofocus**: For the action photographer, this is probably the number one reason to go with a DSLR. DSLRs are built with the most advanced autofocus systems available, which is absolutely essential if you're shooting sports and fast-breaking scenes. There are a lot of compact cameras that produce great-looking imagery, but few of them will lock onto a moving subject, track it with incredible accuracy, and keep it in focus while shooting frame after frame like a high-end DSLR paired with a fast, pro-quality lens.

3 **Bright, through the lens viewfinders**: DSLRs use mirrors and pentaprisms, which give you a direct view of your subject through the lens. Mirrorless cameras use electronic viewfinders that draw the image directly from the sensor. Although they're improving every year, at this point no EVF matches the bright, intrinsic view that you get when you look through the viewfinder of an SLR.

4 **Durability**: If you're an adventure shooter, then you're going to abuse your cameras. It's as simple as that. No matter how careful you are, if you spend enough time traveling or shooting in remote locations under the elements, your gear will take a beating. This is where high-end, pro DLSRs hold their own. They'll withstand being knocked around, dropped, banged against rocks, trees, kayak paddles, bicycle frames, skis, and whatever else you can throw at them, and they'll keep on working.

I've seen YouTube videos of top-of-the-line Nikons being set on fire, frozen into blocks of ice, and being used to hammer nails, and guess what? They come out the other side, scratched, dinged, dented, and even a little bit melted, and they still function. I haven't gone this far with my cameras, but I've certainly given them their share of knocks, and they rarely let me down.

Keep in mind that a mid-level and consumer-grade DSLR won't stand up to this kind of punishment. They're made with more plastic.

On the other hand, they're much lighter, which can be a huge plus to photographers who shoot in the backcountry.

5 **Video**: Many photographers these days shoot both stills and motion, often side by side with the same camera. High-end DSLRs produce superb quality HD footage and have the necessary ports for dedicated microphone input and HDMI output. While DSLRs may not be the ideal tool for shooting a long, involved video project, they do offer excellent versatility in a relatively compact package.

6 **Flash capabilities**: Off-camera flash use is becoming more prevalent with many outdoor photographers these days. This is partly due to the popularity and accessibility of available instruction online, and partly because lighting gear just keeps getting better and more suited towards being used outside in tough conditions.

DSLRs play nice with a multitude of lighting systems, from dedicated hand-held flashes to high-powered strobes. In addition, there's a wide selection of light-shaping tools and wireless triggers that are all designed to work with standard camera flash gear. Overall, DSLRs offer the highest performance and the most options for use with external flash systems.

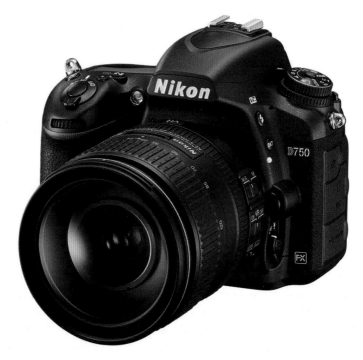

The Nikon D750. A great lighter weight DSLR for adventure and backcountry use.

The downside to DSLRs

I can only think of one: they're heavy. At least the pro ones are. The Nikon D4S weighs almost three pounds. Add a big zoom lens and you're up to six. Slap a flash on the hot shoe, fill it up with batteries, and you're topping seven. That's a lot of weight to lug around when you're trying to hike or ski with your camera. Even a D750 weighs close to two pounds without the lens.

Keep in mind that cameras get lighter as you go down the line. A mid-range DSLR might weigh about a pound and a half with the battery. Still not super light, but if you're trying to keep up with your friends on the trail, those few ounces can make a big difference over the course of many miles and days. That's why mid-range cameras are so popular; they still offer excellent image quality and a host of usable features, but at reduced weight. Of course, they won't withstand the same kind of abuse as a higher end DSLR, but for many shooters, that's an acceptable tradeoff.

DSLR buying guide

There are enough reviews, comparisons, and buying guides out there that can help you sort out all of the hype, so I'll make this simple. When it comes to buying a DSLR, or any camera for that matter, my advice for the action adventure photographer is to consider three things: **durability**, **frame rate**, and **weight**. Since no camera offers the perfect combination of all three, get the one that offers at least two of the three categories, according to your needs, and live with the tradeoff.

For example, the camera with the best performance and highest frame rate will likely be the heaviest model in the line. Likewise, the lightest weight body won't have as much durability. With both Nikon and Canon, there's usually a sweet spot in the $2000–$3000 range that gives you the best combination of these three things. If you're willing to sacrifice rugged-ness, you can usually find a good range of features in the $1200–$1800 range.

Durability

If you plan to travel to the ends of the earth and shoot in the most rugged locations imaginable, then you'll need the kind of rock-solid construction and built-in cushioning elements that higher end cameras offer. These are generally the most expensive cameras, but if you can afford to travel like this, and if your photography depends on it, then you can afford a camera that's built like a tank.

Weather sealing

One thing that determines whether any camera is usable for serious adventure photography is if it's weather sealed. Most consumer bodies are not; this is a feature that's generally reserved for more expensive cameras, but it's well worth it. Consider that you'll probably subject your camera to any number of extreme conditions like wind, sand, rain, dust, snow, ice, and all the other stuff that Mother Nature will throw at you. This can wreak havoc on delicate electronics, and having things like o-rings and silicone covers that prevent all that outside material from getting inside your camera will add years to its life.

Frame rate

If you plan to shoot super-fast action like skiing, surfing, and downhill mountain biking, then you'll likely want a camera with a high frame rate. This allows you to fire off quick bursts of multiple shots, which gives you a better chance of capturing your model's most dynamic body positions and expressions. Moments can vary greatly, even within the bounds of a

Full frame vs. crop sensor?

Full-frame cameras give the same 24 x 36mm view as 35mm film, while most crop-sensor DSLR cameras have sensors that are either 1.3, 1.5, or 1.6 times smaller than traditional film. This means the image view is slightly magnified by the respective crop factor and will have to be increased by the same amount in order to compare in size with a full-frame camera.

The bottom line is that full-frame cameras offer slightly better image quality, especially when it comes to low-light performance, not just because the sensors are larger, but also because each pixel on the sensor has a larger surface area with which to gather light. In effect, full-frame cameras produce higher resolution detail with lower noise.

In addition, your regular wide-angle lenses are no longer as wide as they would be on a full-frame camera. To make up for the crop, camera companies have developed wide lenses specifically designed for crop-sensor cameras, but even so, the selection of high-quality, fast wide-angle lenses is still much greater for full-frame cameras.

By the same token, this gives crop-sensor cameras a distinct advantage on the long end; a 200mm lens on a 1.5x body suddenly becomes a 300mm lens, with no loss of light.

The main tradeoff you'll find is that full-frame cameras are much more expensive, and they're often heavier than the typical crop-sensor camera. Most top-of-the-line, rugged pro cameras are full frame, but that doesn't necessarily mean you need to go full frame for shooting adventure. If you tend towards using longer lenses, or if weight is a big concern, consider shooting a crop-sensor body, or at least having one as a backup for shooting in certain situations.

The reality is that today's crop-sensor cameras produce great quality imagery, and it's certainly better than what full-frame cameras were capable of producing a few years ago. Under most conditions, you may not even notice the difference.

single second, and having a high frame rate increases your odds of getting the very best shot.

Of course, all that speed costs money, so determine how many frames per second you're willing to pay for. I got by for years with cameras that have 4–6 fps; my latest camera gives me 8. Keep in mind, though, that spraying and praying doesn't always get you the great shot. If you're good, often times a selective eye and a single press of the shutter will nail the shot. Plus, more frames per second often means more time editing and the need for bigger hard drives.

Weight

If you plan to carry your camera for miles into the backcountry, the weight is going to be the determining factor here. That's where the mid-range models fit nicely. They're not as rugged and may not have the highest frame rate, but they're generally more compact and easier to lug around all day long.

Compact and mirrorless cameras

Up until recently, when photographers wanted "serious" cameras, they reached for DSLRs. Period. No questions asked. When it came to shooting pro-quality work, small cameras were just not up to the task.

Of course, you could spend a few thousand dollars on a Leica or Contax rangefinder, but below that, almost all smaller digital cameras had two major limitations: tiny sensors and high shutter lag. If you've ever tried to nail critically timed shots with a camera that doesn't go *click* the instant you *press*, then you know what I mean.

Thankfully, times have changed. In just the past couple of years, the small camera revolution has taken the industry by storm. This has opened up a vast playing field of options for photographers who see viable alternatives to DSLRs. Companies like Fujifilm, Olympus, Sony, and Panasonic have introduced models that give big cameras a real run for their money.

Sensor architecture has greatly improved in these smaller compacts, and many of these mirrorless cameras, as they're called, now sport the same size APS-C format sensors that are found in many DSLRs. In fact, since I began writing this book, Sony became the first company to introduce a full-frame mirrorless camera, the a7.

Also, since they don't contain mirror assemblies that have to be moved with each shutter cycle, the latest generation of mirrorless cameras now

sport capture rates that rival even the highest end DSLRs. Want a camera that shoots 10 frames per second? You can either spend $6500 on a Nikon D4S that weighs three pounds or $600 on a little camera that fits in your pocket.

Combined with vastly improved image-processing capabilities and the ability to shoot in RAW, many of today's mirrorless cameras produce imagery that's good enough for just about any kind of professional use. In addition, many of them include a palette of classic film simulations and custom filters that offer a wide level of creativity.

As I write this chapter, we're starting to see a number of rugged, high-performing mirrorless cameras that are capable of holding their own against DSLRs in many respects. By the time you read the final version of this book, we'll likely see the lines being blurred even more.

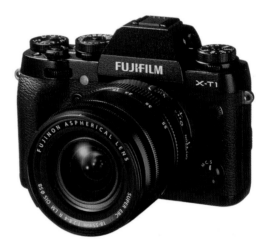

My main camera these days, the Fuji X-T1 offers rugged, high performance in a smaller lighter setup.

Take the Fujifilm X-T1. It's the first mirrorless camera to feature full predictive AF tracking, a rugged, weather-sealed body, an extremely large, bright electronic viewfinder, and a top shooting speed of 8 fps. The Olympus OM-D EM-1 has similar specs, and the even newer Sony a6000 has an AF system that's reported to track at up to 11 fps. With technology moving as fast as it does, we're seeing the dawn of a new era of small, capable cameras. Give it five years and there might not be any separation between DSLRs and mirrorless cameras in terms of performance and overall quality and usability.

I've already shot a number of high-profile assignments with my X-T1, including some that have involved fast action sequences and rather extreme conditions. Having tested the camera extensively during the previous months, I was confident in its capabilities, and in every case, the X-T1 did fine and the clients were happy with the photos. To me, this clearly shows that today's mirrorless cameras indeed are up to the task.

Shot with the Fuji X-T1 and 14mm lens.

If it's the right image and it works for the project, the client doesn't care what camera was used to make it. This photo, shot with a compact Fuji X10, was used as a 4 x 6 ft display print inside a building lobby by a corporate client.

Skiing with a small, lightweight camera around my neck means I can turn around and grab photos on the fly. I wouldn't normally have stopped to unpack my DSLR to take a photo like this. Shot with the Fuji X20.

In addition to the new technology and weight savings, one thing that's made these cameras so popular is that many of them are built with classic construction. In a time when so many things in our society are designed to look "modern," some camera companies are starting to go back to so-called "retro" designs. They're building cameras that look and feel like our parents' cameras, or for those of you who've been shooting for 20 years or more, they feel like our very first manual cameras. They have beautiful styling and refined details like milled metal dials, rotating aperture rings, and full manual controls.

While having a cool looking camera doesn't necessarily translate to better quality pictures, having full manual controls and easy-to-reach dials can make you more efficient with your technique. Clicking a dial with your thumb to adjust exposure or change the focus mode is way faster than digging into the LCD screen and poking through menus and submenus. In the long run, that will translate in a big way. Less scrolling, more shooting.

Some mirrorless camera systems are built around interchangeable lenses, others have fixed lens. Many of the fixed models even have zooms. Keep in mind, though, that interchangeable doesn't necessarily mean better. In fact, there are a handful of fixed lens, rangefinder-style cameras out there that offer exceptional image quality, like the Fuji X100. At the same time, there are an increasing number of budget mirrorless kits that use interchangeable glass. Some of the less expensive cameras even use the

I shot this photo with the Fuji X10, a compact camera with a built-in zoom lens. Even though the sensor is considerably smaller than what you'd find on a DSLR, since it's small and light, I'm more apt to carry a camera like this with me during fast and light adventures. The best camera is the one you have.

same sensors as the higher end models, so you get the same image quality, but with fewer features and a less durable system (read: lighter weight) that has more plastic in it than metal.

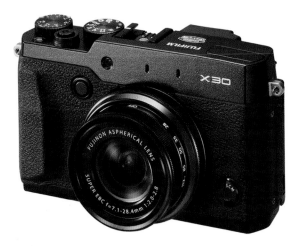

The Fuji X30, a capable, unencumbering, unobtrusive compact camera that's ideal for travel or going ultra light.

As with anything, price is the determining factor with these cameras. Looking at ballpark figures, you'll spend about $1000–$1600 on a good-quality, full-feature mirrorless body, with dedicated lenses falling in the $300–$1000 range. Comparable models in this range include the Fujifilm X-T1, Olympus OM-D EM-1, the Sony "a" series and the Panasonic Lumix DMC series. In fact, upon quick glance, many of the high-end mirrorless cameras out there today look and function very much like DSLRs. Some of them even have add-on battery grips. For fewer featured bodies, expect to pay $600–$800.

At the top of the fixed-lens mirrorless line is the Leica M9. Other cameras in the line include the modern classic Fujifilm X100 and the Nikon COOLPIX A, both in the $1200 range. Below that are a number of mid-level range cameras in the $500–$800 range, like the Fujifilm X30, Olympus PEN EP-2, Sony RX100, Pentax Q, Nikon P7700, and Canon G16.

How does this new class of cameras fit into the picture?

Just about every serious photographer has a decent compact camera these days, and not just to use as a backup. I'm telling you right now, even if you have a DSLR, you should consider adding one to your system. Not only are they serious contenders when it comes to quality, they're lighter and smaller than traditional DSLR gear, so they come in handy when you want to travel light, whether you're in nature or on the street.

For the past two decades, I never left home without my DSLR gear. These days, depending on the situation, I often travel with just my mirrorless cameras, because it means I have at least one camera with me at all times. Even during those times when I'm carrying my DSLR gear, I still take along a compact camera because it gives me more options for creativity and versatility.

For most types of photography, modern compact gear does great, especially if you're primarily shooting for the web, and they certainly lighten up the camera bag. After so many years, this new feeling of unencumbered freedom is liberating. In fact, an increasing number of photographers are ditching their DSLR gear entirely and going all mirrorless with no regrets. There's some real excitement out there about today's smaller cameras, and that kind of excitement is driving the industry in fantastic new directions.

I'm not ready to sell all of my Nikon gear just yet, because as I said in the last section, when it comes to durability, autofocus speed, lens selection, and off camera flash, DSLRs still have the edge for shooting serious action

photography. That said, I've done entire trips with just compact cameras and gotten impressive results. Even though they don't offer the same quality as my full-size Nikons, that's often a trade that I'm willing to make if it means I can go lighter and faster out in the world.

I recently did a week-long bike tour up the California coast, riding the entire route with only a compact camera that I just kept around my neck every day.

My recommendation is this: look seriously at this new generation of cameras, and consider adding at least one of them to your lineup. I promise, you'll find a use for it. If you've already got DSLR gear, consider getting a fixed-lens compact that you can take everywhere and keep on you at all times. Sure, you can always use your smartphone for grabbing quick captures, but there are times when it's nice to have full manual control and the intrinsic feel of using an actual camera.

If your outdoor photography is less hardcore action related, if it falls more in the "people in the landscape" style, if you shoot a lot of portraits and travel photography, or if you don't shoot with long lenses very often, then

I shot this image with the new Fuji X-T1. With the faster AF and high-quality glass that today's mirrorless cameras have, I'm able to travel much lighter and still tackle subject matter with confidence. I see a large part of the future revolving around cameras like this, especially for travel and backcountry adventures.

you might consider bringing a full-sized interchangeable mirrorless camera into your kit and making that your number one body. You'll still get top-quality imagery and, I guarantee, you'll like the weight savings.

And remember, regardless of what you shoot, it's not the camera that makes the difference, it's how you use it.

Getting the most out of mirrorless cameras

Forget everything that I've said about DSLRs. There's really no reason you can't shoot action and adventure with a mirrorless camera. I've started to use mine more and more in my photography, simply because it lets me go lighter and faster than ever before.

In many ways, these cameras are more advanced than anything that Galen Rowell used when he first started, and he did just fine. This is ironic, because he once said:

Small, portable digital cameras that exceed the performance of an off-the-shelf Nikon using 35mm slide film are further away from current reality than the proposed NASA manned Mars mission, although I expect both to happen sometime during my lifetime.

I'm confident that my Fuji X-T1 is more advanced and shoots better quality than any camera that was around during Galen's illustrious life. When it comes to performance, I've shot everything from skiing to bike racing with my mirrorless gear and gotten excellent results. In fact, the slightly different approach and creative options that it inspires can bring a fresh look to your imagery.

Get to know what it does well, and what it doesn't do well, and then adapt accordingly with how you approach your subject matter. For example, if the limiting factor on your particular camera is a slightly slower autofocus system, you may have to figure out a different way to shoot certain kinds of action. If you're dealing with a fixed lens and only one focal length, then you'll obviously be limited with your compositions. However, limitation breeds creativity. Take away the options and you'll be forced to come at your problem in a new way.

Being creative is what it's all about anyway, so make the most of what these cameras have to offer. I recently shot an entire cyclocross race with one of my cameras set to 1:1 square format and black-and-white JPEG mode only. Why? Just to try something new. I had a blast and got some really cool photographs. This from the guy who, a couple years ago, preached that you should always shoot in RAW.

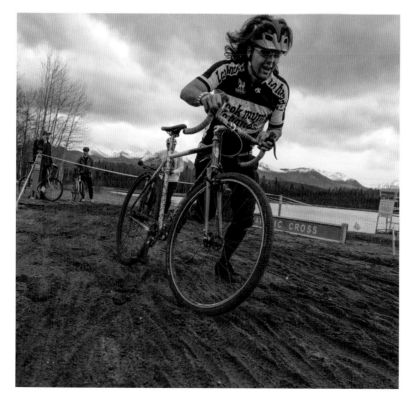

Anchorage cyclocross: Shot with Fuji X-E1 in 1:1 square format set to a BW film simulation mode.

In the end, there is no single "right" camera or setting for what you shoot, so pick something and run with it. You'll have fun. I promise. And if the imagery isn't up to scratch, chalk it up to practice and learn from your mistakes. You'll be better next time.

And like I said, *learn your gear*.

The trick to shooting with little cameras is to treat them like big cameras. Use all of the techniques that you would normally use. Don't think camera, think method. Do what you normally do. Throw yourself right in the middle of the action if you have to and shoot away. Experiment. Vary your settings. Be adventurous. Be bold. Challenge yourself. In the end, it's less about the gear and more about the approach.

It's not just about quality anymore, now it's about look

During the past five years, the main concern with cameras was quality. Well, I'm here to tell you that the megapixel war is over. We won. Just about every decent camera is capable of producing high-quality work. Now we're at a stage where pixel count is becoming less important, and things like form, function, performance, handling, and expanded color palettes are the determining factor for many photographers.

Digital doesn't have to be vanilla anymore; now you can get the look you want right in the camera. This opens up new possibilities, especially when shooting in less than ideal conditions. These days when I'm faced with light that lacks punch, or when I simply want to go for a different feel, I often switch to one of the film simulations, black-and-white modes, or special effect settings that are built right into the camera software. This gives me even more creative options for trying to wrangle out a great image from my scene. Plus it's just one more thing that adds to the fun factor!

Photography is supposed to be fun, right? What's more fun than giving your image different looks? I shot this in "miniature mode" with my Fuji X20.

No matter what kind of camera you shoot with, you should know your gear inside and out. The more familiar you are with the controls and how your camera functions, the more comfortable you'll be when shooting challenging subject matter with it.

Lenses

If cameras are the brains of photography, then lenses are the soul. Where cameras deal primarily with ones and zeros, lenses deal with the intrinsic qualities of real light. They're the ones that do the heavy lifting when it comes to translating your personal vision of the scene into a photograph.

I could have said that lenses are like your eye, because functionally and mechanically, they do the same job. They see what you see. They take all the light, color, and movement of the world in front of you and deliver it to the camera for processing, archiving, and safekeeping. Without a lens, you wouldn't even have a camera, you'd just have a handheld computer.

Depending on how they're built, lenses can see the world with different viewpoints, which is something that our eyes can't do. We humans take in a fixed field of view that extends about 90 degrees from left to right, although our main, non-peripheral field of vision is only about half that. We don't have wide-angle or telephoto capabilities with our vision, and since our eyes are all the same shape, nearly every human being with normal vision sees the world in roughly the same way.

Lenses, on the other hand, can be built to see in ways that we humans can't. This allows a photographer to create images that inherently carry more visual impact, simply because they show a view of the world that we're not used to seeing. Being able to choose different focal lengths

gives you tremendous flexibility in how you compose your images and communicate your vision of the world. Much more than the camera, your lens choice dictates a large part of the overall feel and style of your craft.

Some careful decision-making is required when choosing lenses for action and adventure photography. In addition to focal length, size and weight become important concerns, especially when you're carrying all that glass into the backcountry. Just as with cameras, lens choice becomes a game of tradeoffs that ultimately revolve around which gear offers you the most bang for your buck.

In the next section, we'll cover the range of different lens types with regard to focal length (wide-angle vs. telephoto) and build types (pro vs. consumer.) I'll also cover how to choose the right lens for shooting action photography and show you some creative techniques for getting the most out of each type, no matter what subject you're shooting.

Lens basics

As I mentioned, lenses are very similar to the human eye in terms of design and function. Both are optical devices with curved surfaces that are designed to accurately transmit and focus light onto a single plane, by either converging or diverging the beam onto your optic nerve or your camera's digital sensor.

Both have variable apertures (your eye has an iris) which adjust to let in the correct amount of light for proper exposure and also affect depth of field. (The f-number of the human eye varies from about f/8 in the sunlight to about f/2 in the dark.) The main difference is that where your eye operates as a fixed lens with an effective 45-degree angle of view, a lens can be built to transmit a very wide or a very narrow view of the scene. Also, since we have two eyes, we obviously see in 3D, while consumer cameras can only function in 2D.

Modern lens features

As with cameras, lens technology has come a long way in the past hundred years. While basic optical principles remain the same, modern lenses are manufactured with multiple elements and special coatings that help reduce reflections and flare and increase clarity and resolving power. These designs also correct for certain distortions or aberrations that are caused by the fact that different wavelengths of light focus at slightly different distances, especially in single element optics.

Zoom lenses are built with movable elements, which allow for different view angles and levels of magnification within a single unit. Most modern lenses are also built with highly advanced autofocus motors and electronics that communicate with the camera. Both of these technologies improve with each generation, and the good news for us action photographers is that every advance in lens design and construction plays right into our needs. It's as if they're designing lenses just for us. Many lens ads often feature sports and action subjects.

Forget the lens caps

First thing to do when you buy a new lens? Ditch the lens cap. They only slow you down and make you look like an amateur. Instead of lens caps, use a UV or skylight filter and the dedicated lens hood that is designed for your lens. I keep these things on my lenses ALL the time and never remove them unless I break or scratch the filter or bust off the tabs on my hood.

The filter will protect the front element of your lens, while the hood will protect it against those hard side blows against rocks and trees. It will also prevent flare and make for sharper, higher contrast imagery.

Some photographers argue against placing a much cheaper piece of glass in front of your much more expensive front lens element. In their minds, it degrades quality. While I somewhat agree with the substantive nature of their positions, I still advocate for the filter and hood approach. You can buy good quality filters, and the truth is that if you're that active with your gear, sooner or later, you're going to bash your lens against something that could possibly cause damage. Wouldn't you rather nick or dent an easily replaceable filter then the front element of your thousand dollar lens?

If you do decide to go filterless in the name of quality, at least use a lens hood. I'd still ditch the lens cap, though. Like I said, it's only going to slow you down, especially if you've got a hood on there. You'll fumble with it every time you switch lenses. You'll probably drop it.

The hard truth is that lens glass is tough. It doesn't scratch or chip easily, and if it does, not to worry; just paint the scratch with black paint. This will prevent light from reflecting in the scratch and showing up on your image. Unless it's a huge chip, the paint won't show up in your pictures, because the optics of a multiple element lens aren't designed to focus that close on the elements themselves.

Image stabilization

Many lenses today are built with image stabilization, also referred to as vibration reduction. VR/IS is achieved through gyroscopic motors built into the lens barrel that reduce vibration from camera shake and lens movement. Essentially, VR/IS allows you to shoot at much lower shutter speeds without a tripod than you could normally hand hold and still get sharp pictures. VR/IS is ideal for low light and for shooting handheld. Keep in mind that VR won't freeze moving subjects if you're shooting with very slow shutter speeds, but for most other applications it works quite well. Is it necessary? Not really, but it's a pretty nice feature to have.

I shot this photo handheld at 1/30 sec., with an IS lens zoomed to 200mm. Without an IS lens, I'd normally need a tripod in order to get a sharp image with such a relative shutter speed.

Fast vs. slow

We usually talk about lenses in the context of how fast and slow they are. This is not anything that you'll find written in the manual, nor does it have anything to do with the speed of the autofocus or how fast you can slap it on your camera body. It's an important technical term that's based on the overall design of the glass and the aperture range. The speed of a lens refers to the maximum aperture that's available, or how wide it opens up. Generally, a lens with f/2.8 and wider is considered fast, while anything in the f/5.6 range and higher is considered slow.

A fast lens has larger elements and a wider barrel than a slower lens with the same focal length. This allows it to gather and deliver more light to the sensor. The benefits of using faster lenses are simple—they allow you to shoot at higher shutter speeds, without having to crank up the ISO setting This is, of course, critical to shooting action and fast-breaking subjects, as well as shooting inside or under dim light.

Faster lenses also make for higher quality images because more light equates to less noise on the sensor. In addition, fast lenses tend to give

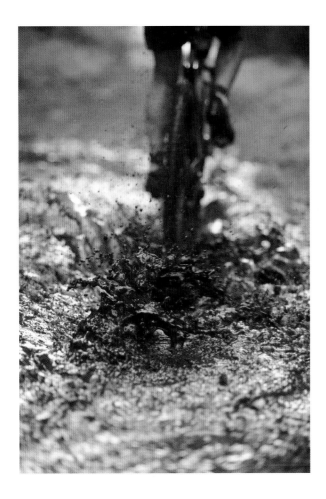

Under the dim light of early evening on forested trails, I shot this with a Nikon 85mm f/1.8 lens at ISO 800, 1/200 sec at f/2.2. With a slower lens, I would have had to sacrifice at least one or two stops, and either risk getting more noise with a higher ISO or losing the sharpness of the water drops with a slower shutter speed. Never underestimate the power of a fast lens!

better bokeh, which is the technical term for deliciously soft backgrounds that portrait and closeup photographers love. Finally, the highest caliber of lenses from any manufacturer are usually the really fast ones. Conclusion: faster is better. So why would you ever want to shoot with anything but a fast lens?

Here's why. Just like anything else that has mechanical parts, speed isn't free. There's always a tradeoff. When it comes to lenses, your main tradeoff is that the fast ones are bigger, heavier and harder on the wallet, because they're built with more expensive and advanced components.

Take the Nikon AF-S 70-200mm f/2.8G ED VRII lens. Costs about $2399. This is Nikon's flagship zoom and it's built like a tank. Weighs 3.39 lbs. Need top notch imagery? This lens won't let you down, but it will surely slow you down if you're trying to hike with it.

Now look at Nikon's AF-S VR 70-200mm f/4G ED VR zoom telephoto. It's full-on pro-quality glass that has the same anti-reflective coatings, but it's a full stop slower, and it's made with lighter weight materials. Costs $1399. Weighs 1.87 lbs. That's a thousand dollars less, and the difference in price is largely for the one stop difference in speed and more plastic in the barrel. Overall, it's a good tradeoff in weight and price, because it still produces pro-quality imagery. The downside? It's a little slower and probably won't handle being dropped as many times as the f/2.8 model.

Finally, take the even slower AF-S 70-300mm f4-5.6 ED IF lens. Price on this one is only $589, which is almost a quarter of the cost of the big f/2.8. Weight: 1.64 lbs. It doesn't have all the anti-reflective coatings that the other two models have, and you certainly can't hammer nails with it, but for general photography use, it's still very good glass. It just won't be as sharp throughout all focal lengths and apertures as the other two.

So, having read the above comparisons, I have three questions for you:

1 Which one of these do you think will give you the best imagery?

2 Which one would you rather carry with you for 20 miles into the backcountry?

3 Which price tag is a little easier to stomach?

See what I'm getting at? That pro-quality f/2.8 version is a killer lens, but it's quite expensive, and you'll certainly feel the weight if you carry it for any length of time over great distances. Believe me, I used to lug my 80-200mm f/2.8 lens just about everywhere I went. As it was my bread-and-butter action lens for subjects like skiing, biking, kayaking, and climbing, I just couldn't leave it at home because it gave me excellent, pro-quality imagery. However, while I loved the lens itself, I can't say that I loved how heavy it was.

Now I use the 70-200mm f/4G lens. Sure it's a full stop slower, but I'm typically using it outside where there's lots of light. Under most conditions, I've found that f/4 is not the end of the world compared to f/2.8. It's durable enough for most uses, and since it's that much lighter, I'm much more likely to pack it in remote locations and use it in difficult conditions.

My advice: Get the fastest lens you can afford

I always advocate for photographers to buy the fastest lens they can afford. Keep in mind, though, I'm not just talking about the fastest lens your bank account can afford.

Shot with the new Nikon 70-200mm f/4G ED VR lens. Good enough for pro work, light enough to carry while backcountry skiing.

Outdoor and adventure photographers are a highly active breed. We're not standing at the sidelines with our huge glass and 10 lb. tripods. We're not just carrying our kit from the airport to the rental car, or from the parking lot to the photo shoot, or from lobby entrance to the elevator, we're moving across landscapes for hours on end under our own power. We're exploring. We're pedaling, walking, traversing, skinning, climbing, scrambling. Sometimes falling. If it's not around our necks, our gear is probably on our backs. Either place, every pound matters.

At the same time, no matter if we're shooting for clients, for stock, or for ourselves, we still aim to capture the highest level of detail and sharpness. We demand gear that will get the job done and survive the rigors of whatever punishment we throw at it. Second best isn't something we usually want to settle for, but depending on our needs and itinerary, there are times when we may need to compromise.

For some people, "afford" may very well mean money. Not everyone wants to spend two grand on a single lens. For others "afford" might mean weight. A great lens isn't worth anything if it's too heavy to carry with you on your trip. If you're often on the move, then consider the reality of carrying a heavy lens. It might be no big deal for you, but then again, it might. It may be worth sacrificing a little quality or durability if you get a lens that you carry with you everywhere.

If you tend to go ultra lightweight (think cycling trips, hikes, alpine climbing, and world traveling) then you probably want to look at the lightest model you can get your hands on. You'll likely be OK sacrificing speed, durability, and maybe a little edge-to-edge sharpness if it means you'll never be without your lens. As with a camera, the best lens is the one that you have with you when the moments unfold in front of your eyes.

I'd stay away from cheap lightweight kit lenses, as many of them have plastic mounts. I've seen cheap lenses break right off of the camera with the mount still attached. That's as good as money down the drain. My recommendation is to stick with metal-mount lenses. If you shoot outside, you WILL bang your gear around, so get gear that will withstand some abuse. The difference in weight won't be that much, maybe the equivalent of a couple energy bars, at most a half-liter of water. Don't skimp on your lens: if you're that weight conscious, then make it up somewhere else. Or just deal with it.

In terms of image quality, great lenses shine, but the reality is that most lenses these days are going to give you acceptable results for publication and anything you're going to do with your pictures online. Just stay away from the bargain bin. Stick with the main manufacturers. If you can afford it, my advice is to treat yourself to pro-quality glass. It's designed to keep working even when being knocked around, dropped, scraped against the rocks, and duct-taped back together. Your photography deserves it.

Fixed vs. zoom

One of the most innovative advances in lens design was, by far, the zoom lens. Zoom lenses allow you to change your focal length to achieve a wider or more narrow view angle, which lets you vary the framing of your shot while standing in one place.

They also eliminate the need to carry a bag full of lenses, which can be highly advantageous when you're moving around outside. One zoom lens can easily take the place of two or three primes, and when you add in

all the potential time and photo opportunities you lose when you have to stop and change lenses, zooms offer great convenience and tremendous versatility when you find yourself shooting in tight spaces.

One could also say that, for the outdoor and adventure photographer, zoom lenses are not only essential, they're potential lifesavers. Think about it: running around with your camera on precarious terrain is dangerous enough, what if you're moving back and forth to compose the perfect shot and you forget to look where you're going? Isn't it safer to just stand in one spot and move the lens barrel back and forth instead of risking falling off of something? You laugh, but when you're in the middle of the action and the moment is about to unfold in front of you, everything else goes out the window, including good judgment. Raise your hand if you've almost done something really stupid while taking pictures. Now look around. See, you're not the only one.

With this in mind, why would we ever want to shoot with fixed lenses? Once again, it's always about the tradeoffs.

Due to the inherent design of zoom lenses, they will never be as sharp through the entire range as a good prime. They're optimized to perform well at all focal lengths, but they're rarely perfect at all focal lengths and f/stops. Often times, it's the open aperture range where you'll see a slight

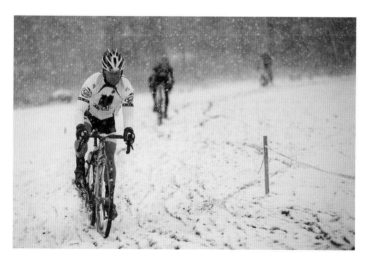

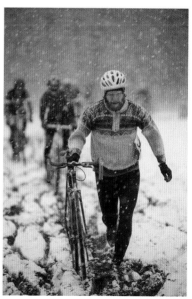

Using a telephoto zoom allows me to vary compositions on the spot. In this instance, I liked the 145mm viewpoint of being able to see the leader with the other racers sweeping out behind. Less than a minute later, I zoomed the lens all the way in to 200mm and grabbed the shot below. The zoom gave me a tighter view without changing vantage points.

loss in sharpness and image quality. This matters because when shooting action with long lenses, you're often shooting wide open (or close to it), so that you can keep the shutter speed high. With most zoom lenses, you'll rarely get the same sharpness and accurate color rendition that you'll get with high-quality fixed lenses, especially with zoom lenses that have an extremely wide range, such as 18-300mm.

This loss of quality is even more apparent in cheaper zoom lenses. You'll also see increased distortion and chromatic aberration with budget lenses. Basically, the cheaper the zoom, the lower the quality. This is unfortunate, because cheap lenses are usually pretty light, and don't we all want to save weight when we're in the backcountry? They're also slower, which as we saw in the preceding page, can be an important factor.

This rule of thumb applies to any lens. No matter whether you're dealing with fixed lenses or zooms, all lenses are a compromise of features, size, weight, build, image quality, performance, and of course price. In the end, you get what you pay for. Good glass isn't cheap, but it's well worth the money. It will let you get the shot in a wider variety of settings and lighting conditions, produce better quality images, and will withstand much more abuse than an inexpensive kit lens.

The look of the lens

In my photography, I mostly shoot with fixed lenses because they're fast and compact, and they offer exceptional image quality. My main kit includes the following focal lengths: 14mm, 24mm, 50mm, 85mm, and 105mm, all of which are f/2.8 and faster.

I also prefer the compositional simplicity of primes over zooms in the short to medium range. Over the years, I've become familiar with the look that each type of lens imparts on my subject matter, and I've incorporated those individual looks into my style. I like to think that my vision has been calibrated to match my favorite lenses.

In some ways, it's about limiting my choices, which I feel is a powerful ingredient in creativity. Because I already know what each focal length will give me when I look at a subject, I can quickly decide on the look I want and then grab the lens that will match my vision of the scene. To me it just feels more definitive. It may be different for you.

I do like the longer zooms, though. When I'm shooting beyond 85mm, I'll switch to the 70-200mm. As much as I love my primes, that big telephoto

zoom has long been my bread-and-butter lens. I couldn't live without it, which is one reason I've used DSLRs so long. By the time this book hits the shelves, I may already have a fast telephoto zoom for my Fuji X cameras.

That's not to say that I haven't made good use of shorter range zooms, but given the choice, I tend to stick with my primes. Of course this is all a matter of opinion. I know plenty of pro outdoor shooters who love their shorter range zooms, like the 14-24mm, 17-35mm and 24-70mm. All of these are great options, but with versatility comes increased size, weight, and price.

You'll probably find that different lens combinations work for different shooting situations. That's why your lens choice should be dictated by

Made with my Nikon 24mm f/2.8. This is one of my most often used lenses. I know my gear so well that I can look at a scene, immediately see how it will be rendered with a given lens, and quickly compose a shot as the action is unfolding in front of me.

Shot with the trusty Nikon 80-200mm f/2.8. It's a heavy beast, but I've sold more photos taken with this lens than any other.

your activity, and why you'll probably want to have a wide selection of glass in your arsenal. What works for a weekend ski photographer may not work for an expedition mountain photographer, and that may be different from what might be ideal for overnight hiking trips. Ideally, you'll want to have gear that covers all your bases.

My advice to you is to build a kit that revolves around your own shooting style. Before buying, you can always rent lenses for a week or two; this can give you a pretty good idea of whether a particular length might fit well into your system. Even if you find that zooms work well for you, I would highly recommend getting at least one or two fast fixed lenses. I guarantee you'll learn to love them and find situations when they'll prove to be indispensable.

Cameras come and go, but nothing is as important and lasting as good glass. As I said before, buy the very best lenses that you can afford. You'll never regret it.

How to use lenses

Now that we've covered some of the technical and usability aspects of lenses, let's spend some time studying how they actually see the world. A large part of becoming a better photographer is being able to anticipate how different lenses will affect the look of your imagery and recognizing which lens will let you reproduce your subject in the way that matches your own vision of the scene. By knowing how each type performs, you can better use them to your creative advantage.

I like to break lenses into four different categories: Wide Angle, Normal, Short Telephoto and Long Telephoto.

Wide angle

Wide angles are the lenses that make you feel like you're right in the middle of the action. They're indispensable for the extreme sports and adventure photographer, because they give your viewer the impression that they're nose-to-nose with your subjects, sharing the same belay ledge and riding the very same wave. Wide-angle lenses blow out the perspective, which gives images a very three-dimensional look. The optical design of wide lenses gives them increased depth of field, which allows you to shoot images with sharp focus front to back.

These are the lenses that I use to tell a broad story within a single frame. By taking advantage of the inherent characteristics of these lenses, you

can shoot very close to your subject matter and still show them within the context of their background. This gives your photos an intimate feel and creates a narrative that allows the viewer to track their eye around the frame and explore the different elements in the shot. Wide lenses let you accentuate your foreground, which helps you define a strong main subject for the photograph.

Also, since they greatly expand the perspective of your viewpoint, wide angles are less prone to camera shake at slower shutter speeds. If you use the general rule of hand holding the camera at shutter speeds no lower than the reciprocal of your lens focal length (e.g., no lower than 1/25 sec. for a 24mm lens), wide angles let you shoot at slower speeds, which makes them more useful in lower light conditions.

Ultrawide lenses for DSLRs can get kind of heavy (my 14mm f/2.8 is a beast), but when you hit that sweet middle range of around 17–28mm, they're usually pretty small and compact. My favorite all-around wide angle is the 24mm f/2.8. It's gone with me on every single trip, assignment, and

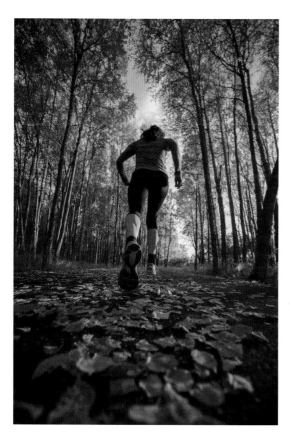

The extreme wide-angle lenses let me get in really close and almost be part of the action.

Wide-angle lenses let you get in close and still show the environment.

expedition. If I leave the house with my DSLR, then my 24mm lens is in the bag nearly 100 percent of the time. For my Fuji mirrorless cameras, my wide angle of choice is the relatively small 14mm f/2.8, which effectively gives me a 21mm view when compared to full frame.

Normal

Normal lenses are called "normal" because they offer similar visual characteristics to the way we see. The standard 50mm lens closely matches both the viewpoint and the spatial perspective of the human eye, which is why it makes a great first lens for beginning photographers. Shooters who are just starting out have enough to deal with when it comes to learning how to work with their camera. When you're trying to train your brain how to "see'" in this brand-new medium, it can be overwhelming to throw in too many focal lengths at the start.

Normal lenses are great when you just want to show the scene as you see it with your own eyes. They have very shallow depths of field up close, but that's lost when you back up, so they're not great for isolating distant subjects against a background, unless you're trying to show them in the context of their environment. They're great for showing details up close, and since normal-length primes are small and compact, they rock for travel photography.

Normal lenses have a very shallow depth of field when you're shooting close.

They're also great for portrait work.

I go back and forth with my normal lens; some months I'll use it quite often, other times it sits in my bag unused for weeks at a time. I don't have this kind of warm/cold relationship with any of my other lenses. It's like an old friend; I don't see him all the time, but when we get together, we always manage to get into lots of trouble. My favorite normal lens is the Nikon 50mm f/1.8, and the ultratiny 27mm (41mm view) pancake lens for Fuji X series.

This is the same scene as the wide-angle running shot on the previous page. Notice how this has a more intimate feel.

Normal lenses closely equate the view of human vision. They make the viewer feel as if they're looking at the scene from a first-person perspective.

Short telephoto

I like to break telephoto lenses up into Long and Short, because I think that these lenses each have a specific set of characteristics that make them ideal for different uses. I consider short telephotos to be in the range of around 85–120mm, which is considered the standard length for shooting portraits.

If you've ever looked really closely at the human head, you'll notice that it's got kind of a funny shape, and our ears are pretty far back behind our eyes. The view angle of a short telephoto like an 85mm or 105mm lens beautifully compresses the perspective slightly, which brings our ears forward a little bit. This makes us look more pleasing. In addition, their relatively shallow depth of field creates deliciously soft backgrounds that can isolate your subject matter beautifully against a gentle wash of color, texture, or tone.

Aside from portrait use I also love the short telephoto for shooting details in the landscape and isolating particular parts of the scene. I love them for narrowing in on the adventure, and when traveling, the short telephoto is a great "across the street lens," because it lets you back up just enough to give your subject some space for candid work.

As much as I love how it looks, though, the real appeal of a fixed short telephoto is that it's much more compact than a big telephoto zoom, which means that it packs easily inside your bag and makes it easy to take just about anywhere. Sure, a full zoom lens will have this focal length within its range, but when you're moving quickly, you can't beat a fast short telephoto prime. Slightly compressed viewpoint, killer bokeh, great for isolating subjects . . . what's not to love?

My favorites lenses in this range are the 85mm f/1.8 and the 105mm f/2.5. I rarely go anywhere without either one of these. For my mirrorless cameras, I have a Fuji 56mm f/1.2, which gives the same view as the 85mm on my Nikon.

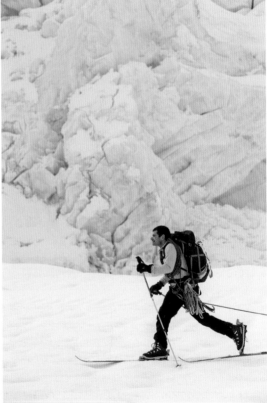

The short telephoto is the ideal lens for portrait and detail work. Shot with the Nikon 85mm f/1.8.

Back up and you can show more environment and still blur the background slightly, which makes your subject stand out crisp and sharp and gives them a sense of place.

The short telephoto lets you back up and compress your scene a little bit, while still leaving room for enough environment to tell the story.

I love the way short telephoto lenses isolate parts of the landscape from a distance.

Long telephoto

Finally, we come to the big glass—the workhorse lenses of most action and sports photographers. I'd be lost without mine, or at least in another career, because without it, I'd never be able to compete with the other pros. According to the metadata in my Lightroom catalog, it shows me that I've shot more images with my 80-200mm f/2.8 than any other lens, and this from a guy who LOVES shooting wide angle! Add to that everything I've shot with my new, lighter weight 70-200mm f/4 VR lens, and the numbers climb even higher. Between those two lenses, the total is over twice as many images as I've shot with both my 24mm and my 85mm and six times as many as with my 50mm.

Despite it being way more cumbersome that any of my other lenses, I've managed to cart it just about everywhere, because I love how it pulls distant subject matter up close. Even on subjects that are relatively far away, the long telephoto will bring them in and drop them in front of a soft, out-of-focus background. That's the real strength of a long telephoto, being able to isolate your subjects and make them pop with razor sharp focus against a wonderful, contextual blur.

I use this blur in a couple of different ways. I'll either pin the subject on a simple backdrop of color or tone, or I'll use it to include one or two other

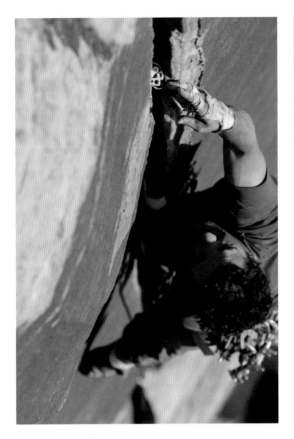

The fast telephoto zoom is the quintessential action lens for shooting subjects like climbing and skiing. It's always my first choice for capturing razor-sharp images and compressing big settings.

Long lenses let you focus on details that draw your viewer's eye into the frame and let you operate from a wide range of possible vantage points.

secondary subject elements that also lie in the scene and relate to the main subject somehow. Even though these secondary subjects are not sharp, they still draw the eye and help tell the story of the shot, which is a technique that adds a great deal of visual power to a photograph.

Sure, there's much bigger glass out there than the standard 70-200/300mm lens telephoto zoom, but pound for pound, dollar for dollar, this range is a great compromise if you plan to run around outside with it. Again, the f/2.8 versions are by no means light or easy to carry, and they will surely slow you down, but if you figure out a workable way to bring that thing on your adventures, it can mean getting some fantastic, up-close imagery, which will later negate any physical hardship that you may have encountered during your trip. Suffering is temporary, but a killer shot lasts forever.

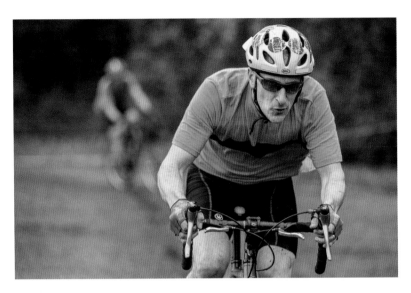

Long lenses let you nail those expressions and make them pop against a soft background, and at the same time, they suggest subject elements to help tell the story.

Of course, with all that extra weight on your back, your friends might leave you in the dust on the trail, but that just means you'll have to work harder and get in even better shape. I never said that adventure photography was easy.

Memory cards

Film is still cool, but if you're a high-volume shooter, why settle for 36 frames on a roll when you can get a few hundred or a few thousand frames on a little plastic chip that's about the size of a coin? Besides,

those little chips are way more durable than film ever was, which makes life as a photographer so much less worrisome.

With memory cards, you never have to agonize about scratched emulsion, heat, fogging, expiration dates, color shifts or X-Ray machines anymore, and if you accidentally send your card through the washing machine or run over it with your car, there's a good chance that it will still work. Please don't try this at home. On second thoughts, never mind. See just how much abuse it will take. Drop it off a building. Go swimming with it. Throw it in the freezer. Just make sure you download your images first. You know, just in case.

Shopping for memory cards is pretty easy, especially since they've come way down in price over the years. I bought my first 4GB card in 2006 for almost $200. Today, you can buy a pair of 16GB cards at Costco for about forty bucks. With today's cameras and bigger file sizes, I recommend going with at least 16GB, if not higher. However, if you have an older camera, make sure you check the compatibility chart for your camera, as some cameras don't support the newer, higher capacity cards.

The other main thing to consider is card speed. This is how well the card performs, specifically how long it takes for the camera to finish writing those images from the buffer to the memory card. For some photography styles, this isn't much of an issue, but it becomes one when you're shooting action, especially in RAW.

If you're shooting a series of 20 RAW photos or 40 JPEGs in quick succession onto a card that only has a write speed of say 30 MB/s, it might take a minute or more to finish writing all of those images. Once you hit the buffer limit on your camera, it basically locks up until it's finished. If the action keeps rolling in front of you, too bad. You're SOL. You won't be able to snap even a single frame until the card is done writing your initial burst of image files. When you're in a fast-breaking scene, 30 seconds seems like an eternity. What if you have to wait for a full minute or more? You might as well go out for coffee.

A faster card that has a 95 MB/s rating might only take 10 or 15 seconds to write the same number of files, which means you'll be ready to shoot again in a fraction of the time. As I write this chapter, UHS-II cards are starting to hit the market with write speeds in the range of 240–280 MB/s. These cards are designed to maximize performance of the newest cameras, some of which have buffer capacities of up to 100 JPEGs and 40 RAW

files. They cost a little more, but if you're shooting action with a newer camera, it's probably worth the investment. How much is your time worth? How much are those moments that you missed worth? If you're on a budget, I'd go with 95 MB/s cards, they offer a good tradeoff in speed vs. price.

If you don't regularly shoot bursts of 10 to 20 shots (or more), you probably don't need an ultrafast card. I've got some 30 and 45 MB/s cards that work fine for general shooting, travel, people, and adventure, even in my newest cameras. However, when things start to speed up, that's when I break out the "super cards."

Card errors

I have no idea how memory cards work. Nor do I really care. All I care is that they DO work. I can try to understand how the camera's image-processing software converts a beautiful scene into a series of ones and zeroes, but just that fogs up my brain. The only thing that matters when I'm out there in the elements is whether those magical plastic chips will safely store my pictures until I get back to the computer.

Preventing memory card errors

What makes cards fail? Sometimes it's nothing that you could have prevented, but there are a few simple things you can do which will lessen the chance of getting card errors.

- Never remove the card from your camera while your camera is on. Keep in mind that your camera might still be writing images to the card, even after you've switched it to OFF. This is often the case, especially after shooting a series. Only remove the card when the indicator light on the back of the camera shows you that it's completely done writing and when the camera is completely powered down.

- Always reformat whenever you stick a new card in the camera. Errors can sometimes occur if you take a card out to copy photos onto your computer, then put it back into the camera and keep shooting without reformatting. Make it a habit to start from scratch every single time you insert a new card.

- Keep your memory card inventory fresh. Supposedly the average memory card is good for about 10,000 write/erase cycles. Push that number and you could start to experience unreliability. You'll probably be getting new cards every few years anyway as they get bigger, faster, and less

expensive. Since buying my first 16GB cards, I rarely use my old 4GB cards anymore.

- Use cards from reputable manufacturers. The way I see it, you can't go wrong with the four big brands: SanDisk, Toshiba, Panasonic (these three collaborated on the invention of the SD card format), and Lexar. There are a lot of other brands out there, but why chance it? Besides, many of the other brands are simply different label OEM cards that are made by these companies. I've always used SanDisk cards in my cameras and have found them to be extremely reliable.

By whatever miracle of science and technology, they function as perfectly intended about 99.9 percent of the time, if not more. In all my years of shooting digital cameras, I've only had a small handful of memory card failures, and none of them was permanent. After my initial panic attack, which is usually followed by a hysterical string of profanities, I've always been able to recover my images with data recovery software.

After shooting a remote, multiday magazine assignment a few years ago, one of my cards failed when I returned home. By using SanDisk Rescue Pro software, I was able to retrieve every single image within minutes. I highly recommend getting this program, or one like it. (It comes free with some of SanDisk's higher end cards.) You may rarely need to use it, but the first time you do, you'll instantly forget about the price.

Carrying your gear

Your job as an adventure photographer is to capture your subjects during the peak moments of the action as they struggle and revel in the excitement and challenge of pulling the hard moves on a rock climb, scrambling to the summit of a pristine peak, pedaling through the most eye-catching landscape, or carving turns down the most awesome powder slope imaginable. You'll often be right there with them, which means you'll need to have an efficient way to carry not only your camera gear, but your outdoor gear as well.

Add in the fact that everything in the real world moves and shifts constantly. Backgrounds change in relation to your subject's position in the landscape, expressions change, body positions change, and the light changes. A scene can go from OK to awesome in mere seconds, so you need to be ready. So, with this in mind, it isn't just enough to have your camera with you at all times, *you need to have it accessible.*

In my mind, accessibility is the number one thing that determines whether you'll get the shot or not. Chase Jarvis says that "the best camera is the one you have with you." I concur, but there's a huge difference between *having it with you* and *being able to get it to your eye within seconds.* Chase is also an action shooter, so I'm sure that he would agree with me on this qualifier to his original statement. Maybe I need to come up with my own catchy phrase. Wait . . . I think I just did.

Accessibility is about coming up with a system that lets you grab your camera quickly without having it get in the way when you're trying to

navigate challenging terrain. Based on years of experimenting with different methods of carrying my camera gear in various outdoor situations, here's a rundown of what I feel are the best options.

Chest or waist pouch

This has been my most reliable and favorite system for almost 20 years. My main bag is a Photoflex Galen Rowell–signature Chest Pouch, which is, sadly, no longer made. (Lowepro has a chest pouch series called the Toploader AW, and Clik Elite has a number of chest-carrying solutions as well.) I've worn out two of them and I recently found a third—brand-new on eBay—that had been sitting in some guy's closet for over a decade. You can either wear it at chest level, keeping the strap around your neck, or tuck the strap in and wear it on your waist. It's padded, zips shut, and has a velcro tab closure for even faster access.

I love this solution because it keeps the camera right there at my fingertips. I can get it out of the bag and up to my eye in about two seconds. I've hiked, biked, skied, climbed, trekked, and moved through the world in just about every other mode of human-powered travel that I can think of with my chest pouch. This method is very conducive to traveling light; with the pouch and a single lens case on my belt, I can carry my camera and two lenses (usually a wide angle and a fixed-fast short telephoto) and be ready for just about anything.

The downside to this solution is that it can get in the way if you're climbing or navigating tight terrain, although you can always spin it around to your back. It can also get a little cumbersome if you have bigger heavier gear, like a pro body with a battery grip or a long lens. I never carry my 80-200

zoom with this method, it's just too bulky to wear on the front of my smaller 5' 7", 135 lb. frame. If you decide that you don't want your camera gear up front, you have to shove the case somewhere, as well as your camera.

Overall, this is great for things like hiking and skiing, but it's not so great for biking or rock climbing with a bigger DSLR. It works OK for trail running if you've got a neoprene camera strap and can secure the pouch securely against your body so that it doesn't bounce.

Pros: Fast access, lightweight.

Cons: Not ideal for every activity, can get bulky in front, especially with bigger zooms.

Camera fanny pack

These are slightly bigger bags that let you carry more gear in a single bag at your waist. They vary in size; some are small enough for just a body and two lenses, some are big enough for your full rig. I've seen people hiking with huge waist packs that are full of gear. You'd never be able to run or move very quickly with that much gear in front, but I guess if you're walking slowly and are big enough to handle all that stuff, this method is about as accessible as you can get.

The Lowepro Inverse 100AW. A typical camera waist pack.

I've got a small Lowepro Inverse AW that works great for trail running, cross-country skiing, and hiking, because it sits securely on my waist/lumbar region and doesn't bounce when I tighten it down. If I want to shoot, I slide it around my front and my gear is right there.

The disadvantage of a bag like this is that it doesn't really work with a backpack, unless you carry it in front. However, then it doesn't work as well for running. If I'm going on a quick outing and don't need to carry much beyond my camera, a snack, and maybe a small water bottle, this method works pretty well.

Pros: Fast access, minimal weight.

Cons: Limits the amount of camera gear you can comfortably carry.

Dedicated photo backpack

I'm really excited about the latest generation of specialized adventure photo backpacks that have hit the market in the past few years. Companies such as Lowepro, Clik Elite and F-Stop offer very good carrying solutions that are specifically designed with outdoor and adventure photographers in mind.

The Lowepro Photo Sport 200 has a dedicated camera compartment that's accessed from the zipper on the side of the pack.

The Lowepro Flipside Sport 10L is a tiny, hydration-ready camera pack that's perfect for trail running, hiking, or mountain biking. With back panel access, it even fits a big telephoto zoom lens.

These packs have dedicated compartments for your camera gear (usually at the bottom), as well as a main compartment where you can put extra layers, jackets, food, water, and other essential outdoor gear. With many of these models, you access your photo gear by simply unslinging one or both shoulder straps and rotating the pack around so that you can reach the camera compartment. They're all rugged and highly weather resistant, with either built-in or optional rain covers, and are designed with good suspension systems and lots of highly technical features like side pockets, ice axe loops, and hydration pockets.

My personal favorites these days are the Lowepro Photo Sport AW series that have top-loading design and side panel zipper access to your camera gear. I also like the smaller back-panel-loading 10L Flipside Sport AW, which I use when I want to go really light.

Another solid choice in this arena is the F-Stop Tilopa, which is big enough for serious technical adventures, travel, or overnights. The Tilopa carries a surprising amount of camera gear and has a very supportive suspension system. The F-Stop Kenti is a slightly smaller pack that's good for day trips and travel. I haven't tried any of the Clik Elite packs, but I know some very active mountain shooters like Matt Trappe who swear by them.

Pros: All your stuff is in a single pack. Good weather protection.

Cons: Not as quick access as a chest pouch. Can be limiting as to how much camera gear you can pack, but then again, isn't that the idea?

My setups

I own a lot of gear, but I rarely carry it all at the same time. In fact, on most occasions, the majority of it gets left behind. While I might cart a full bag of lenses, flashes, radio triggers, and lighting tools with me on a big photo assignment, when I'm headed on a personal mountain ramble or a stock shoot, I've usually only got a few items with me. Here are the typical setups that I'll often carry with me into the outdoors these days.

Ultra lightweight: single lens

Single body, either the Fuji X-T1 or my Nikon DSLR, and a single lens. With the Fuji, lens choice is usually the XF 14mm f/2.8 or the tiny 27mm f/2.8 pancake prime. This isn't much bigger than a standard rear lens cap, it hardly weighs anything, and yet it's sharp and fast with a 41mm traditional 35mm view. If I'm taking my Nikon instead, then the 24mm f/2.8 is my

I grabbed this shot with my Fuji X10, which I slung around my shoulder during a quick, evening ski outing.

mainstay. I've had this lens for over 18 years and it's gone nearly everywhere with me.

In these situations, if I'm just taking a mirrorless camera, then my camera bag is actually the camera strap. Cameras are tough, and I'll often travel with it slung around my neck or shoulder. I don't worry about it getting beat up under normal circumstances, and if things get really tough, I can always stash it in my pack. If I'm going completely minimal and want something to take "fun" pictures, I'll often just grab a small compact or a point-and-shoot.

Standard lightweight kit: add a telephoto

There are few situations when I can't bring more than one lens, so for a wide variety of outdoor work and lightweight hiking, backpacking, bouldering, cross-country skiing, or cycling, I usually like to bring along a telephoto as well. My favorite short tele is the 85mm f/1.8 on the Nikon and the 56mm f/1.2 on the Fuji. These primes are fast, relatively compact, and sharp as hell. They're great for shooting outdoor portraits, street scenes, and isolating subjects within a tight environment.

The 85mm f/1.8 is my go-to short Nikon tele. It's light enough for fast hiking and occasional trail running.

Again, the Nikon 85mm f/1.8 in action.

Trading weight for pro versatility: adding the telephoto zoom

As much as I love wide angle, my most used lens is actually my Nikon fast f/2.8 telephoto zoom. Although these lenses are considerably heavier, it's a worthy tradeoff, because there's nothing like big, fast glass if you want pro-quality imagery. A fast lens in the 70-200mm range can weigh up to 3 lbs., but it will bring in the background and isolate your subject in a field of wonderful blur like nothing else. (Think skiing.) I've sold more images that were shot with my fast tele zooms than with any other lens.

My current version of the Adventure Photographer's Dream Lens is the Nikon 70-200mm f/4G VR ED. That one stop difference, which makes

My Nikon 80-200mm f/2.8 has long been the staple of my pro camera rig. It was the first piece of gear I bought the day I got laid off from my day job and became a full-time photographer. I've shot more frames with this lens than any other during my career.

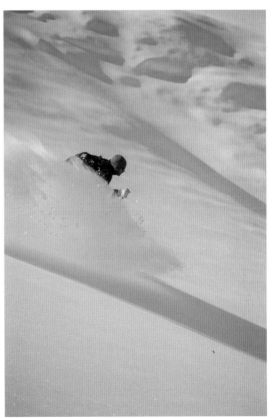

My newer 70-200mm f/4G weighs a pound more than the older f/2.8 model, and it costs a thousand dollars less. It's already seen heavy use in the year and a half since I bought it.

little difference in most outdoor situations, cuts half the price and half the weight. If you're a Nikon shooter, you should have this lens. Canon also makes a 70-200mm f/4 lens as well. They've had it for years. Where do you think Nikon got the idea?

Of course, the crux is figuring out how to carry a lens like this into the outdoors. It's a little too heavy to fit on my belt, and it's definitely too big for my chest pouch. There are some chest pouch bags that will fit a lens this big, but I'm a smaller guy and this would cover my entire torso.

For years, I kept it in a padded lens case and shoved it inside my backpack. Thankfully, the newer packs offer much better carrying solutions for these bigger lenses. It fits on-camera inside my Lowepro Photo Sport 30, which is one thing that makes this an ideal backcountry ski pack. It also fits in the Lowepro Flipside Sport AW series packs, which are ideal for mountain biking, nordic skiing, and lightweight hiking. I can even run with it inside this bag.

Adding more gear

Depending on how complex my shoot is, what I'm photographing, or how long I'll be out there, I'll add more camera gear as necessary, usually in this order:

- **A third lens**: If I have room, I'll start to fill in the middle-ground focal length with a fast fixed normal lens like the Nikon 50mm or the Fuji 27mm pancake. These lenses are both quite light, so they open up my creative possibilities without weighing me down very much. They're also versatile. There's a reason that so many of us started out in photography with a normal lens; they're great for shooting a variety of subjects. They'll do portraits quite well, they'll do landscapes in a pinch, and they're awesome for travel and low light.

- **A flash**: Adding a single flash can make a huge difference in the quality of your photography, especially when you're shooting in challenging conditions. A flash can also be a very welcome addition when shooting portraits or when trying to deal with high-contrast light, so if I think I'll need one, I'll take along a single handheld flash, a tiny portable folding softbox like the Lumiquest Softbox III, and a sync cord to get the flash off-camera. This very simple setup gives me great results, and even without the softbox, it can help you rescue a scene from challenging light. I consider this an ideal rig for travel, portraits, and shooting after the sun has gone down.

- **Accessories**: Most tripods are too big for ultralightweight travel, but the Joby Gorillapod only weighs a few ounces and easily straps onto

the side of my pack. In a pinch, it lets me brace a camera or flash to small trees, signposts, branches, ski poles, or my bike frame. It's not super sturdy, but if I don't have any other tripod with me, it will do the trick and it hardly weighs anything. I've also got a 3 lb. carbon fiber tripod that I'll take when I can spare a little more weight. It's certainly light enough for backpacking.

- **Second camera**: With the exception of a having a backup body for assignment work, I almost never carry two full-sized cameras with me into the backcountry. However, I'll often bring along a compact camera like the Fuji X20. There are times when using or carrying a big camera is simply not practical. Sometimes you even leave it behind for short periods of time, like during the fast dash to the summit or during a very technical rock climb, and having a compact lets you grab shots that you normally wouldn't be able to get.

Of course, these are just my own methods. Yours will vary, and they'll be dictated by your own style of traveling and shooting. Experiment with different setups and change them up until you find a system that works best for you.

Using two cameras side by side

Even when I'm using my Nikon DSLR, I still like to take along a compact camera like the Fuji X20 or the X-T1. Sometimes I'll even use the compact as a second body in conjunction with the DSLR, usually shooting telephoto with the Nikon and wide angle with the compact.

This lets me work quickly without having to change lenses, and it's certainly lighter than having two full, full-size bodies around my neck. I can also give it to a friend or art director so that they can document my setups and shooting methods for things like social media, blog posts, tutorials, and books.

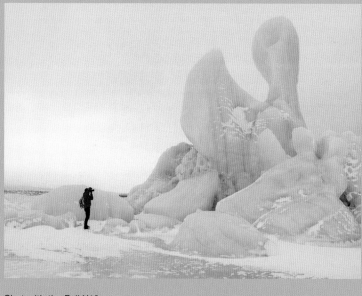

Shot with the Fuji X10.

Securing the camera

When people talk about camera security, they usually mean keeping it from being stolen. I'm talking about not dropping it and having it go careening down the cliff while you watch little bits of metal and glass fly off before it finally explodes into a thousand pieces. (I've seen this happen.) Or watching it disappear into the snow. (I dropped a piece of gear last winter and never found it.) Or watching a gust of wind blow your tripod off the cliff into the ocean with your DSLR still attached. (This happened to a friend of mine. I wish I were kidding, but I'm not.)

There are a million ways to destroy or lose a camera, and I'll bet that you have no desire to experiment with any of them. The way to prevent total camera demise is to come up with a simple way to secure your equipment when you're shooting in high-angle or exposed situations. Whenever I'm up on a rope or climbing with my camera, I use a webbing sling and a locking carabiner to secure my chest pouch and lens cases to my harness. If the bag somehow gets unbuckled, it won't go anywhere.

Also, you don't want to be fiddling with your gear while you're shooting from an exposed position, so before you go vertical, assess the situation and figure out what gear you'll need and what you can leave behind. Going minimal in these kinds of environments is key. Opt for zooms over primes, because changing lenses on the rope is always a bit hair raising. Take it from a guy who shoots mostly with primes.

Keeping you and your models safe

As adventure photographers, it's almost expected that we create images that communicate concepts like extreme, dangerous, perilous, hair raising, etc. I recently saw a blog post that was titled "30 Death-Defying Photos," and many of the photos were of subjects like climbing and kayaking that were shot by pros, guys that I know personally.

Of course, before you try shooting from a rope, or in any kind of high-angle, exposed, or dangerous situation, you should be very well versed in these kinds of techniques. If you don't know EXACTLY what you're doing, seek expert training and instruction before tying yourself to ANY rope, no matter if it's on a cliff or on the tree in your own backyard.

Also, take into serious consideration the safety of your models, who may or may not be quite as well versed in these techniques as you are. Even if they have a competent level of experience in the activity that you're shooting, keep in mind that people sometimes do crazy things when the camera comes out. Whether we're talking about you or your athletes, you need to balance the safety of the situation against getting the shot. In the end, no shot is worth a serious accident.

In other words, don't do anything stupid, and please don't hurt yourself or anyone else in the name of photography. There. Consider yourself warned.

If you think you'll shoot different angles, it might be a better idea to go with two cameras: one with a wide lens and one with a zoom. This will eliminate the need to undo anything while you're up there, although it will make things a bit more cumbersome around your neck. This is when using a compact camera as a second body really makes sense.

Please don't be the one who watches your expensive tripod and camera go tumbling into the ocean. Tie the thing to your car bumper if you have to. Anything to make it so you're not THAT GUY.

Protecting your gear

Cameras are both tough and fragile at the same time. They're made to be used, and even abused, and some of them can take quite a beating. Most higher end pro cameras are built with magnesium alloy chassis, rubberized grips, and weather-sealed buttons and knobs. Pro lenses are made with metal mounts and barrels and heavy-duty glass.

As you get lower in the range, you'll see more plastic in the bodies and lenses, even in the lens mounts. Obviously, entry-level camera gear won't stand up to nearly the same amount of punishment, but that doesn't mean you can't use them in challenging environments. The best advice I can offer is to be careful and try not to smash it or get it overly wet.

As I mentioned in the lens section, get yourself a good camera bag and consider using UV/skylight filters and lens hoods on your glass. And if you can't stomach the thought of putting a cheap piece of glass in front of your really good glass, then at least go with the lens hood. Every dent in your hood is a dent that didn't damage your filter threads or ding the front element of your expensive lens.

In transit

When I'm traveling, I usually pack my gear into a camera bag or photo backpack and carry it with me. Or I shove it into the hatchback, the truck bed, the back seat, the trunk, the duffel bag, etc. If more protection is required, that's when I turn to hard shell Pelican Cases. Pelis are gasket sealed and come with customizable foam inserts that allow you to pack your gear the way YOU like. They're also durable enough to send through as checked baggage on the airlines.

Every day, thousands of photographers, cinematographers, and camera operators send millions of dollars worth of gear through the airlines and transport them on jeeps, trucks, buses, trains, speedboats, camels,

horseback, and pack mules inside Peli cases, and most of the time, their gear arrives just fine. Some Pelis are even configured like roller bags with handles, which makes them even easier to transport.

Above all else: keep your camera dry!

Sometimes it's all about the misery. Want to make great imagery? Don't put your camera away when the weather gets bad. Let's face it, in this genre, the best pictures are made when your subject is suffering under the anguish of utterly horrible conditions. Nothing screams "Adventure!" like a shot of someone fighting against a wall of blowing snow or enduring torrents of driving rain.

Of course, nothing will make YOU more miserable then having your camera fail just when the action is getting good. Cameras and water don't mix, and short of smashing it into a thousand pieces, nothing will cut your photography session short like soaking your camera to the bones. In fact, the only thing that's worse is soaking it in salt water.

Water drop on the lens. Picture ruined.

I'll stress again, if you'll be shooting in rainy or wet conditions, you should get a weather-sealed body. Even if you do have one, you should take extra steps to protect it from excessive moisture, because water can go just about anywhere, and once it gets in, it's going to mess things up. Modern cameras are full of tiny circuit boards and electronics, and water will short things out in a big hurry. Salt water will coat and corrode all those little chips, screws, and gears, even when the H_2O evaporates. Soak your camera in the rain, and you may be able to dry it out. Dunk your camera in the ocean and you'll turn it into a worthless box of junk. A paperweight. A doorstop. You get the idea.

If conditions are wet enough, loosely covering or placing your camera inside a plastic bag might help protect it from a heavy deluge. You can even go the extra step of tucking the entire camera into a bag and then duct taping the opening to your lens hood. A hood will even help keep water off the lens, but keep checking to see how many drops are accumulating on the glass. A couple drops might make for a cool effect, but a big drop in the wrong place will ruin your photo.

Shooting in wet conditions.

Keep a cotton cloth or bandana handy so you can wipe the water off both the lens and the body. If the lens is too wet, synthetic fabrics will just smear things around. You might need to use both; cotton to get the big drops and a lens cloth to do the finish cleaning.

If you shoot in really wet conditions all the time, then you might consider getting an underwater housing, especially if you kayak or go rafting with your camera. Compared to some cases that cost over a thousand dollars, Ewa Marine makes affordable housings for DSLRs and mirrorless cameras. You can also use a housing to shoot those cool, half-submerged water shots in lakes and streams.

Always carry a second body in these situations, especially if you're shooting on someone else's dime. Sure, it adds weight, but if your main camera goes down for any reason, you can be back up and running almost immediately.

This happened to me recently. I've shot for years with a weather-sealed DSLR that had never let me down, even in the worst conditions. Then, on the first day of a big assignment, it got wet and locked up with error messages. With no hesitation, I pulled out my backup camera and shot the entire rest of the assignment with my second body. On a side note, this is why you should be completely familiar with ALL of your gear. Trying to learn a piece of gear that you don't use very often is not an option when you're under the gun.

Drying it out

If you do get your camera wet enough that it stops working, turn it off immediately and remove the battery. Bring it inside and blast it with a hair dryer on LOW for a while before putting it in a warm dry place overnight. Or stick it inside a bag of rice for a day or two. (This usually works with mobile phones.) If you're able to get all the moisture out, the camera may come back to life. If it doesn't, you'll probably have to send it in for repair. Ugh. Like I said, don't get your camera wet!

Outdoor clothing and equipment

Adventures aren't supposed to be comfortable. They're supposed to be one part fun, one part hardship, and one part total suffer-fest. That's why they make for such good stories later on. They're not meant to be easy, they're specially designed to test the limits of your resolve and your endurance. And your clothing.

Just as you'll need camera gear that can handle any type of shooting situation, it's equally important to have outdoor gear that will handle any kind of atmospheric conditions. Remember, when it comes to adventuring, there is no such thing as bad weather, only bad clothing.

I almost didn't include this section; I figure that most of my readers will already know this stuff. However, since getting it wrong can easily cause you your life, a few digits, or at the very least a few hours of misery, I decided that it wouldn't hurt to go over it again. If you're new to adventuring, please take careful note.

- **Base and middle layers**: The best way to keep yourself warm, comfortable, and dry in the outdoors is to dress in layers. Start with base layers made from synthetic material that will wick moisture away from your body. Add mid-weight fleece layers as needed, depending on your activity.

 The worst thing you can do is wear cotton in high-exertion or cold-weather activities because if you sweat, it will stay stay wet and won't insulate at all. They say "cotton kills," and while you probably won't die if you wear a t-shirt in the outdoors, under the wrong circumstances, it will make for an extremely uncomfortable day. If things go really wrong, you might get hypothermic, which actually might lead to death. Please don't die because you wore too much cotton. There are much better ways to risk your life.

- **Outerwear**: Depending on the conditions, you should always have at least one or two extra jacket options, a windbreaker and a rain layer. Most modern windbreakers are so light that there's no reason you can't have one with you at all times. They even shed light rain, but if you think you might encounter a real downpour, bring along a breathable Gore-Tex™ or similar type layer to keep you dry.

- **Insulating layer**: If you think it might get chilly, consider bringing a light puffy vest or jacket made of down or synthetic insulation. Even if you don't think it will be cold, if you're heading into the mountains, bring one anyway, because mountain weather often changes quickly. Also remember you'll probably spend a lot of time standing around waiting for the good light, and that puffy will make your quality of life that much better when things cool off.

- **Hat**: Always have one. At least one.

- **Gloves**: This is tricky, because cameras can be hard to use when you're wearing gloves. The tradeoff is often frozen/numb or very slow fingers, so you can decide which is worse: warm hands or getting the shot. I like windblock fleece gloves that have at least some grippy friction material on the palms and fingers.

 If it's really cold, I prefer double-layer gloves over mittens. I also like to use chemical hand-warmer packs. You should always carry a few of these with you at all times in the wintertime and in the transition seasons. Keep a spare set right in your photo pack.

Bottom line: overdress a little bit, knowing that you'll probably be standing/hanging still for periods of time while you're in picture-taking mode. You can always shed a layer. If you're not sure what to wear, talk to your athletes or visit your local outdoor specialty store.

Technical Concerns

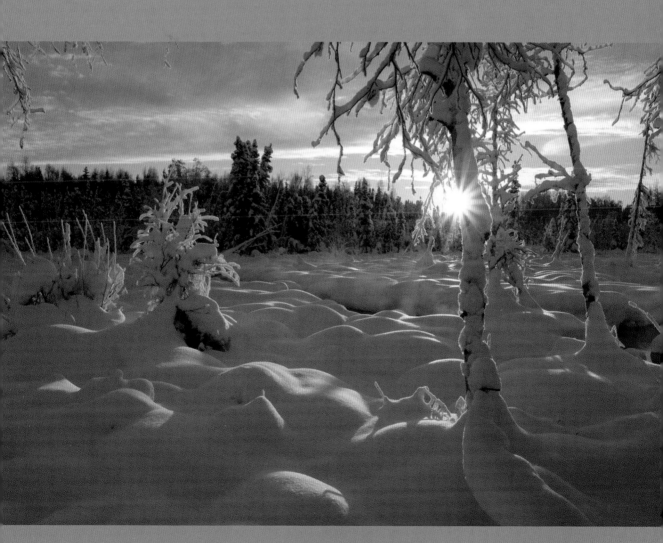

Technique

Mastering the techniques of photography involves a lifetime of learning, practicing, experimenting with your equipment and trying out new creative ideas and camera settings. In other words, occasionally stumbling, fumbling, and totally missing the shot. Don't worry, that's all part of being a photographer and it rings true no matter who you are.

Becoming proficient enough to get the difficult shots takes much less time, but it still requires a solid understanding of the fundamentals. Throw yourself into fast-breaking situations before you've fully grasped some of the basic concepts and you're asking for trouble. It's like throwing yourself into the deep end of the pool when you're barely learning to tread water. You'll probably come out alive but you'll be hesitant to go into that side of the pool again any time soon.

To be a great action and adventure photographer, you've got to know your stuff. You need to have complete familiarity with your equipment and a reflexive understanding of how to quickly compose and execute a technically perfect frame in the blink of any eye.

Sometimes your subjects will move so quickly, there will barely be time to breathe, let alone fiddle with your gear. That's when it all needs to be second nature. Your command of the camera needs to be so ingrained in your psyche that you forget that you actually know all this stuff. When the scene breaks in front of you, you don't think, you just act. You just shoot and hope you nail it.

I've broken up this chapter into three sections: Composition, Exposure and Focusing. I realize that "Composition" probably sounds like it belongs in the "Creativity" chapter, but I've decided to include it here, because just like knowing how to set f/stops and expose for tricky situations, knowing how to effectively compose a good image is a skill that should be second nature.

Although composition is indeed a creative aspect of photography, there is a definite technical aspect to the process of analyzing a scene, recognizing the relationships that exist between different subject elements, and quickly establishing how to frame it all within the boundaries of your viewfinder. In this way, photography works both sides of the brain.

Let's get started.

Composition

Creating successful photographs

In photography, composition is the placement and arrangement of visual elements in your frame. In other words, it's how you organize the picture. While the exact ways that you arrange your subject matter are dependent on your own individual ideas and creativity, there are a number of fundamental techniques that you can use as shortcuts when you're on location.

Even though I evaluate each and every scene differently, based on all of the factors that are present, I don't always start completely from scratch. Instead, I pull from my bag of tricks and use any number of tried and true, classic design techniques to get me going.

As I gauge the scene, I might have a basic idea of how I want to show the subject, and by drawing from one of these compositional techniques, I can begin to work out in my mind how it all might play out as a two-dimensional image.

This is where previsualization comes in. This is a very important step in the process, because it gets the creative and technical juices flowing in your brain. It also makes you think not just about the subject matter itself, but also about your own general perceptions of the scene.

If you can begin problem solving and coming up with compositional ideas before the action starts to unfold, then you'll usually make better photographs. Even just a few minutes to check out the scene and study the light can make a huge difference in the creative process, which is why most big jobs have location-scouting days built into the schedule.

Going in blind can force a certain level of inspiration too, but you'll need to have your bag of tricks dialed or else you'll flounder.

Subject positioning

How you position your important subject elements determines the overall balance of your composition and it can make the difference between an interesting picture and a boring one. Subject placement can easily make or break the shot, and so after gauging the light, one of the first things you'll want to do is figure out how you'll arrange the elements in your frame.

Even though photography is a subjective, creative, and often interpretive medium, wouldn't it be nice if there were some sort of "golden rule" to help us with this kind of stuff?

Fortunately, there is such a thing. You've probably heard of the Rule of Thirds, which states that you should place important subject matter at the intersections of imaginary lines that split your frame in three sections, both horizontally and vertically. I'm betting that you are familiar with this technique, but let's dive in and see why this simple rule works so well. In order to do that, we need to go back through history.

The Rule of Thirds is based on a complex mathematical formula called the **Golden Ratio** that was devised by the classically minded Greeks and used by artists like Leonardo da Vinci. Cathedrals were built using the

Golden Ratio, as were the Pyramids, the Parthenon, and Stradivarius violins. To my knowledge Leo Fender never stated as such, but I'll bet he used the Golden Ratio to design the Stratocaster.

The Golden Ratio is 1.618033988749895 . . . or, to be more concise, 1.618. (You'll be tested on this.) It's derived by dividing a line or parts of geometric shapes so that the ratio of a whole line (A) to the large segment (B) is the same as the ratio of the large segment (B) to the small segment (C). Combine these ratios within groups of ratios and lines, and you get two- and three-dimensional shapes that are all based on that one relationship.

In practical terms, the Golden Ratio is a mathematical formula that describes the seemingly random yet perfectly repeating geometric relationships that are found throughout nature. We see these relationships in flower petals, seed heads, tree branches, seashells, fruit, animal bodies, hurricanes, and spiral galaxies. It's essentially a formula for beauty. All throughout history, humans have been visually drawn to things that display these proportions, which explains why they're so often used in art and architecture.

The Rule of Thirds and the Golden Ratio work so well because they place subject matter in seemingly random areas around the frame and keep it away from areas that normally indicate order by the brain's pattern-recognition system. By using them in your photography, you inherently create more dynamic images.

Although the Greeks knew nothing about photography, even though they unknowingly invented the word (loosely translated: to draw with light), they knew everything about classical geometric and mathematic principles. The Rule gives you solid guidelines about how to place your subjects at seemingly "random" points in the frame. It's not the only method to use, but it's an effective one.

Don't be afraid to color outside the lines, though. Experiment and place things where YOU think they should go, not just where the RULES say they should go. After all, you didn't become an artist so that you could follow rules, right?

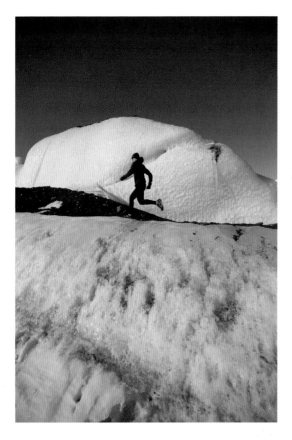 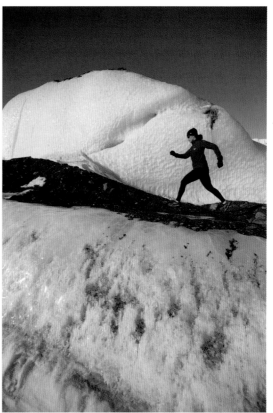

Even though this is an exciting scene, notice how much more bland the first image feels with the subject in the center. Bringing them out of the middle helps make the shot more dramatic.

Pulling the subject just a little bit off center gives the photograph much more power.

Framing

As we'll see in the next section, the way that we humans respond to photographs is largely based on the hard-wired nature of our visual systems. Using this knowledge, we can guide the viewer around our images and make it easier for them to digest what they're seeing. Any time you make it easier for your viewer, and especially any time you engage their brains, you've gone a long way towards creating a successful image.

Let's explore these concepts and see how they affect how corresponding imagery is perceived.

Subject in the center

One of the first things that we hear when learning compositional techniques in photography is, don't put the subject in the center. Sounds good, but why not? The reason for this is rooted in the evolution of human vision and it's largely related to our instinctual perceptions about the world.

People and animal brains are geared towards pattern recognition, which helps us navigate and survive in complex environments. In order to quickly identify and process visual information about the world around us, we're hard wired to be able to recognize a natural sense of order.

When things don't belong, they catch our attention, often because they're either something that we need to pick and eat or some danger that

we might need to run away from. We look carefully at everything, but as soon as we make sense of the visual material in front of us, our brains tend to relax as we turn our attention to the next thing.

However, good photography isn't about relaxing the brain, it's about creating visual tension that engages the brain and holds the attention of our viewers. We don't want them to move on too quickly, we want to keep their eyes wandering around in the frame as they explore the different compositional elements that we've included in our images. It's this visual tension that holds our viewers and keeps them looking for order that just isn't there.

When we survey a scene and recognize elements that indicate regular order in our immediate world, our mind relaxes and we let down our guard. "Nothing else to see here, let's move on to the next thing." So when you place your subject in the center of the frame, you've created an easy bullseye that draws the viewer right in as if the subject were a perfect target. The viewer locks onto that easily identifiable order inside the frame and says, "OK, found it. Done. Next photo please."

By contrast, with a subject that's outside of the center, the viewer looks at the photo and tries to discern that perfect arrangement. When they don't see it, their natural instinct is to remain alert and keep scanning the frame as they look for order that isn't there. They become caught in an internal struggle between the compelling subject matter and the subconscious need to mentally organize everything in the frame. This pull drives them to make a few visual laps around the image before finally moving on, which makes for a much more dynamic viewing experience.

In effect, a photograph that doesn't show perfect visual order is perceived as more "interesting" because it engages your brain and makes you want to look at it longer. Does this mean that you should never place the subject

Composing around the AF sensors

When using modern DSLRs, we can't help but have our subject placement be influenced by the pattern of autofocus zones in our viewfinders. In fact, AF modules have always been designed with composition in mind.

As a longtime Nikon user, I've always found that the sensors in their pro bodies are placed in such a way that they allow for intuitive subject placement that gives a seemingly "random" feel to the images. The outer sensors especially seem to be perfectly placed. They're far enough outside the center, but still far enough away from the edges to let the subject breathe.

Using the Nikon AF grid as a compositional aid.

By contrast, many mirrorless cameras offer an array of selectable AF sensors that cover the entire frame. This gives you wide flexibility in composing your images.

in the center? Of course not, but do so sparingly when the situation or feel of the scene calls for it.

Keep the edges free

I feel like the edges are sacred. I don't usually like to place subjects right at the borders of the image; leaving the edges free gives the photo room to breathe. Elements that are too close to the edge make the photo look sloppy, as if the photographer wasn't sure they were supposed to be included in the picture or not. To me, this is being lazy, and a photograph should always be deliberate. The exception is including some sort of line or pathway that helps lead the viewer's eye into the frame. (See below.)

Here's the same scene we just saw on page 72. You don't want to have anything pushing through the edges, that just looks sloppy. Even right up against the edge is a little too close. The subject needs room to breathe.

Multiple subject elements

I often like to include multiple subject elements in the frame, preferably two or more that relate to each other in some way. The different subjects play off of each other and help tell the story of the image. It can be a background, another prominent subject, or an abbreviation of some other element in the frame, but again, what, where, and how you use them should be deliberate within your composition.

Including a secondary subject will help lead your viewer's eye back and forth, which makes them spend more time looking at your photograph. Adding secondary elements in the frame adds considerable depth to the images, but don't add too much or you'll start to clutter the photo. Above all else, strive for simplicity and include only as much information as you need to tell the story.

The first shot is cool, but adding that second element adds interest and tells more of a story.

A prominent background works well as a secondary subject, especially when using long lenses.

Leading your viewer in, around, and out of the frame

By creating visual pathways with your image, you can lead your viewer into your frame, allow them to travel around and explore different parts of your photograph and then guide them out. These pathways make for a much more dynamic composition and it brings the viewer into the photo as an active participant. Anytime you engage your viewer in the photography process, you've gone a long way towards making an image that they will remember.

With wide-angle lenses, you can lead through the photo from your subject to your secondary element.

Notice how much more power the second photo has since it has a second subject element. That second skier at the bottom of the slope pulls your eye right over and creates additional interest for you to explore in the image, and both sets of ski tracks work as visual pathways to direct the viewer's eye around the frame.

Here I've created a simple pathway with a sharp foreground that leads into the main subject, which is farther away in the background.

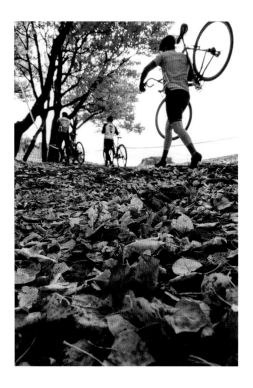

Hot and cold

Like our animal ancestors, human beings have developed a natural awareness of hot colors, like red, orange, and yellow. We're hard wired to take special note of these colors because they often represent a universal language of either warning (most venomous snakes, wasps, and poisonous frogs have brightly colored markings) or food (think ripe berries and fruit).

It doesn't take much to grab a viewer's attention when using hot colors, and by placing them in specific areas of the frame, you can draw your viewers into the image. When a viewer sees a hot color in a photograph, their eyes usually go right to that mark. After exploring the brightest area of the frame, they'll likely track their eyes along an implied line, shape, or direction that you've placed within the frame, or they might jump to another subject element entirely. Either way, the hot color always gets the first glance.

Here the eyes are immediately drawn to the climber in the bright orange jacket. How easily would you have picked him out if he were wearing a dark blue jacket? You should have a closet full of brightly colored gear and orange jackets.

Lots of empty space in this photo. Over 3/4 of the shot is nothing but a big blank field of blue.

Empty space

You don't have to fill the frame up with stuff. In fact, it's better if you don't. In most cases, a cleaner, less cluttered composition will make for a much more powerful image. One approach is to leave large swaths of empty space in your photos.

Although we call it empty space, or negative space, large fields of like-minded pixels can actually have a very positive impact on your imagery. For one thing, it gives the picture an air of simplicity. As with life, simplicity is always preferable because it doesn't distract the eye and clutter the image-processing centers in your brain. Remember, photography is as much about the brain as it is the eyes. Give your viewer room to think, and they'll be able to take in everything with a much clearer head.

Give your subject room to breathe and it will stand out more from the background. In addition, you can use these open areas of color or texture

Remember to leave room for copy.

to help create a stronger sense of balance in your photos. You'll find that this seemingly empty space can become a prominent subject element in itself, and it can enhance the storytelling aspect of your photo by creating suggestion, mood, environment, and ambience.

The obvious candidate for empty space is a large open patch of sky, whether it's deep blue or fiery orange pink. Clean, uncluttered parts of the landscape work as well, as do large shadowed areas.

Generally, the more powerful the subject, the more space you can include around it. By combining this technique with the ideas about framing your subject that we just explored, you can create some very dramatic and eye-catching imagery.

Color

In the span of human and cultural evolution, the human brain not only evolved with the need to recognize and differentiate color, it formed an emotional symbolism with regards to the concept of color. Throughout history, people have used color to illustrate and symbolize moods and traditions. As a species, we're not only drawn to color, we're driven by it in all walks of life.

Roughly 80 percent of all the visual information we gather comes through our eyes, and much of that is related to color. Some research shows that color can alter our moods and even boost our memory for stored mental images. Close your eyes for a minute and think about some of your favorite images. Do they contain prominent bold colors? How do they make you feel?

Fortunately for us as creatives, the world is full of color. By understanding how the human visual system perceives and responds to color, we can use it to create stronger compositions that impact our viewers. As we discussed earlier, human beings are especially sensitive to certain colors, and as photographers, we can use this to our advantage when making our images.

Blue projects feelings of calm, harmony, confidence, stability, and sometimes sadness. Blue is noble and dignified. Blue is the color of the sky and the ocean. Being the color of ice and glaciers, it also projects the idea of cold.

Our eyes do not tire of the color blue, which in the context of outdoor photography means that you can use huge swatches of blue in your imagery without overwhelming your viewers. However, blue alone doesn't always cut it if you're trying to create a dynamic image; you'll need to

Blue needs something else to make it more dynamic, like a leap!

include another element or color to contrast the blue and add life to the cool background.

Red, on the other hand, projects excitement. It's the color of blood, fire, roses, and the belly of a black widow spider. Red signifies danger, passion, beauty, and anger. Red incites energy, and heightened emotion excitement.

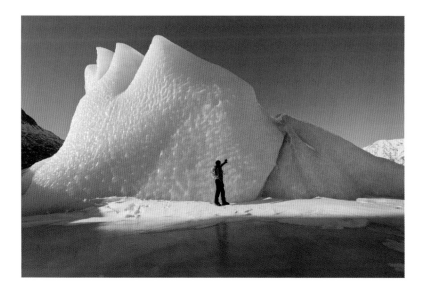

An image that's predominantly red can overwhelm the viewer. This is not a bad thing if done very sparingly; it can be used on occasion with great effect. Too much red will get old fast, though.

On the other hand, a tiny splash of red in a photograph will act like a visual target. No matter what other elements are contained in the image, your viewer's eye will be immediately drawn to the red thing first, no matter where it sits in the frame. Including small bits of red in your photos is a very effective compositional tool, and deciding where to place it will affect how viewers look at your image.

In the context of outdoor photography, we find red on autumn leaves, flowers, berries, ropes, packs, and of course jackets. I'm always trying to put red jackets on my models. I've got a number of them in my closet and make use of them whenever I can. Nothing in the world stands out better than someone with a bright red jacket as they're carving turns down a powder slope or running through a landscape. In addition to your camera gear, at least one red jacket or shirt should be an essential part of your adventure photography inventory. Put that on your subject and you'll increase the power of your shot almost every time.

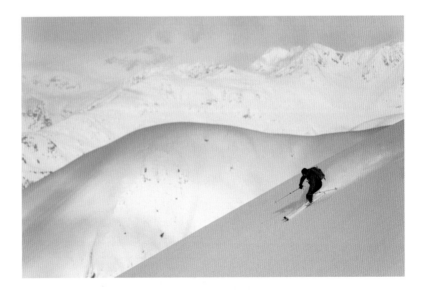

Yellow is the brightest color in the spectrum and it's the most stimulating and fatiguing color to look at, for good reason. Things that are yellow are *meant* to be looked at, like school buses, warning signs, and the stripes of a coral snake, which can kill you with one bite. For this reason you

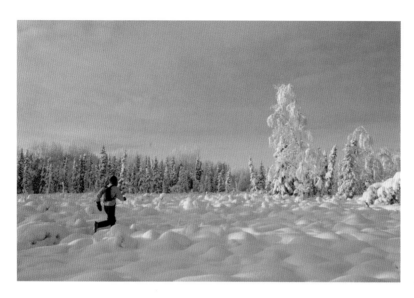

It only takes a little bit of yellow to draw the eye in.

should use yellow sparingly in your images. Like red, the eye will hone right in on anything in the frame that's yellow. There are no hard and fast rules, though. Experiment. Go behind my back and use lots of yellow in your photos. See what happens.

Red, yellow and blue are, of course, the three primary colors. They ALWAYS look good together and an image that features all three can end up being

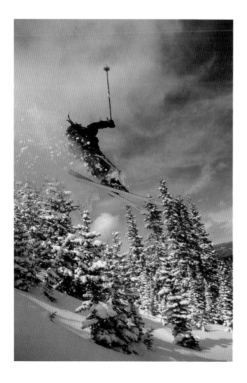

a very powerful shot. I didn't plan it this way, but this ski photo has been one of my more successful stock photos and it has sold many times over the years. Red, yellow, blue. Triple whammy. Money in the bank.

Between red and blue you have **orange**, which is often the color of sunsets and brightly colored jackets. Orange often works better than red on outerwear if you're shooting against green or in front of a dark background, like a wall of granite. Whereas red can get a little muddy in certain scenes, orange will always stand out.

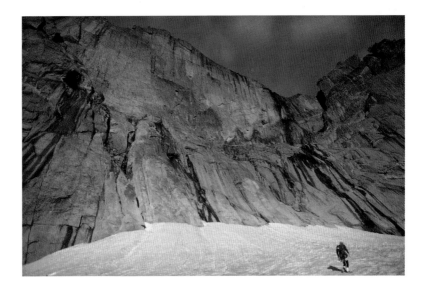

With orange, we're starting to get into the secondary colors, the second being **green**. Green is timeless. It's the color of nature, environment, and hope. Think grass and vegetation. Put green with blue and you'll create a very serene, subdued image that will project timelessness and tranquility. However, green and blue alone won't make for a very dynamic shot, and no matter what's in the frame, it will usually fall a little flat unless you include another color like red or orange.

The last two colors I'll discuss are the secondary colors of **pink** and **purple.** When I use purple in my imagery, it's usually in flowers or the sky, not jackets. It's a little dark for your main subject because it tends to pull in too much light. You might as well have your subject wear black. Good solid pink, on the other hand, usually looks great. It stands out extremely well against a variety of backgrounds because it's bright enough to catch the eye and dark enough to soak up the saturation.

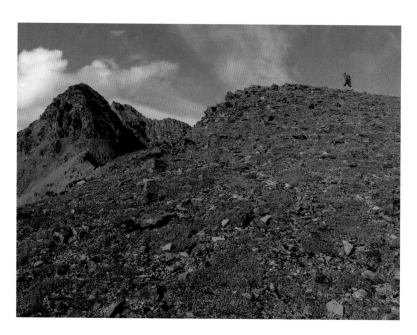

I like the composition and feel of this image, but it would be much more powerful with a splash of warmer color. Like an orange jacket.

Pink draws the eye in as much as red. Maybe even more, because it's a unique color in the spectrum.

Pink also looks great in the sky at sunset. You know what looks the best at sunset, though? The combination of pink, purple, and orange together. How can you go wrong? Stick an interesting silhouette shape underneath a sky like that and you'll always have a winner.

Warm vs. Cool—Bold vs. Subdued

Good photography is largely about contrast and juxtaposition. As we've seen, some colors are most effective when used in large areas, others when used as accents. In any case, we're attracted to warm colors, which

Warm against cool.

is why they create a stronger pull. Imagine a photo that's mostly blue with a red accent; now an all red photo with a blue accent. How would your brain perceive each of these two combinations?

We are also attracted to complimentary colors, that is colors that are opposites on the color wheel. Yellow and purple, blue and orange, green and red. These colors always look good together, especially if you pay attention to the warm vs. cool rule. My favorite is blue and orange; that combo always seems to have the most pop in outdoor imagery.

Dark vs. Light

Another way you can use color and light is in the way you choose your backgrounds. A dark background that is set behind a strongly lit subject is particularly effective, especially when the background is in shadow or a shadow itself. Do it the other way around (shadowed subject against a bright background, such as a dramatic sky) and you create a silhouette.

Light against dark. Always a winning combination.

Lines

Whether they're actual lines or implied by the subjects themselves, lines help dictate how your viewer will get in and out of the shot with their eyes. Actual lines can be rays of sun, mountain ridges, ski tracks, climbing ropes, trails in the landscape, trees, branches, etc.

Implied lines might have to do with the way a person is looking or the simple arrangement of your subject elements. Creativity is wide open here, and whatever method you can think of to help guide your viewer will help strengthen the shot.

Of course, not every image needs to have lines. Let the subject matter dictate.

Exposure

Exposure: The overall brightness level of the photograph.

For many people, exposure remains the most technical aspect of photography, because it's the one part that revolves around numerical values. This scares people because it almost sounds like math. In fact, it is math. Exposure has everything to do with numbers, ratios, and long division. Actually, it's just simple division, but that's not as much fun to say, is it?

Modern cameras have little tiny blackboards inside them where little electronic math professors are constantly crunching numbers, doing equations, and plugging in special algorithms, all to make sure that you get the perfect exposure. You don't have to actually DO the math, but you do need to understand the basics, because there will be times when

the camera won't get it right. That's when you'll have to pick up the chalk and figure out how to make the necessary adjustments.

This is why you need to have complete familiarity with your equipment and thorough knowledge of how the whole exposure process works. It can be hard enough to figure this stuff out when you're standing still on flat ground. Do you really want to be trying to remember the relationship between aperture and shutter speed or how ISO affects flash exposure when your subject is about to go bombing down the trail past you in great light? Didn't think so.

Proper exposure

The right exposure is achieved through a combination of your three main camera settings: ISO, shutter speed, and aperture. All of these things act in direct relation to each other, and while you can use any combination of these three settings to achieve the same exposure, each setting affects the picture differently. This is where you need to decide which tradeoffs to make with regards to your camera settings.

Approaching the scene—determine your limiting factor

When evaluating these exposure tradeoffs, there's always one factor that's more important than the other two. Based on how you want to portray the scene, there's one thing you NEED in order to create the right look.

I call that the *limiting factor*. When determining proper exposure, you should always have this limiting factor in the forefront of your mind. It's the first thing you should think about after you've decided how you want to frame your scene. Sometimes you'll consider this even before worrying about what goes where.

Here are some examples of how I think about the limiting factor. In other words, these are the kinds of creative concepts that I might need to deal with as I imagine the picture that I want to create.

1 This skier is moving down the slope quickly and I want to freeze the action with my long lens.

Limiting factor: fast shutter speed

2 I want to create a motion blur shot of this runner as she passes by me.

Limiting factor: slow shutter speed

3 I want a shallow background behind the subject to make him or her pop.

Limiting factor: long lens w/ large aperture

4 I want minimal noise and the highest resolution for this scene.

Limiting factor: low ISO

5 I want to show maximum depth of field so that everything is in focus.

Limiting factor: small aperture

6 I'm going for a gritty picture and want lots of grain in my photo.

Limiting factor: high ISO

Going from these six questions, you can see that each of them corresponds to one extreme or the other with regards to shutter speed, aperture, and ISO. Of course, not every picture situation will fall on the far ends of the spectrum, but looking at it this way gives you an idea of what you're dealing with.

While you can combine some of these concepts in your shot, out of these six possible creative situations, there might be some that you cannot combine. Depending on certain factors, such as overall light level, lens speed, how fast your subject is moving, and how far away they are, you may not be able to achieve a fast shutter speed with maximum depth of field and the lowest noise.

There will always be situations where at least two of these concepts will clash, especially when you're shooting in challenging, dim, or contrasting light. You may not have the limitations during the middle of the day, but during those times you usually don't have the most important limiting factor of all, which is good light.

When you're trying to catch last light on your subject or shoot dynamic action at sunrise, you're going to run into problems, and the way around it is to ask yourself these two questions:

1 What limiting factor do I need to have in order for this shot to succeed?

2 What other factor(s) am I willing to sacrifice for this shot?

Once you come up with your answers, you'll use them to adjust your exposure so that it corresponds to the limiting factor that is crucial to getting the shot. As you become more skilled and familiar with your camera, you'll learn to incorporate this little exposure checklist into your mental workflow every time you approach a scene:

Exposure checklist:

1 Gauge the scene

2. Determine your limiting factor

3 Determine proper exposure

4 Adjust your controls to compensate for your limiting factor.

Remember, the limiting factor and your corresponding exposure will vary depending on conditions, light, and your own ideas about the scene.

It won't necessarily give you the *right* exposure, and in fact another photographer might have a totally different approach and thus a different set of camera settings and exposure.

Exposure modes

Most cameras today have four exposure modes: P, S, A, and M, which stand for Program, Shutter Priority, Aperture Priority, and Manual. With Canon cameras, it's Tv for Shutter Priority and Av for Aperture Priority.

Program is simple. Put the camera on P and you're shooting in auto mode. It will take into account what lens you're using and try to keep the shutter speed high enough to avoid any camera shake. Keep in mind that Program is different than "Full Auto Mode" that's found on many consumer cameras; with P you can usually override the camera's basic exposure settings with the command dial.

S and A are both "semi auto mode." Set one and the camera will automatically adjust the other to achieve proper exposure. In effect, they do the same thing, just with a different control. Think about it. With S, you set the shutter speed with your dedicated command dial and watch the aperture change automatically. With A, you're doing the opposite—you set the aperture with the appropriate command dial and watch the shutter speed change.

Essentially, you control one with the other, so rather than think about whether you should be shooting in Shutter or Aperture Priority to get the same results, decide on a mode to use and turn the dial until you get the setting that corresponds with your desired limiting factor. (With many cameras, you can set the command dial to control either S or A.) Keep an eye on the display and stop when you see the parameter you want, whether it's shutter speed or aperture. Neither way is right or better, and both methods will get you the same place.

I prefer Aperture Priority mode, partly because it's what I've always used. More than anything, it's a carryover from my early days when aperture was adjusted by rotating the f/stop ring on the lens with your left hand. This is one reason I like the Fuji X camera system; most of the lenses have functioning aperture rings.

Regardless of which method you use, consider S and A interchangeable methods to get the exact same results.

M is old school. All manual. You set the shutter speed, you set the aperture. A little graph inside your viewfinder tells you if your current settings will give you proper exposure or if they'll over or underexpose the scene. I still use manual mode quite a bit, especially when I'm shooting in tricky light or with flash. More on that later.

ISO

ISO manages the sensitivity of your camera sensor and determines how much light is needed for proper exposure. ISO used to be synonymous with film speed, and just as with film, the higher ISO you use, the more distortion will be present in the picture; where film had grain, digital has noise.

The other thing that affects noise in digital photography is the construction of the sensor itself. A camera sensor is made up of light-gathering pixels that are spread across the entire field. More pixels mean higher resolution photos. However, pixel size affects how much light each one is able to gather during the brief period when the shutter is open. Larger pixels gather more light than smaller ones. This is why a camera with a large sensor, such as a full-frame DSLR, performs better in low light than say a point-and-shoot that has the same number of pixels.

Most digital cameras today have a base of ISO 100 or 200. This setting is optimized to produce the sharpest image with the lowest amount of noise. Some cameras allow you to shoot at a setting lower than the base ISO, but this doesn't necessarily get you better quality, it gets you a slightly underexposed capture, which is then "over developed" in the same amount by the camera's image processor. You end up with slightly brighter darks, but at the expense of some lost highlight detail. Essentially, it's the same as if you "push processed" a roll of film.

When you crank your ISO setting up to 400, you're actually reducing the amount of light that's needed to take the picture by one-half. Your tradeoff is increased noise. Crank it up to 800 and you cut that amount by half again, but you're adding even more noise. At ISO 1600, you've reduced that by half yet again, which means that you now need only one-eighth the amount of light that was needed for the original picture at ISO 200, but you have considerably more noise.

Beyond ISO 1600, you'll really start to see the noise build up and it gets worse as you increase the setting. It's not a standard amount, though. Each camera has its own noise-reduction system built into the hardware and software, so with two cameras, you might have very different amounts of noise at high ISO settings.

Ultimately, it's your tradeoff, though. There is no "right" setting, but there is a setting that gives you the sharpness and depth of field that you're going for and that produces an acceptable amount of noise for your tastes.

Become good friends with your ISO control, because changing settings is a very quick way to rescue a scene that would otherwise be rendered too blurry or too dark by your current camera settings.

Some cameras have Auto ISO control, which allows you to set a predetermined ISO range and a minimum shutter speed to ensure

ISO 100

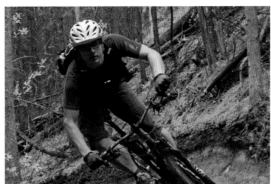

ISO 1600

1/5000 sec shutter speed

1/30 sec

sharpness. When the light changes, the camera will automatically adjust the ISO so that you do not drop below your set shutter speed. Auto ISO can be a really handy feature to have and I've used it quite often when shooting in variable light.

Shutter speed

Shutter speed controls the duration of your exposure, or how long the sensor will be exposed to the light. It's measured in fractions of a second or, in some cases, full seconds. A faster or shorter shutter speed, of say, 1/2000 sec, lets less light in to the camera, while a longer shutter speed of 1/8 sec, lets more light in. As with ISO and aperture, shutter speed works primarily in halves and doubles: 1/1000 lets one-half as much light in as 1/500, which lets in half as much light as 1/250, and so forth.

Shutter speed also controls the overall sharpness of your picture. It's how you freeze water droplets and create a blur effect in your imagery. It's what allows you to stop time and prolong a moment in a way that's beyond the scope of real-time human visual perception.

For most action and adventure photography, shutter speed is often times your most important concern. You're either trying to stop the action or let it blur through the frame, so when you size up a potential subject, you'll probably want to set your shutter speed first and let the aperture fall where it may. If the light is too dim and you're not able to get as fast a shutter speed as you'd like, that's when you'll need to crank up the ISO.

Aperture

Where shutter speed controls the duration of light that hits the sensor, aperture controls the physical amount of light that makes its way through the lens. Each lens has a little circular doorway inside it that gets opened or closed partway when you change the aperture setting (it never closes all the way). When you set the f/stop of your lens, you're controlling the size of this opening and thus changing how wide or narrow the beam of light is that will hit the sensor when the shutter opens.

In addition, aperture controls the depth of field of your images, or the amount of information in focus from front to back in your scene. For landscapes, you generally want a greater depth of field, where nearly everything is in focus, whereas with portraits and closeups, you generally want a much more shallow depth of field, i.e. keeping the focus on your subject and throwing the background out of focus.

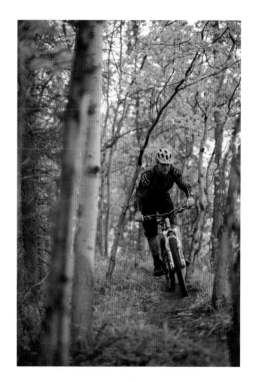

For some compositions, aperture will be a more important concern than shutter speed. During those situations, you'll want to set your f/stop first and then watch what your shutter speed does.

If you don't have a tripod, or if you're not using some form of image stabilization, make sure you adhere to the rule of thumb that the lowest shutter speed you should hand hold is the same as the lens focal length. For example, with a 100mm lens, you don't want to go much lower than 1/100 sec unless you have a tripod or can brace the camera in some way. Otherwise, you'll get camera shake, and there's nothing like zooming into a great-looking photo in Lightroom only to see that the image is a little fuzzy because you didn't brace the camera well enough.

A large aperture of f/2.8 draws your eye right towards the subject.

A wide-angle lens and a small aperture of f/13 gives sharpness from front to back.

Move closer and you reduce depth of field, even with a wide lens and a small aperture.

The science behind how aperture works

Due to the fact that the lens has a convex surface (just like your eye), using a wide or "open" aperture that has a smaller number, e.g. f/2.8, will cause the light to bend in such a way that only a narrow plane of subject matter is in focus on the sensor. When using a small aperture (a larger number, e.g. f/16), the relative amount of curvature is drastically reduced on the lens, which causes the light to bend very little.

The consequence is that a much wider plane of subject matter from front to back appears in focus on the sensor. The same happens with your eye when you stop down your eyelids or, in other words, when you squint. Squinting reduces the effective curvature of the eye, which causes more things to be in focus when the light from the world hits your retina.

Distance plays a large factor as well. No matter what aperture or lens you're using, depth of field increases as you get further away from the camera and decreases as you get closer. This means you can potentially have a very shallow DOF with wide-angle lenses and a wide DOF with telephotos simply by varying your distance to the subject.

Metering

Your camera is just a machine that knows nothing about the nuances of photography and what constitutes a "proper" exposure. What it does know is how to reproduce your subject with an average level of brightness.

When you point your camera, the light meter in your camera evaluates the reflected light that's bouncing off the scene. It then determines a specific value of brightness that will create an average amount of reflectance in the overall scene. For most things, this works fine, because the world is generally full of some light stuff, some dark stuff, and some middle-toned stuff. Add that all up, divide by three and you get average.

However, not every scene is average. Many scenes have unequal amounts of bright and dark stuff (think open powder slopes and black-sand beaches.) To compensate for this, modern camera metering systems are designed with computer processors that break up the viewfinder scene into a number of separate zones. Each of these zones is evaluated individually and compared with the others. Finally, the entire scene is compared to an enormous database of possible exposure scenarios and run through complex algorithms, which assign a recipe for proper exposure, based on the current lighting conditions.

This has greatly increased the exposure accuracy of modern cameras when shooting in tricky light. In most situations, you'll find that they do a great job, but they still aren't perfect. Scenes that have exceedingly bright or exceedingly dark subject matter will still throw off even the best camera meters. Also, keep in mind that depending on your subject matter, the amount of reflected light may not accurately represent the overall ambient light that's falling on your scene.

Limitations of exposure: The camera vs. your eye

Upon quick glance, the human eye is able to discern about five to seven stops of contrast from lightest to darkest. By comparison, the average DSLR sensor can discern a contrast ratio of about ten stops of brightness. However, give our pupils a few seconds to adjust to changing light and we can suddenly discern about 10 to 14 stops. Add in the special chemical adaptations that our eyes make in dim light and our total contrast range jumps to about 20 to 24 stops.

The strength in human vision lies in our vastly superior image processor, known in laymen's terms as our brain. This is where the real work is done. Whereas our eyes actually see and respond to changing light more like a video camera, it's our brain that reconstructs the constant motion vision into a series of still images for long-term storage. It's been shown that although we see in motion, we actually remember events and actions as still images and short video clips. In other words we're basically walking versions of Instagram.

What this means is that under most circumstances, you're never going to be able to capture a scene with your camera that exactly matches the way you saw it with your own eyes. The sooner you come to terms with that, the better photographer you'll be, because you won't go through life surprised and often disappointed at how different your pictures look than what you remember seeing. Instead, you'll know how to translate what you saw with your eyes into an effective image.

How the camera works

Photographers who used to shoot color slide film remember how little latitude it had compared to digital. Most professional slide film could only render about five stops of brightness before washing out, so you really had to nail it or else you threw the slide away. Overexpose and you had a worthless piece of celluloid, which is why many film photographers, especially outdoor shooters, made it a common practice to slightly underexpose their images. With film it was way better to have your photo be a little too dark than too light.

With digital, it's the opposite. Today's cameras have a much wider dynamic range compared to film. When you click the shutter, the camera records the amount of light that hits each pixel on the digital sensor. The sensor itself does not discern color, but a special matrix of red, green, and blue filters that cover the sensor allows each pixel to record this brightness as a specific tonal value for each of those three colors or channels.

Most cameras have 12-bit sensors, which means that each pixel can discern and record any one of 4096 different levels of brightness for each channel. Thus, every digital image is recorded as nothing more than a unique combination of 0s and 1s that represent the RGB color values for each pixel. For a 12-bit image, the tonal value of each channel falls somewhere between 0 and 4095. (Shooting in 14-bit RAW gives 16,384 levels of brightness!)

Since there are three channels—red, green, and blue—this represents 4096 x 4096 x 4096 or 68.7 billion possible color combinations for each pixel, which translates into an extremely wide and smooth range of color gradations. Multiply that by the number of pixels that your camera has (10 million for a 10-megapixel camera) and you can see why RAW camera files are so big!

However, due to the way the sensor captures light, digital cameras are much more sensitive in the brighter part of the light spectrum. So much so, in fact, that it's recommended that with digital it's way better to overexpose your image than under expose. Here's why.

Those 10 f/stops of contrast that a DSLR is able to record are not divided equally among the stops on the histogram, they're divided logarithmically among the stops. With a CMOS sensor, half of all of the exposure data of a 12-bit image (2048 possible levels of tonal range) is recorded in the brightest f/stop, which contains the highlights. The next brightest stop has 1024 levels, while the third stop has 512 levels, and so forth.

In other words, half of the histogram is made up of only the very brightest information in the image, while half of the remaining half is comprised of the next stop of brightness, etc. When you reach the very left side of the histogram, which contains the very darkest perceptible shadow detail in the image, that tenth stop only comprises four possible levels of brightness.

Because there is much more tonal information contained in the brighter areas of the image, you'll have smoother tonal gradations and considerably lower noise when you make exposure and color corrections in post-processing. Conversely, if your image is comprised largely of dark tones that reside heavily on the left side of the histogram, you won't have nearly the same level of tonal range when you perform your adjustments.

In this straight JPEG (*above*), both the highlights and darks are lost over the edges of the histogram. However, in a RAW image of the same scene (*below*), you can see the highlight and shadow detail are both preserved.

Even small corrections within the shadows can add noise and degrade the image.

Armed with this information, you can why it's much better to shoot an image that's a little too bright than too dark. You have much more latitude to rescue detail in the highlights than the shadows.

RAW vs. JPEG

RAW

When you shoot in RAW, the camera writes the unprocessed data from the sensor onto your memory card, along with a thumbnail JPEG preview and all EXIF and metadata for the image. This includes camera and lens info, date and time, all your camera settings at the time of capture, and any other info you might have assigned to the file, such as your name and copyright.

When you open the RAW file in an image-editing program like Lightroom, Photoshop, or Capture One, you can adjust any of the settings your software provides, like exposure, white balance, sharpening, noise reduction, highlight recovery, contrast, and saturation. You can also add new metadata, such as keywords, captions, and star/color ratings.

The important thing to note is that these settings are only tagged with the RAW image data. Any edits you perform are non-destructive, which means you are not actually altering the RAW file itself, you're only modifying the metadata.

Nothing you do to a RAW file affects the original sensor data in any way, and any changes you make to the image are only written into a small .xmp sidecar file that accompanies the RAW file. As long as you don't trash the .xmp file, your adjustments are always saved the next time you open the file, even if you open it up in a different program.

In addition, when you open a RAW file in a 16-bit RAW conversion program, the color and brightness data are spread out into a 16-bit workspace. You now have 65,536 levels of brightness to work with in each of the RGB channels, and 281 trillion possible color combinations (65,535 x 65,536 x 65,536). This translates into an enormous amount of latitude and headroom with which to fine-tune exposure and color correct your imagery.

When you finally convert the RAW file to a JPEG or TIFF, your edits get written permanently onto the newly saved image. However, your original RAW file is still preserved; it never gets written over, which means you can go always go back and make changes to your original image. In that way, RAW is essentially a digital negative, and unless you throw away the file, you can always go back to square one and start over if you get new software, new creative ideas, or new image-processing skills.

JPEG

When you take a picture in JPEG mode, the initial step is the same. The scene is still captured in full resolution by the sensor, just as if you were shooting in RAW mode. However, all of your camera settings, like white balance, sharpness, and saturation, are merged with the sensor data and written permanently onto the image file.

Then it's run through the camera's image processor, where it is converted down from 12 bit to 8 bit, which means that those 4,096 levels of brightness and color that were recorded by the image sensor are squeezed into only 256 brightness/color levels. Finally, the image is crunched according to the compression and size setting you have set on the camera and saved as the final JPEG. Note: this also happens when you convert a RAW file to a JPEG on your computer.

Once the image is converted to JPEG by the camera, none of the original RAW data or camera settings can ever be accessed, changed, or altered in any way. Essentially, you've let the camera decide how you want your final image to look. Also, when you open the image on your computer, you have remarkably less latitude with which to make level and tonal adjustments than you would with a RAW file in a 16-bit workspace.

That's not to say that you can't achieve high-quality imagery and very good results when shooting in JPEG mode; in fact, many digital cameras produce very high-quality JPEGs. An 8-bit image still yields 16.7 million possible color combinations, which is the standard bit depth for professional color printing.

While some very high-end printers and monitors are capable of rendering 16-bit images, the majority of the digital and ink world revolves around 8-bit files. The limitation is that once you've gone from 16-bit down to 8-bit in the processing stage, you can't go back. A lot of the original color information is lost and you can no longer make fine corrections or rescue any more detail from lost shadows or blown-out highlights.

Here, in this straight JPEG, I've lost all of my highlight detail. There was simply too much contrast for the sensor to handle. If I shot this frame in RAW, I would have been able to preserve a lot more of the highlights and bring this photo under control.

Why shoot RAW?

Shooting in RAW will allow you to extract the maximum quality from your digital photographs. Most images benefit from some adjustments and you'll get better results by tweaking them yourself in the software, instead of letting the camera make those decisions for you.

This is especially crucial when dealing with high-contrast subject matter. If you're shooting scenes with an exceptionally wide range of tones, you should shoot RAW. Shooting in JPEG in these situations, you risk losing information at one or both ends of the histogram, and once you lose it you can never get it back.

Shooting with the RAW frame of mind

Keep in mind, editing and converting all those images takes time. Are there steps you can take to minimize this time and maximize your efficiency? Absolutely. Do you have to take the time to convert each and every frame that you shoot? Absolutely not. There's no need to.

The best way I can think of to explain the "RAW frame of mind" is to equate it to old-school black-and-white photography. It's actually a timeless method of shooting. The process goes something like this: you put great effort and concentration into photographing the image, you print a contact sheet when you're done, you pick the shot you like the best, and then you go print the image in the darkroom.

With digital imaging, the computer is your darkroom, your contact sheet, and your negative storage all rolled into one. Modern software actually gives you more editing tools than Ansel Adams could ever have dreamed of, but the basic process remains the same: shoot, choose your selects, and transform those frames into stunning photographs.

I always shoot RAW with my DSLRs and much of the time with my mirrorless cameras, especially if I'm shooting for a client or if there is a high degree of contrast in the scene.

Why shoot JPEG?

Shooting JPEG saves you time, as well as hard-drive space. The image processors found in modern cameras are very good, and they're capable of producing wonderful looking images. In addition, many cameras today have special shooting modes, creative filters, and film simulations. These can be a lot of fun to use, but they sometimes only work in JPEG mode.

If you're not shooting scenes that push either side of the histogram, or if you're just shooting for fun, chances are your camera will do a fine job. In camera JPEGs are certainly good enough for online sharing, and depending on your lighting conditions, they can be adequate for professional publication as well.

Metering patterns

In addition to highly advanced image processors, modern cameras have multiple metering patterns which give you increased flexibility and accuracy when composing in complex lighting situations. Here are the three types that most cameras have and how to use them effectively.

Even though the background is relatively bright, a center-weighted meter would handle this composition just fine. Place him outside of the center, though, and the camera will get confused.

- **Center weighted**: Center-weighted systems are programmed so that most brightness information is gathered from the middle part of the scene. They're designed like this to reflect the most commonly photographed subject in the world: portraits with people's faces right in the middle of the frame.

 Center-weighted meters don't work nearly as well with complicated scenes or if you compose so that your subjects are positioned in other

areas of the frame. However, this type of pattern is quite predictable in how it sees the world, so it's a good idea to become familiar with it so that you know how it works and when it doesn't.

- **Matrix/multi-pattern/evaluative**: Multi-pattern meters are the most advanced metering systems available. They break the scene up into multiple zones (anywhere from 5 to 1005) and evaluate each zone for brightness and color. Some camera systems even factor in distance to subject and the location of the selected focus point within the frame.

From there, they run the scene through a series of very sophisticated algorithms that are preprogrammed into the camera's computer to determine the best possible exposure.

Multi-pattern meters are much more accurate, and in most cases deliver surprisingly good results. Whereas my all manual Nikon FM2, which only had a center-weighted meter, would always make the snow too dark, my newer Nikons render snowy scenes with a much more true-to-life appearance.

However, in exceptionally bright and dark conditions, even the best multi-pattern meters can still get fooled.

Despite the predominantly bright background, I used aperture priority mode with matrix metering and got a perfect exposure. This is straight with no adjustments.

- **Spot**: Spot meters make all of their relevant exposure decisions based on a very small portion of the scene. Usually, the area makes up about 1–5 percent of the viewfinder. Some cameras allow you to set the spot meter so that it reads from the area where your selected focus zone is located.

Spot meters are useful if you're metering off of a relatively small subject within a predominantly dark or light scene. One example

Large shadowed areas will throw off the meter even more than any other type of scene. By using a spot meter, I'm able to control the highlights on Jim's face while retaining the nice, rich, black background.

The +/– EV dial

I make heavy use of the exposure compensation dial. Many times, rather then switch to a different metering pattern, I'll simply grab the EV dial and spin it to correct for the overall brightness of the scene. My Fuji X cameras have an actual +/– EV dial right on the top deck of the body; with my Nikons, changing the EV setting is as easy as pressing a button with one hand and turning a dial with the other. Both methods let me make corrections almost immediately.

I'll often use +/– EV in conjunction with the histogram. Many cameras let you see the histogram in real time right inside the viewfinder or on the rear LCD screen. If I'm unsure about the light, I can check the histogram and make the necessary EV adjustments on the fly. Or just burn a test frame, check the histogram on my image preview, and adjust as needed.

Although I understand how each pattern works, I just find this method

to be fast and intuitive. Rather than let the camera have the final say with regards to exposure, the EV dial puts me in the driver's seat and gives me the quickest, most accurate real-time control when using autoexposure modes.

might be a skier or hiker set against an entire scene filled with snow. Another might be a person's face that's lit by the sunlight inside a scene that's all in shadow.

In both of these cases, the amount of reflected light doesn't accurately indicate the amount of ambient light that's illuminating your subject. The spot meter disregards the overall scene and allows you to precisely measure the brightness of your subject matter.

Dealing with tricky light

Limitations

For as much information as a 16-bit RAW file can contain, digital images still can't match the tonal range that your eyes and brain can recognize out in the world. No camera can render accurate detail in both the extreme highlights and the darkest shadows at the same time. Of course, you can do this with HDR photography and by blending multiple exposures, but it doesn't look quite real and our brains know that.

In the previous section, I told you that it's technically better to overexpose your images. However, that doesn't take into account what looks aesthetically better to us as viewers. We actually prefer it the other way around. We're drawn much more to darker, more saturated colors over less saturated highlights. There's almost nothing less appealing in a photograph than a white, washed-out sky.

So how do we get around these limitations and contradictions and shoot imagery that is both appealing to our viewers and that preserves enough visual information without blowing out with too much white?

Decisions: Expose for the most important bright subject matter

This is where your own creative decision-making process enters the equation. Knowing that the camera won't be able to record everything you see, you need to evaluate your scene and prioritize your subject matter in terms of overall importance and go by this guideline:

Your BRIGHTEST SUBJECT MATTER and your MOST IMPORTANT SUBJECT MATTER must be IN THE SAME LIGHT, or else you'll have too much contrast.

Let's say you're shooting a scene that contains bright skies and dark shadows. Your subject is moving in and out of the shadows or perhaps there's some important subject matter in the darker areas of the frame that, ideally, you'd like to preserve. If you expose for the highlights, your shadows will drop to black and any subject matter in those areas will be completely indiscernible. If you expose for the shadows, your nice, rich blue sky will end up as a washed-out field of white, which as I pointed out above won't look very good.

In order to shoot the scene in such a way that lets you create the most dynamic, exciting image, you need to establish a hierarchy of subject matter in terms of visual/creative importance and do one of these four things:

1 **Wait for different light**: Wait until the shadows pass, or come back and shoot the scene during another time of day, perhaps at sunset or when the sun has shifted enough to illuminate your shadowed areas.

After shooting this scene, I came back a little later the following evening and created a much more dynamic image.

If you're shooting in the shade, clouds can actually work to your advantage. You can see how the reduced contrast of a cloud patch over the sun (right) brings the open areas on the ground much more in control.

2 **Wait for your subject to come out of the shadows**: If your subject is moving, maybe you just need to wait a few seconds or minutes for them to pass through the shadows and come back into the sunlight. When they do, you'll be able to capture the subject in the same light as the sky and preserve details in both.

Here, my subject is lost in the dark tones of cloud cover. By waiting until she's out of the shadows, I can capture a much brighter, more defined image.

3 **Recompose and exclude the highlights**: Instead of trying to show both, recompose your scene and exclude as much of the highlight detail as possible. This way you won't have to worry about it washing out. Simply remove it from the equation. This could involve changing vantage points or zooming in with your lens.

By simply changing vantage points, I can create a composition that has the same feel without including the large washed-out area.

4 **Let your shadows drop to black**: Instead of trying to look into the shadows, let them drop to black. If there's no way you can get your subject out of the shadows, then take a different approach and shoot the scene as a silhouette. This will preserve your bright sky (this works very well with a dramatic sunset), and it will create a suggestion of your subject.

With many scenes, you don't actually need to show every single detail in the subject to tell the story. Sometimes the less you show, the more powerful your image will be. Silhouettes can make for very powerful compositions.

Focusing

Perhaps the greatest and most useful advancement in camera technology, at least for those of us who shoot things that move, was the invention and evolution of autofocus. Not that we couldn't do our jobs without it, but certain types of photography would be way more challenging if we had to manually focus everything.

Maybe Chuck Norris can manually focus on a subject who's bombing downhill straight towards the camera at 30 miles per hour in dim light, while hanging from a branch by one hand and shooting in continuous mode. Give us even one of these scenarios and we'd be lucky to nail even one frame that's sharp, let alone the whole series.

For photographers like us who shoot action and adventure, autofocus is an essential tool that we depend on nearly every single time we pick up the camera. As good as it is, though, autofocus doesn't always work perfectly. Even with the best gear, we sometimes miss the shot. Let's see how autofocus works and learn how to make the most of it in difficult situations.

Shot with a Nikon DSLR and 80–200mm f/2.8 lens.

How autofocus works

Modern autofocus systems work by evaluating changes in contrast within the scene and controlling the distance of the lens in relation to the point of optimum focus. When the highest level of contrast has been achieved on the sensor, the camera's autofocus processor tells the lens to stop moving and then it sends out the alarm, usually a green light and a beep. You press the shutter and get a razor-sharp image. Most of the time, anyway.

DSLRs primarily use an autofocus process called **Phase Detection**, which involves a dedicated AF sensor module that's placed in the bottom of the camera below the main mirror assembly. When you activate the AF, a percentage of the light that enters the camera through the lens passes through the mirror and is reflected down onto the AF sensor by way of a secondary mirror.

The AF sensor splits the light into two and sends each beam through a tiny pair of lenses onto a pair of corresponding CCDs, where it measures how much out of phase the two images are from each other. It then estimates how far the lens needs to move in order to achieve proper focus, and instructs the lens to move accordingly. The AF sensor will continue to make additional measurements and refine the position of the lens until the two images line up. When the two images are no longer out of phase, the image is in focus.

The advantage of Phase Detection AF is that it's fast. The system generally knows how far and in which direction the lens needs to move. This minimizes AF errors and erroneous hunting of the focusing elements.

Point-and-shoots and most compact cameras use **Contrast Detection**, which relies on individual pixels on the image sensor to determine contrast. Essentially, the AF processor tells the lens to keep changing focus until the contrast level from one pixel to the next is at the highest possible level.

Contrast Detection AF is actually a much more accurate process than Phase Detection since it doesn't rely on separate hardware, it reads right from the sensor. However, the main problem with Contrast Detection is that the camera doesn't always know *which way* it needs to move the lens. This often causes the lens to "hunt" or move back and forth before finding the focus point, so while it's generally more precise, it's a much slower system.

Also, since distance is not measured or calculated by the AF processor, Contrast Detection is not very good at tracking moving subjects. If the subject is lost, it's pretty much lost for good, because the camera has no way of knowing which way to turn in order to reacquire the subject. When this happens, the camera sends the lens off on a wild goose chase for your subject, usually in the wrong direction.

Contrast Detection only works with Live View mode, which is the view system that all mirrorless and compact cameras use. This is also how a DSLR focuses when it's in Live View mode as well. However, most photographers rarely use DSLRs in Live View; usually we have the things pressed right up against our faces. Live View can be useful when the camera is on a tripod, but for most types of shooting, it's just not very practical to use DSLRs in this way.

The newest generation of mirrorless cameras use a system called **Hybrid Autofocus**. With this method, all initial focusing is done through a series of Phase Detect points that are placed right on the sensor array. Once the Phase Detect points get close, the Contrast Detection system takes over to fine-tune for critical focus. This combination has greatly improved the performance of modern cameras, but the systems aren't perfect, they're still a bit prone to hunting, especially in lower light.

DSLR AF performance factors

When it comes to how well cameras track moving subjects, AF performance is largely tied to three things: 1) price of the camera; 2) price of the lens; and 3) how much light you have.

Essentially, the more expensive the camera, the better the AF module will be. Higher end modules have more AF points, which means that the camera will do a better job of tracking the image through the frame, and it will offer you the most creativity when composing your shot.

Same thing when it comes to lenses. Pro-quality lenses generally have better autofocus motors and brighter maximum apertures. In addition to being quicker, they're able to dump more light down onto the AF module. The more light the sensor has to work with, the faster and more precise the focusing will be.

No AF system works great in the dark. Dim light will slow things up tremendously, and it might even make it so your camera can't focus at all; it will hunt endlessly and you'll just wear down the battery. Some cameras have an autofocus-assist beam, which helps light up the subject and create more contrast.

Mirrorless camera AF performance factors

Up until now, mirrorless cameras were simply unable to keep up with DSLRs when it came to autofocus speed and tracking moving subjects. Even a year ago, you were lucky if you could track a person walking at 3 fps.

Today, we're seeing the first generation of cameras that combine Hybrid Autofocus with predictive motion tracking systems that work at higher frame rates. The Fuji X-T1 and the Sony a6000 both feature highly capable AF systems that track moving subjects at impressive frame rates (8 and 11 fps, respectively.)

Adventure shooters and athlete photographers can rejoice because these advances in camera technology play into our favor. Lightweight camera gear that delivers pro-quality imagery and that can operate to the standards that pro shooters demand is something we've wanted for years.

While mirrorless cameras are still not quite as good as DSLRs when it comes to AF performance, they're getting close. By the time this book is actually published and in your hands, we may already see the next generation of compacts that blurs the lines even more. I, for one, am very excited.

Shot with the Fuji X-T1 mirrorless camera. We're finally seeing comparable AF technology with smaller cameras.

Autofocus modes

Autofocus is without a doubt one of the most highly technical aspects of photography, mostly because it's so dependent on the gear and the technology inside your camera. It's capable of giving you amazing results, but it can also let you down in a big way. It's usually equipment limitations that give us the most trouble. If you can fully understand how autofocus systems work, you can avoid many common problems and experience a higher success rate. As with any other element of shooting, you rarely just turn the camera on and start blasting away on full auto. Depending on what kinds of subjects you're photographing, you evaluate your scene and make careful decisions about how to approach your subject in the best way. The same goes with autofocus.

AF mode: AF-S or AF-C?

AF-S

This mode usually stands for Single Servo or Focus Priority. Canon calls it "One Shot Mode." In this mode, the camera won't release the shutter until it's gotten confirmation from the AF system that it has the subject locked in sharp focus.

This is the mode you use to shoot still subjects. That's not to say that you can't shoot moving subjects in AF-S mode, and in fact if you're just going for a single shot of the action, you might actually prefer to use this mode.

In fact, there's no reason you can't use AF-S to shoot action. There are some real advantages to using this mode, but as I said above you need to know its limitations. Since the camera won't track moving subjects in AF-S mode, you can't shoot a series of photos in continuous mode and expect any of them to be sharp, except for the first frame. Once the lens locks onto your subject, it will stay there, even if you hold down the shutter button.

The obvious exception is when your subject is moving in such a way that the relative distance to your lens remains the same. This is the case when they're moving across your field of view instead of towards or away from you.

The result is that when using AF-S mode, there's no "spray and pray." However, this is not necessarily a bad thing, because it forces you to

deliberately compose the scene and then press the shutter at exactly the right instant so that you capture the peak moment of the action. A good eye and perfect timing counts for everything if you can get it right.

Every once in a while I'll try to shoot action with a camera or mode that doesn't track just to keep my chops up. It's good practice. Try getting up close and shooting sports with a rangefinder or a point-and-shoot. If you've got good timing, you should be able to get a great shot regardless of what camera you're using.

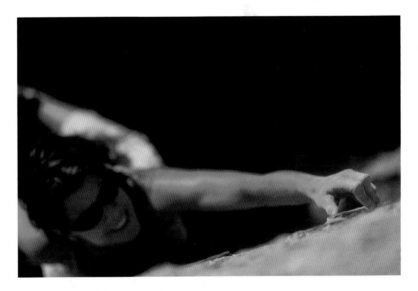

Knowing that the climber would reach for that handhold, I quickly locked on with AF-S and waited for the right moment.

AF-C

This stands for Continuous Servo or Release Priority (with Canon, it's called "AI Servo"), and it's what you usually use when shooting a series. Unlike AF-S mode, not only will the lens keep adjusting focus when your subject moves, it will do that in between shots and track motion through the frame across multiple exposures.

The essential thing to know here is that in the default mode, as long as you press the shutter button, the camera will fire regardless of whether your subject is in focus. If your lens doesn't lock on before you fire the camera, you can end up getting an entire series of blurry photos. (With many cameras, you can change this setting so that it won't take the first shot unless it's in focus.)

The main limitations of AF-C mode depend on two main things: your gear and your technique.

This is where better cameras and lenses shine. Higher end DSLRs and the newest generation of pro-class mirrorless cameras have better AF modules and faster processors. More expensive lenses have wider maximum apertures and faster AF motors. In no way does this mean that you can't expect to get any good action shots if you don't have an expensive DSLR, but the simple fact is that better camera gear will make shooting fast-moving subjects much less frustrating.

Of course, as with any aspect of photography, if you've got good technique and you know how to use the gear, you can at least partly overcome the limitations of less expensive equipment. In the next section, we'll explore how you can stack the deck in your favor, no matter what camera and lens combo you're using.

Predictive AF tracking

A "predictive focus tracking system," such as Nikon's "3D Tracking AF mode," uses special algorithms and processors to forecast where the subject will be when the shutter opens.

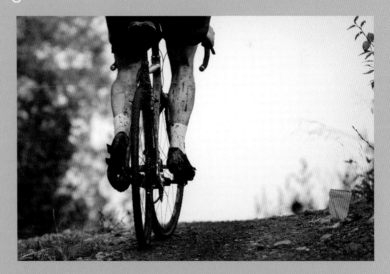

When you activate the AF system, the camera takes a series of measurements to determine the subject's distance and rate of motion, then factors in your biomechanic's release time lag (the average human delay that occurs between *seeing* and *pressing*) and moves the lens accordingly to ensure sharp focus.

"Predictive" autofocus is what allows a camera to successfully freeze multiple shots of a high-speed subject like a biker who's riding directly towards or away from you. It all happens in the blink of an eye, and some cameras are even smart enough to track erratically moving subjects that you'd never be able to track with manual focus, like birds and children.

Autofocus in action

AF point selection

The big thing with autofocus when you're shooting action is knowing where to start. Before blasting away, you'll want to make sure you have everything set right on your camera. You'll also need to gauge your scene and plan for where you think or want your subject to enter the frame.

First, go into your camera menu and choose the AF option that allows you to select the appropriate focus area in the viewfinder via the thumb pad on the back of the camera.

You can also let the camera decide which focus area to activate, and while this mode comes in handy during certain situations, it doesn't always give you the results you want. It's programmed to select whatever is closest to the camera, which may not be where your subject is.

I'll occasionally use this mode when I'm shooting one handed and can't manipulate the buttons with my right hand. However, I find that on many occasions it always seems to grab the wrong thing, like the ground right in front of my subject. Then I end up with sharp toes and slightly blurry eyes. That's never what I want.

I find that simply having your subjects walk and interact with someone off camera can lead to better portraits. It can be hard to set a focus zone when they're constantly moving, so in this case, I let the camera grab the most appropriate AF point.

Sometimes my subject is the closest thing in the viewfinder, but it might be moving around the frame in such a way that makes it hard to keep it inside my selected zone. Photos of people who are very close or who are moving quickly fall in this category. It can be pretty challenging to keep their eyes locked on, so in cases like this, I'll let the camera take control of the focus zones.

This is when I like to turn on Face Detection. I don't use this mode very often, but it's there when I need it, and it works surprisingly well. In most cases, though, I prefer to have control over which focus zone is activated.

Focus tracking

Next, set your desired focus-tracking setting. Your options are to either have a static focus point or one that will hand your subject off to the other zones if it moves away from the initial zone. I recommend the latter. Why take chances? Even if you're shooting still subjects that aren't moving, leaving focus tracking on lets you recompose your shot without having to worry about trying to reacquire your subject. I use this technique a lot.

With my Nikons, I have a few different options that are optimized towards different types of erratic or steady motion. I usually set it to full 51 Area 3D tracking, which uses both distance and color information as well as motion prediction algorithms in order to keep the subject locked. Depending on what kind of action you shoot, you should do some tests and see which option works best for you in different situations. If your subject is not moving all over the frame, then one of the tighter, smaller AF pattern arrays might perform better for your given subject matter.

Get (your subject) in the zone

Once you've got that set up, look through the viewfinder and select the AF point that's closest to where you think the action will begin to unfold. This way, when it comes into frame, your lens won't have to go hunting. The closer you are at the start, the less likely it will grab some other part of the scene and leave you with a bunch of out of focus frames.

Then, as soon as the dirt starts flying, make small adjustments to your composition so that your subject falls right under your desired AF zone. Even if that's not exactly the shot you're going for, you want to get a lock as early as possible so that the lens can stay with your subject when it reaches the optimum location in the frame.

If you're shooting with a DSLR, you can either use Continuous or Burst mode, or fire a series with single rapid clicks of your finger. Unless you have a very high frame rate (6 and up), this can actually be more precise, especially if your subject is moving very quickly. Remember, it's all about timing. In the end, it's better to snap right at the perfect moment than have a series that misses the one exact moment you were going for.

If you're shooting mirrorless cameras, you'll definitely want to use CH mode. Whereas DSLRs can process and get ready for the next shot almost immediately, nearly all mirrorless cameras and compacts have a short blackout/processing lag when shooting in S mode.

With fast-moving subjects, that brief blackout may be short, but it's essentially like shutting your eyes to the world. By the time your viewfinder is ready again, the moment will likely be gone. Faster memory cards will decrease this lag by a little bit, but even so, my advice is to use continuous mode whenever you're shooting any kind of people or action pictures. Even with portraits, expressions and body positions can change in a split second.

Prefocusing

This is a great technique for shooting subjects with extremely fast motion or during those times when you simply cannot keep a lock on the subjects. It might be because the subject is emerging from behind another object that throws the focus off. Perhaps there's one single moment that is far more important than all the moments leading up to it. Capturing those lead-up shots wouldn't mean anything if you don't nail that one crucial shot at the end.

There might be a technical reason or an equipment limitation why you can't accurately track the subject, the most likely being the fact that you're using a camera with a limited autofocus system, such as a point-and-shoot or a compact that doesn't track very well, or a slow lens. Maybe you're using a manual-focus lens. Sometimes you just can't part with that ultrasharp old-school glass from the past. With the right camera or adaptor, it still has life, but it won't autofocus.

Or you might be working in low light. Trying to get your lens to lock onto a shadowed subject is like throwing money into the air and trying to catch it with your eyes closed. You might get lucky, but don't count on it. Get ready to watch your lens go on a hunting expedition while the subject goes by.

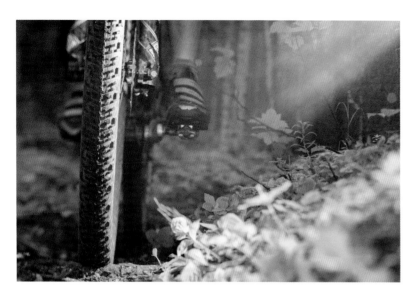

I'm riding the bike here and since I can't track AF when I'm not holding the camera, I set the focus point to a specific zone and trigger the camera with a Pocket Wizard when I reach the right spot.

Prefocusing is simple, at least in theory. It involves identifying the exact location where action and moment will converge, setting your focus point to that spot, and then waiting. As soon as they subject reaches that point, you snap the shutter and hopefully nail it in sharp focus.

As I said, it's easy in theory. In practice, it can be pretty challenging. If your subject is moving extremely fast, it can be hard to nail the exact moment, although predictable motion is easier to deal with than highly erratic motion. A trail runner is easier than trying to capture a hyperactive toddler. Ask my parents how many sharp pictures they have of me from my youth.

In either case, timing is key. My old Nikon F5 used to have a Multi-Control Back that would let you set the camera to fire only when it detects subject movement on a prefocused point. I don't know of any camera systems that have that option now, so you have to rely on your fast eyes and even faster fingers. Keep in mind that the eyes are much quicker than the hands; there's always a slight delay between when you SEE something and when you can actually press your finger down on the shutter. Firing off a short burst in Continuous mode can help you nail the right moment.

Fortunately, most adventure-type activity is fairly predictable. You pretty much know where the climber, the kayaker, the biker, and the runner will be next. Even base jumpers have a very defined path, they're just really fast.

For subjects that aren't quite so predictable, or if you don't know where they'll be, you might just have to throw it all out the window and guess. Pick a spot, wait for the subject and then fire as many frames off as you can. That's when "spray and pray" just might be the way to go.

Here are some examples of prefocusing techniques in action.

(*Left*) Here I set the focus point to that little pronounced pebble right where the runner's back foot would land and had her run past me. As soon as the back foot is planted, I press the shutter. It often takes a few tries to get it perfect.

(*Right*) For this shot, I was using a Nikon 45mm manual focus tilt-shift lens. I got into position, prefocused on a determined location, and fired two quick shots right when he hit the zone. The second frame was sharp.

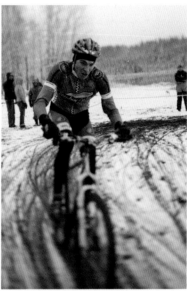

Here I prefocused on the handhold so that when the climber slapped over the lip of the boulder, I was ready to shoot.

Creativity

What is creativity?

By definition, creativity is the set of cognitive brain functions that revolve around solving problems, expressing ideas and concepts that are uniquely original or producing something new that has never been made before.

In most cases, human creativity stems from the need to complete a previously impossible task or from the desire to entertain or outwardly express an inner feeling. Whereas task-inspired creativity usually results in the invention of tools or methods, expressive creativity is what drives us to produce things like art, writing, dance, and photography.

Oftentimes, those ideas are met with opposition or criticism, and it's the persistent individual who is able to push forward with his or her ideas and potentially change the lives or the perceptions of others. Throughout our long human story, creativity has not only allowed us to evolve technologically as a species, it has also allowed us to find meaning in our lives, communicate our own individuality, and define our personalities.

Successful creativity requires risk tolerance and the confidence that your ideas will have some inherent value or merit, either to yourself or to society. With photography, and specifically with adventure photography, creativity is largely about finding new ways to wow our viewers and temporarily transport them into our world. In other words, making photographs that portray certain locations and activities in the most amazing way possible. Our drive is to put them on the edge of their seats and to take their breath away.

The process of creativity can be broken down into five stages. Let's look at how they could play out with regards to adventure and action photography.

Fact finding

This is where you do research and collect data about your surroundings. You notice a subject that you'd like to photograph and note the different elements of the environment that attract you to the scene. Or you imagine a subject and how you'd like to portray it.

Surfing the web. Reading guidebooks. Poring over topographic maps. Looking at other photos of the specific places you want to visit. Studying the way a specific trail cuts through a magnificent landscape. Scoping out new areas to photograph.

Problem findings

This is where you pinpoint specific problems in the current method or areas that could be made more efficient. You evaluate the lighting conditions, shadows, backgrounds, and anything that might hinder your image.

Maybe you're having trouble seeing a possible vantage point from which to shoot a certain rock-climbing route that has already been shot a hundred times before. You don't want to use the same, easily accessed vantage point; you want to find a new one.

Perhaps the trail you like is only lit during certain times of day and you don't see an easy way to shoot the scene without having too much contrast.

Idea finding

This is where you mull over your collected data from the first two stages and brainstorm for new ideas for success or originality. You come up with ideas such as angles of view or directions and quality of lighting that might better emphasize your subject.

You've established where you want to shoot and when the good light will appear, and you've identified the challenges of finding a good vantage point or making your subject stand out from the shadows against your chosen background. Now you have to figure out how to get around those problems.

Solution finding

This is where you come up with specific solutions to the problems or barriers in your process. You nail down exactly what equipment you'll need, which lens to use, and where you'll need to stand in order to effectively capture the scene as you imagine it.

After thinking it over, you know that you'll need 200 feet of rope, an extra hour to hike to the top of the cliff on the other side of the valley, and a telephoto lens. And you'll need to leave at 5:00 AM to allow time for set up if you're going to catch the good light.

After scouting the location, you found a spot on the trail where the runner will be temporarily lit up by the sun against a shady background for just a few steps. Perhaps you also determine that using a remote flash will make them pop even more.

Plan of action

Where you carry forward and implement your new ideas to achieve something brand new. You plug in your lights, grab your camera, move around, reposition the subject, and actually take the photograph.

You schedule the morning shoot, arrive on location, hike up with your gear, rappel down while your climber subject racks up at the bottom of the cliff. You clamp your flash to a tree branch, make sure it's set to the correct channel on your radio trigger, get into position, tell your model exactly what path to take as they run through the sunny spot on the trail.

You don't have to memorize and plan out all of these specific steps every time you take photos. I've just outlined it this way so that you can recognize all the steps that make up the creative process. The next time you find yourself in a rut, try running through these steps in your mind and see if any new ideas emerge!

TIP: Need Ideas? Take a walk. Time alone like this can dramatically increase brain activity and your propensity for coming up with new ideas.

Approaches to image creation

During my years as a professional shooter and workshop instructor, I've spent a great deal of time analyzing photos and exploring the methodology of creativity as it applies to photography. In order to illustrate the creative approach that we often use to make our images, I've come up with three specific concepts that define the imagery itself, and four different concepts that describe the actual process of creating that imagery.

Expanding on the ideas about creativity that we explored in the previous section, let's look at these new ideas and see how they can apply to your own photography.

As with the previous ideas, you don't necessarily have to think about these methods every time you go out and shoot photographs. Just storing these concepts in the back of your mind can help you to further understand what actually goes into the process of making compelling imagery.

Types of images

Found

An image that shows a scene "as is," with no manipulation or alteration in any way. Most nature, wildlife, and journalism photographers create "found" images. Landscapes are found images, as are candid portraits, and any shot where you don't change anything about the scene or direct how it unfolds in any way. Shooting great found images means being in tune with your surroundings and having a highly perceptive eye.

I liked how the afternoon light looked, so I simply dropped back and let my three friends get ahead of me in order to get the vantage point I wanted.

Controlled

Controlled images use minor "direction" to create a scene that might not have happened exactly that way without your involvement, but very well could have. Examples include having your subject pose a specific way or follow some sort of action that is dictated by you.

Many of my adventure images are somewhat controlled. I'll often direct my models to "ski that line" or "run right past me on the trail." It could be as detailed as "stand on that rocky outcrop and look towards that mountain with your arms outstretched."

Even though I direct the situation, sometimes by varying degrees, the final images represent scenes or actions that conceivably *could* have played out that way, whether I was there to photograph them or not. The key here is *plausibility*. Your goal is to create an entirely believable image.

Although these two women would have hiked this trail without me, I went along with my camera and had them wait for me to set up a few times so that I could catch specific moments.

Contrived

An image that was totally made up or "faked." It probably would never have happened that way in real life, but nonetheless, by the hand, direction, or special effect of the photographer, a unique image is created.

We see plenty of contrived adventure imagery on those generic motivational posters, and while it may sell from a pure business standpoint, in the outdoor and editorial world, where we all know better, it lacks validity.

Most accomplished nature photographers rarely make images of this type. Or they're just not telling anyone; they just cash the checks and keep quiet, because no matter how hard you try to explain it to them, that's what the client wants.

I'll leave it up to you how much "realism" you want to put into your imagery. If it's done well, contrived imagery can communicate very powerful messages.

Methods of creation

Snapshots

Just pointing your camera and shooting. Very little thought process, if any, is involved in creating the photograph.

Example: You're hiking down the trail and you come across a scenic vista that you like. You pull out your camera, snap the photo, and move on.

I saw this scene while driving up the canyon to go skiing. I quickly pulled the car over, snapped one frame, and drove away.

There's nothing wrong with this, in fact I would guess that most of us shoot like this all the time. If you just want to capture certain elements as you pass through the world, then snap away and have fun!

Passively Created

Fine tuning or working a scene that already exists. You are using your own personal vision to record the scene in a unique way. You might not alter any aspects of the scene, but you do give some thought to your compositions, angles, and lighting while you're shooting.

Example: You and your partner are skinning up the ridge of a mountain when you notice a dramatic peak in the background. You decide to hang back a little bit and let your buddy get ahead of you while you stop and switch lenses. You put your camera up to your eye and wait for him to reach a certain point that puts him in direct line with the peak. When he gets there, you take the shot.

This is my approach much of the time when I'm adventuring in the outdoors. I often like to move fast, which means I don't really have time to set up shots, wait for different light, or direct specific situations. Instead, I keep my eyes tuned to the scene with geometric vision, I make quick observations about where my subjects are in relation to prominent features in the environment or the lighting and take shots as I see them unfold. Then I run to catch up!

Even though I'm changing things about my own situation, I'm not directing or changing anything about how my subjects are interacting with the world.

For this shot, I scouted out the best vantage points, communicated with the kayaker about when to start paddling, and then waited for him to come into view.

For this image, I stopped and let my skier friend continue ahead for a few hundred yards. This gave me plenty of time to look for the best vantage point on the slope and set up for the shot.

Actively Created

Having previsualizations about the way you want a particular subject to look in your final image. This means deciding on factors like composition, exposure, subject placement, and lens choice in advance, and then waiting for the optimum lighting conditions.

Example: Let's say I've just gotten to the top of the ridge with my friend and we're about to ski down. I notice a very dramatic cliff that I think would make an excellent background. Right now, there's a cloud overhead. After we take our skis off, I tell my friend to wait for me while I ski down to the shoulder and set up.

When I get there, I switch to a long lens, wait for the sun to emerge from behind the clouds, and then give him the signal to ski down the slope. With my camera set to Continuous mode, I shoot a series of him skiing down the hill in front of my chosen background, which is now in the sunshine.

While engaged in my activity, I noticed a possible shot and worked to make it unfold. Identifying the present situational and environmental factors that would most affect the image, I worked actively to get the best image by putting myself into the right position and waiting for the best light.

As with Passively Controlled, shooting like this requires quick thinking and constant observation, evaluation, and anticipation of the scene so that you can recognize and make the most of possible situations.

Totally Previsualized

This means having an original image idea in your mind, even before you have camera in hand, and then working to turn those creative ideas into a finished photograph. This method involves searching in advance for the right subject matter, location, and lighting, and then bringing all the elements together. With the right planning, logistics, and technique, previsualized images can end up being our most rewarding work.

There are many levels to this kind of approach. It can be as involved as planning out your entire shoot on paper before heading to a defined location with a bag full of specialized equipment. Or it can be as simple as coming up with a general "shot wish list" before going on vacation, and then searching out possible locations when you get there.

Example: Let's say that you get an idea for a dramatic shot that involves a runner leaping over the camera. After finding a model with perfect-looking calf muscles, you search for a good location. When you find the ideal spot, you have her run a little bit while watching her stride, then you set up and have her do multiple passes until you nail the right combination of lighting, motion, and body position.

Here's another example. Let's say you know of a specific rock-climbing route that's situated in such a way that sunset light only hits it a few days per year. In the middle of the climb, there's a move that requires the climber to cut his or her feet loose as they reach for a particular handhold. You imagine how powerful it would look to shoot a climber pulling this move right when the golden rays of last light hit them.

Totally Previsualized. I wanted a twilight photo of Tim jumping his fat bike, so we made plans to shoot, scouted out the location, and built a kicker in the middle of the trail. Knowing that I'd need supplemental light, I brought along a battery-powered strobe and a large softbox.

Depending on the time of year, you could potentially have to wait a few months for the light, so during that time, you line up a climber and a belayer and scout out the best vantage point. You might even rehearse the shot with your climber once or twice before that optimum day, just to make sure you've got everything right.

Then, when the magical day arrives, you head to the location, set up, wait for the light, and hopefully nail the shot just when the climber pulls that move under rays of pinkish, orange light. Money shot.

Using different types of light

Above all, photography is about light. The word itself *photography* means "writing with light," which is exactly what we do when we take a picture. We're not simply making a visual copy of whatever happens to be in front of the camera, we are recording the light that is being reflected back at us from the subject.

Subject matter gives the photograph context, but it's light that gives a photo its look and style. Variations in direction and color temperature (the warmth and coolness of the light) cause subjects to appear vastly different from one image to the next, and it's how we use those factors that usually makes the difference between mediocre pictures and great images.

Unappealing light will generally make for average and unappealing photos, while interesting light, with rich, dark shadows, strong contrast, and bold colors, will always make for more interesting shots.

The quality of light

Making great photographs requires an understanding of the complexities of light and the knowledge of how to use it to your advantage. The main reason that successful shooters produce such good-looking imagery is that they use pleasing light.

Inside, studio photographers control and shape light with high-power strobes, reflectors, and large soft boxes. We don't have quite the same control outside, but we do all share free access to an even bigger, better, and more diverse light source than anyone could ever invent: that huge ball of fire in the sky we call the sun.

The sun can be a tricky beast, though. For one thing, it's brighter than any strobe, which means it can throw down with ruthless contrast, especially on faces. Also, you can't control the sun. Sometimes you wish it weren't so brutal, other times it disappears when you long for it most. How many times have you found yourself in front of a spectacularly grand landscape at noon? How many hours of your photography life have you spent waiting for the sun to emerge from behind the clouds?

As tough as the sun can be, it does offer some huge technical advantages over studio flash. For one thing, it illuminates everything in its path with the same intensity. It doesn't fall off with exponential drop from foreground to background. Also, the sun is a constant light source, so you know

exactly how it will look before you take the picture. There's no guessing. If it looks bad in real life, it's going to look just as bad in your photo.

Of course, these are inconsequential matters, aren't they? Our lifelong fascination with the sun as outdoor photographers isn't based on things like lighting ratios, it's based on something much more aesthetic and wonderful.

Every day, as our sun journeys overhead, it casts a wide swath of colors that shift from soft pastel to rich golden pinkish reds to cool shadowed blue and harsh bright white. Add in an endless possibility of atmospheric conditions and you get gentle diffused whites, ominous grays, soft yellows, and sometimes even an eerie green shade when tornadoes are near.

In addition to color change, the sun creates some pretty incredible shadows, which vary greatly in length and direction as the hours and seasons change. When the sun is low, it can draw slender, 50-foot shadows behind your subject that add tremendous interest. From a different vantage point, though, the same shadow can complicate your scene and make for tough shooting conditions.

Although photographers often speak of "bad light," I prefer to think that there is no such thing. In any given moment, the light may not be ideal for your specific ideas, but that doesn't mean it can't be made better with a change in vantage point, equipment, or timing. If you can understand how best to use all of the differing qualities of the light, you'll watch your success rate with photography climb to new heights.

Let's explore the possibilities.

Magic hour

As most of us learned early on, the best time to photograph outdoor subjects is usually during the "magic hours" of sunrise and sunset. Those are the times when the sun's rays skim along the edge of the earth and pass through a thicker swath of the atmosphere. The much shorter blue and violet wavelengths of the sun's spectrum get scattered out of the beam, leaving only the longer rays of red and orange to fall upon the earth.

During magic hour, the entire scene is enhanced and rendered with a much warmer cast, and shadows become both longer and more pronounced as the sun's rays hit the scene from a lower angle, instead of directly overhead as at midday. Whereas shots taken at solar noon tend to render subjects in a rather ordinary and unappealing manner, the lighting qualities that are present during sunrise and sunset usually produce dramatic, striking photographs that jump right out at the viewer.

Great light even makes shoveling snow look awesome!

As photographers, we lust for those moments. Nothing in life peaks our interest or gets our blood pumping like the elixir of golden pink light. For many of us, it's the root of our passion for the camera. Everything looks better during magic hour, and if there's only one piece of advice I could give that would ensure more exciting imagery, it would be to get up earlier and stay up later.

Providing that the sky is clear near the horizon, magic hour light usually begins to occur anywhere between one and two hours before sunset and after sunrise, with the best light occurring when the sun is lowest. The exact color of the light on your scene is influenced by the amount of dust, haze, ash, pollution, and moisture in the air.

Any clouds that are present in the higher areas of the sky will begin to shift colors with the warming light. This can add lots of drama to the scene. Just as the sunset light makes your subjects appear more brilliant, the clouds will continue to become more brilliant the closer the sun is to the horizon.

Morning light vs. evening light

Theoretically, there should be no difference between the quality of the light at sunrise and sunset. However, since prevailing weather, atmospheric conditions, and the amount of dust, haze, ash, pollution, and moisture in the air will affect the color and intensity of the light, no two sunrises or sunsets will look exactly alike. In addition, the sun follows a slightly different trajectory each day, which causes it to draw different paths of illumination and shadows on the earth throughout the calendar year.

For me, the two have a different feel. There's something unique about waking up early and enjoying the peaceful solitude of the morning while you wait for first light to hit. At the same time, it's no less satisfying or exciting to chase afternoon/evening light, match subjects with backgrounds, and watch everything turn a deeper shade of orange by the minute. They're just different. You can create beautiful photos during either time, you just need to get out there with your camera.

First light on a winter morning.

Last light on a winter afternoon.

After sunset

Dramatic photographic opportunities often continue even after the sun dips below the horizon. During those few minutes of pre and post dawn, direct shadows disappear and the light becomes more muted, but clouds often glow with increased illumination. You might even see alpenglow, a phenomenon that sometimes occurs when the sun is just below a clear horizon. Alpenglow is caused by the indirect scattering of sunlight on dust, water, and ice particles that may be present in the sky, and it's usually seen as a glowing band of red or pink light at the edge of the opposite skyline. It's especially dramatic when it appears on high mountain peaks.

Chasing the sunset

Keep in mind that what may look like alpenglow is often just the last few rays of the direct pink sunlight that we see hitting the high peaks. Remember, due to the earth's rotation, the exact time of sunset varies by elevation. It's later the higher you go, so even though the sun has already set from your perspective, that doesn't mean it has set on the higher peaks. Knowing this, you can prolong the sunset by chasing it up the hill or by increasing your altitude some other way.

Shooting from the air lets you chase good light all the way to the top of the peaks.

Cloudy days

Just because the best light happens during magic hour doesn't mean that you should put away your cameras for the rest of the hours between sunrise and sunset. Great photographs can be taken at any time of day, and in fact some types of photography lend themselves very well to midday and even cloudy days, when there is no direct sunlight. Knowing how to take advantage of these situations can help you produce good imagery in conditions that often seem less than ideal.

While it's not always the best light for shooting broad scenes that include large parts of the sky, overcast days are great for shooting closeups. As it turns out, direct sunlight is not your friend when shooting that close, as it adds too much contrast. Clouds diffuse and soften the light; they act like the world's biggest soft box in front of the world's biggest flash. This gives you a much more gentle look without any harsh shadows.

These conditions are ideal for shooting in very high-contrast locations like inside thick forests, shadowed dihedrals, the shaded sides of cliffs, and other locations where the prominent levels of bright and dark are too extreme for your camera's sensor when it's sunny out.

Skiing in a whiteout isn't very easy. Neither is trying to shoot an awesome action vista shot. When the clouds roll over, it's time to move in and shoot closer.

Example 1: Shot in direct sun inside the forest. Example 2: Shot under cloudy skies.

Example 1: Shot in direct sun. Example 2: Shot under cloudy skies.

Cloudy overcast days are also great times to move in close and shoot portraits because you won't have to deal with squinting, heavily shadowed faces, blown-out backgrounds, hot spots on the forehead, and harsh, direct light that highlights every single nook, cranny, crag, wrinkle, and divot in your model's skin. This might be ok if you're shooting someone with an extremely rugged appearance, but for most people it's not a good look. Dudes, don't ever photograph your wife or girlfriend in harsh light—wait for the clouds.

However, there are always exceptions to the rule; occasionally, heavy overcast can play an important part in the scene as illustrated in the left image. The cloud cover in this shot is certainly a feature element and it adds a dynamic quality to the image that you'd never get on a blue sky day.

Exception to the rule.

Position of the sun

Shadows. Inky streaks that filter through your scene and reveal only a tiny yet significant portion of what's really important. Soft velvety shadows that creep gently around the side of a model's face. Bold fields of black that hang with dominance behind the subject . . .

Easily the most intriguing ingredient of photography, shadows create mood. They insinuate drama. They show texture. They suggest shape. They help tell the story while concealing the rest of the story. Photography without shadows is like an ice cream sundae without the fudge. It's not really a sundae then, is it? It's just vanilla and whipped cream, and that's a little bland.

How do you get shadows? Simple. You alter the direction of the incoming light by shooting off axis from the source. Outdoors, this means changing the position of the sun in relation to your subject, and it allows you to create very bold and interesting compositions, no matter what you're shooting. As with other creative techniques, try to combine variations of direction and quality in the same image. Here are a few techniques.

Side lighting

Side lighting accentuates texture and shape, and it creates a sense of three dimensionality. It gives your compositions a much more complex and dynamic feel than if you used regular-old front lighting. With people, side lighting makes the good kind of shadows on their faces. In fact, leading male movie stars during the golden era of Hollywood were often lit with side lighting, because it made them appear rugged, bold and mysterious.

Most portraits look great with at least some side lighting. So does just about everything else. Light that streaks in from the side has power. It has freedom. It forces your subject to stand strong against the clash of being illuminated on one side and being dark on the other.

Backlighting

Backlighting can be tricky, especially when photographing people. Use it wrong and you'll have the bad kind of shadow to deal with; you know, the kind that just gets in your way. Use it right, and you can create portraits that have a more relaxed feel. Under these circumstances, the main benefit of backlighting is that your subjects won't be squinting, because they won't be looking right into the sun.

Backlighting also gives a more even textured light to your subjects, which can sometimes be a very appealing look. It also transmits vibrant light through semi-transparent subjects, just like looking at slides through a light box. Check out the kayak shot below.

When shooting subjects in this kind of light, you'll probably want to move in closer so that you don't have too much contrast with the much brighter background. This might look OK, but realize that you'll end up with blown highlights.

By shooting backlit portraits at the end of the day, you can outline your subjects with a golden 'halo' of sunset light. The sun doesn't even have to be directly behind them to make it work. This technique can be even more effective when you're using fill flash.

Silhouettes

Silhouettes are another way of using backlighting; you just let your main subject fall into shadow against the brightly lit background (usually the sky). This only works if your sky is either a deep rich blue or if it is tinted by the colors of the setting sun. Also, silhouettes don't work very well when you're shooting in a field of snow. All that bright white just reflects light exactly where you don't want it.

The most common way to shoot a silhouette is to place your subject in front of a dramatic sunset sky. The more colorful the better. As with any photograph, the more dynamic the subject, the more interesting your silhouette will be.

To create the effect, use your desired metering technique to expose for the background. This will let your subject drop to black and leave them in shadow against a perfectly exposed sky. The key is to underexpose your subject. To add to the effect, place your sun directly behind the subject and let a tiny sliver of it creep out from behind an edge. If you stop your lens down all the way, you'll create a "sunstar."

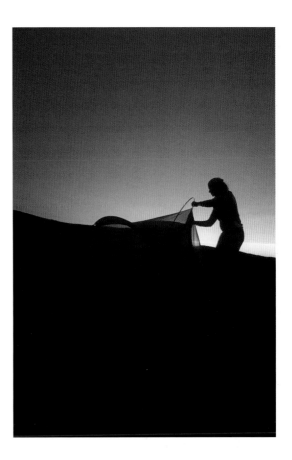

Don't be afraid to experiment with your exposures until you get the look you want. Shoot, check your work, and make the necessary adjustments either up or down until you get it right. Remember, if you're shooting in an auto mode, you'll need to use the EV +/– dial to brighten or darken your sky. Also, keep your flash turned off when shooting silhouettes, even if the camera thinks you need it. Trust me, you won't. Flash will only kill the effect.

If done well, a good silhouette no longer becomes about the subject itself, but a powerful representation that suggests the activity or place. Since the shadowed subject is usually not recognizable, it allows viewers to imagine themselves in the scene, and anytime you do that, you've created a more engaging photograph.

With the endless qualities of light that each day brings, the opportunities for taking great photos are virtually limitless. Experiment with different lighting conditions and subject matter. Combine color with direction and practice for the rest of your life. You'll discover some amazing possibilities along the way.

Shooting different camera modes

Most digital cameras today feature a number of creative different shooting modes, including film simulations and an array of special effects. For example, my Fuji X mirrorless cameras can replicate a number of old color and BW Fuji film stocks like Velvia (my #1 film choice for years), Provia, and Astia, and it also does things like sepia, miniature/tilt-shift effect, HDR, selective color, and panorama.

While some photographers dismiss these "fun" effects as not applicable for legitimate pro work, I find them highly useful for expanding your creativity and telling the story in a new way. Who said that creativity had to follow specific rules about what effects you could add to a photo or not? Also, in today's world, where clients are starting to use Instagrams and iPhone photos in national ads, you never know what will garner the attention of an art director. Most of them don't care about RAW and JPEG, they just want original photos that look great.

The way I see it, photography should have a very high "fun factor" or you're not doing it right. If these kinds of modes and effects inspire you to look at and shoot the world in a new way then I'm all for it. I never shot much black and white as a film photographer, but now that I have these options available to me on my digital camera, I make use of them quite often.

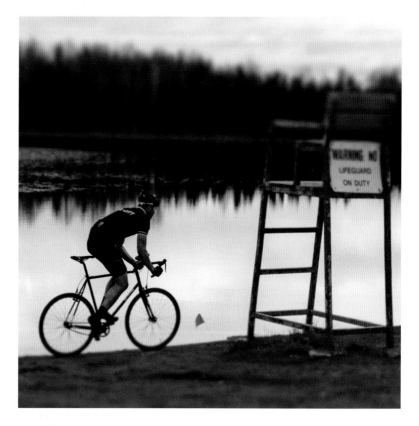

I recently had a client request to use this image as stock. It was shot with a Fuji X20 on "miniature mode."

You can use these modes to reflect varying shooting conditions as well as your own vision and ideas. Just as photographers in the past made use of different film stocks based on subject matter, lighting, weather, and more importantly the specific look they were going for, these modes allow for some very personal results. You can always apply these kinds of effects in postproduction, but there's something to be said for gauging a scene, coming up with a fun creative idea in the moment, and running with it.

Remember, photography isn't about accurately reproducing the scene with perfect clarity, it's about telling the story of the scene in your own unique way. Whether that includes special toning, soft focus, simulated film grain, or some other retro look, if you're happy with the image, then that's what counts.

I find these effects and film simulations to be quite useful in my photography. They're great for rescuing a scene from bad light. Switching to black-and-white mode can work really well if you're in front of a great subject in less than ideal conditions.

During a recent trip to Iceland, I found myself at one of the geysers on a dim overcast winter day. Shooting color would have given me nothing. Shooting RAW would have meant spending more time later, trying to make better in post. Instead, I switched the camera to one of the BW film simulations, shot the scene, and walked away with a photo that I was really happy with. Immediate results and creative gratification on the spot. So much better than saying, "I'll deal with this later."

Here are a few more examples.

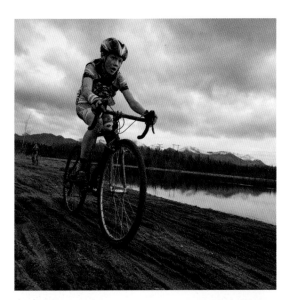

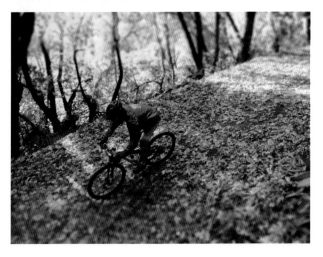

Vantage point

Out of the millions of outdoor photos that are shot every year by eager adventurers, nearly all of them have something very much in common: 99 percent of them are all shot from roughly the same vantage point of between five and six feet above the ground. Think about it. How do most people hold their camera? At eye level while standing upright. With this in mind, it's easy to see why so many photos all have the same look.

Altering your vantage point is a very easy and effective way to give your images a different feel. We are not used to looking at the world from views other than from our own eye level, so any photo that is taken from a drastically different vantage point will inherently appear more interesting to us.

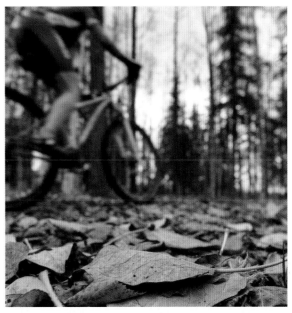

Changing your vantage point can be as simple as standing on top of a rock, sitting up in a tree, crouching or kneeling, or lying with your belly in the dirt. Or it can involve using more elaborate methods to get you or your camera into a higher or lower position, such as shooting from the side of a cliff, scrambling to the top of a boulder, or shooting from a plane or helicopter. Also, you don't always have to hold your camera to your eye. Shooting from the hip, holding your camera very close to the ground, or holding it very close to your subject with an outstretched arm are all methods that can lead to some very dynamic imagery.

Having expertise and a solid understanding of the sports that you're photographing can help you push your creativity and get the best images. When I'm shooting rock and ice climbing, I'll often use ropes to get myself into position right above or next to my subjects. This gives a perspective that only climbers can ever get, so it works with your viewers on both levels. Nonclimbers are wowed by this foreign, extreme look, and climbers who've been there can relate. A great photo speaks to both types of viewer.

If I'm shooting in the mountains, I use my knowledge of the terrain to choose possible routes that will get me into the best position and, at the same time, keep me from falling or getting hit by stuff. Remember the golden rule. No, not the one about composition and ratios, the one that says safety first!

Actually, I've broken it enough times. (You probably have too.) I wouldn't say that I've done anything to deliberately put myself in danger, but I've certainly pushed it on occasion. Keep in mind the safety of your subjects and please try not to hurt anyone. This is important, so don't be surprised if I remind you again later.

Although it helps, you don't need to be an expert in the sport you're photographing and you don't necessarily need special equipment or training to get great adventure photos. As I said, finding good vantage points can be as simple as hiking up a low angle hillside opposite a vertical wall, standing on the other side of a canyon, looking down from the top of an easily accessible high point, or simply changing your own body position in relation to the subject.

Clamps and other vantage point tools

Another way to get dynamic vantage points is to use tools like clamps, arms, monopods, and wireless radio triggers. Video guys use cranes, but I can't imagine carrying all that gear into the backcountry. Actually, there are some really nice boom arms that weigh less than 4 lbs. The Aviator Travel Jib folds down to about 24¨. It might fit on the side of a pack.

A common setup that I use is the Manfrotto Super Clamp and the Manfrotto Variable Friction Arm. These handy tools let you stick the camera onto bikes, vehicles, kayak paddles, wing struts, etc. Using these clamps, I've attached my cameras to bicycles and other moving vehicles, and used the self-timer or radio-controlled remote triggers to fire the shutter.

Add in radio controlled 'copters and the possibilities become endless; you're only limited by your imagination, equipment, and budget. Of course I make no claim as to the condition of your equipment after doing this stuff. Be smart.

You can do a lot by just fixing your camera to the end of a monopod or tripod and holding it above or out in front of your subject. Or placing your camera on the ground in a really tricky spot and using Pocket Wizards or the self-timer to trigger the shutter. Try different things and see what you can come up with! Get close, get wide, get right in there, and get dirty. The more you immerse yourself into the scene, the more exciting your photos will be.

(*Top right*) Fuji X-T1 and 14mm lens attached to my snow bike with a Manfrotto Super Clamp and Variable Friction arm.

(*Middle right*) I stuck the camera on the end of a monopod and held it in front of me while I hiked down the trail.

(*Bottom right*) Nikon D700 and 14mm lens attached to my snow bike with a Manfrotto Super Clamp and Variable Friction arm.

Anticipation

So far, we've touched on three main ingredients of the creative process in photography. **Vision** is about identifying your own feelings and ideas about adventure and distilling them into a workable composition. You use your **Equipment** to translate what you see into an actual image. **Technique** is the bridge between vision and equipment. It's the specific set of knowledge and skills you use to get around limitations of the equipment when it can't quite keep up with your vision.

We haven't talked about the fourth main ingredient yet: **Luck**. Luck is all about moments. Sometimes all it takes to capture a fabulous photo is to be in the right place at the right time. We can't control those exceptional moments, though, they just happen . . .

. . . Or do they?

I like to think that there's actually a secret ingredient behind luck. It's called anticipation, which is essentially knowing or having a pretty good idea of what's about to happen next. In many ways, anticipation is akin to seeing the future, only without 100 percent certainty. It's thinking geometrically instead of linearly. Using this concept will allow you to create great images on a more regular basis because it makes you a more active participant in your craft.

Anticipation plays a huge part in the photographic process, especially in the outdoors when situations, light, and environments often change within seconds. By carefully evaluating your scene, studying and understanding all the elements that will need to come together in order to make a great image, you can put yourself in the optimum position to get the shot.

When and if a great moment does unfold, you'll be ready. Think of it like stacking the deck in your favor, because to the lay person who doesn't understand all that goes into making great images, it would seem as if you just got lucky. The truth is that most outstanding images are often rooted in anticipation rather than in pure luck.

The types of elements that you might anticipate in your scene can vary, but they often involve some sort of convergence. You might imagine how the light from the setting sun will look on the background in an hour. Or you might look ahead and see a spot a half-mile down the trail where your subject will pass in front of a magnificent mountain face. Placement of your subject in the frame is a big one, especially for adventure and sports photography. A good photographer keeps his or her eyes tuned not just to the immediate surroundings, but to what lies off in the distance as well.

Anticipation is also about understanding your subject and having familiarity with the setting. Most good sports and adventure photographers succeed in part because they understand the activities that they're shooting. Having an idea of just when a rock climber might lunge for a specific handhold or knowing the path a kayaker might take through the rapids helps you better anticipate and plan for capturing those decisive moments when they happen.

The same goes for any type of photography really, whether you're shooting dancers, racecars, baseball, little kids on the playground, or even a simple portrait. It all involves studying your subject and thinking about when the right moment or expression might occur.

Let's say you're shooting a mountain biker. You watch your subject follow a certain path through the landscape. All the while, you're scoping out the scene until you see the perfect background or setting that you want to capture them in.

This means looking outside of your immediate surroundings for possible vantage points or backgrounds that will give additional power to your photograph. If you spot something good, you work backwards and figure out how to make the shot work. This might involve moving to a new

location or switching lenses—whatever you need to do in order to frame and capture the shot as you see it in your mind.

Eventually, the biker reaches that spot and you fire the shutter. You got the shot because you engaged your imagination, anticipated a potential image, and worked to make it come alive. You didn't just stand there and take a passive snapshot. You played an active part in the process by looking, seeing, using your imagination, continuing to evaluate your scene, and maybe even scrambling a few hundred feet up the opposing hillside.

If you learn to think geometrically, expand your vision, and work the element of anticipation into your photographic style, you'll go from being an audience member to a director in the image-making process. You'll start to see a vast improvement in the quality and production value of your photographs.

The challenges and techniques of portraying motion in a still image

The flurry of action goes by quickly, and it doesn't stop, no matter how exciting or impactful any particular moment might prove to be. When we're awake, our eyes run 24-7 like real-time video cameras with no pause button.

We can't actually stop to analyze or replay anything that happens, and to complicate things even more, our vision doesn't actually register each individual moment as a "moment." We view the world in constant motion, and once any particular moment is over, it's gone forever, never to be repeated, except in our memory.

However, our memory doesn't quite work the same way. It's been shown that humans don't remember events exactly the way we saw them, we remember everything in our lives as still images and brief clips. Add the fact that our memory is often quite selective at best and in many cases quite spotty.

This could be the reason why human beings respond so strongly to photographs. They mimic the way that we remember the world, and they stimulate us to reflect on those moments that we either didn't see with our own eyes or that went by too quickly for us to register. Photographs trigger our memories and they allow us to dwell on moments that are long gone.

Still imagery engages our brains more than videos do. Watching a movie is largely a passive activity that shows us life in real time, whereas looking at photographs, which are abbreviations of real time, gets our imagination running in a big way.

One of the unique aspects and challenges of photography is that we can portray motion and represent the concept of passing time in a still image. Through a variety of techniques, we can create photos that communicate the concept of motion in a format that is, for the most part, two-dimensional and completely static.

Single moments

Frozen time

By using very fast shutter speeds, we can freeze movement and portray split-second moments in a way that our eyes could never register. For example, it's physically impossible, both with our eyes and our memory, to recognize the individual droplets from rushing water or the mud splatters that are flying off of the back tire.

Another example is the split-second expression of an athlete who's at the peak level of exertion. In reality, that singular moment of facial intensity wasn't so much of a moment as it was a passing transformation within a constantly evolving expression over a period of a few seconds.

With the camera, we can forever preserve moments that went by way too fast for us to see. This is a common technique for shooting sports and action. By combining fast shutter speeds with dynamic camera angles that accentuate subject matter that we might not normally pay attention to, we can create very powerful imagery.

Our eyes aren't able to pick out those brief individual moments that the camera can record.

Static time

Things that happen in static time are the moments that we did recognize with our eyes. We saw them happen and registered them in our short- and long-term memories. We recall these moments very much as they played out in front of our eyes, or at least the way they played out in front of the photographer's eyes. Even though it's portrayed as a static moment in the image, our brain tells us that the subject is actually in motion.

Think portraits, a person standing in front of a magnificent overlook, a timeless landscape, etc. Even a subject in motion, as long as the focus is on movement and placement in the frame, as opposed to capturing expressions and freezing incremental moments. The significance of the image revolves more around the subject than the moment. In these kinds of images, the concept of time is almost irrelevant.

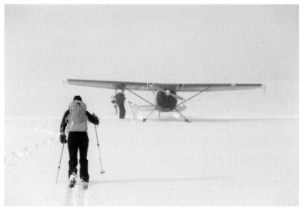

Our mind recognizes these fleeting moments just as they happened and tells us that there's motion invoked in the image.

Blurred time

The opposite of frozen time, blurred time involves using very slow shutter speeds to blur the scene to capture the entire range of motion that occurs across a brief period of time, say 1/15 second, one full second, or more. This can be a very powerful technique, because although humans see in "motion," our eyes don't actually register the blur that a camera is able to record.

Depending on your camera settings, blurred time usually portrays a subject "flowing" through the frame, and it's usually the most common method in photography to show the idea of movement in a still, two-dimensional image. Blurred time and slow shutter speeds are best accentuated by using different panning techniques, which I'll cover in the next section.

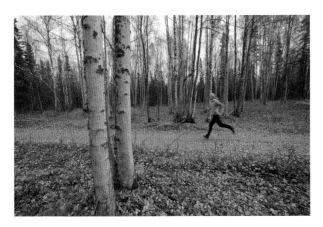

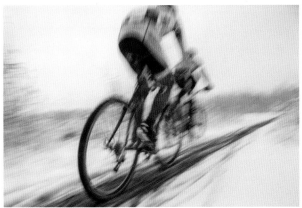

The first image has a blurred subject against a sharp background; the second has everything blurred.

Multiple moments in a single frame

The concept of recording motion as a series of multiple moments in a single frame is less about specific camera techniques and more about telling the story of motion and the subject matter. I don't use these techniques very much in my photography, but they're worth exploring in order to expand your creative options. Remember, photography isn't just documenting places, people, and activities, it's an art form that can help you tell whatever story you want.

Overlapping time

One way to create a narrative of motion within a still image is to combine a series of consecutive moments into a single photograph. Oftentimes, this involves creating a sequence and presenting them as a multiple exposure, or as a montage. This is often done through the use of high-speed motor drives and fast-moving subjects.

Ski and mountain-biking photographers often do this with athletes as they fly through the air off of jumps, firing at speeds of up to 10 frames per second and more. In the final image, the viewer sees the entire sequence as a set of successive frames, all of which are shot within a fraction of a second from each other. The advantage of this type of storytelling is that the photographer can show the viewer the entire path or journey of the action as it unfolded in front of their own eyes.

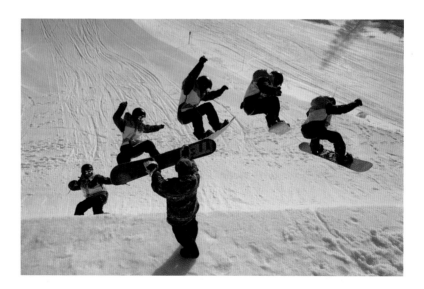

Moving single image

Portraying the concept of time as a moving single image on the page is an approach that "brings to life" motion into a series of still images that are viewed in quick succession. Think stop-motion photography or flipbook animation, such as Eadweard Muybridge's famous photo series of a galloping horse from 1878.

Panning

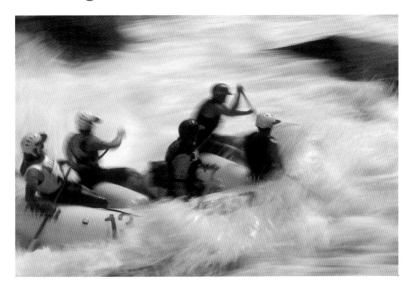

Panning is one of the most basic and fundamental techniques you can use to show motion in a still image. The idea behind panning is very simple: you use a slow shutter speed and then continuously follow the motion with your camera while taking the photo. Your camera motion and slow exposure create a distinct feeling of movement on a blurred background.

However, since the camera is moving at roughly the same relative speed as the subject, they'll actually be sharp, or in most cases, they'll have a few elements of relative sharpness that contrast with the blurred background.

Your subject doesn't have to be tack sharp for this to work. In fact, slight blur in the subject is not only unavoidable, it usually makes for a more powerful image. You'll often have different levels of blur within the subject itself, depending on how different body parts are moving against the main direction of your camera.

Take a cyclist for example. If you pan with the rider's body, chances are then that their head, back, and hands will be the sharpest elements in the photo, because these parts of the body are moving at the same relative speed and direction as your pan. Again, they don't have to be dead sharp. (Your shutter speed will determine this.)

But what about the cyclist's legs and feet? His upper legs are pumping up and down within a relatively small area at a regular cadence. A slow shutter speed will indeed show blur in the legs, but not nearly as much as will be shown in his feet, which are not only spinning at a much greater speed in relation to the camera, each one is actually moving backwards and against the camera during the back and upstroke on the pedals. These parts of the body will be rendered with much more apparent motion.

It's this contrast of different levels of motion that makes for the most successful panning shots. Varying shutter speeds also determine the overall look of the image; slower speeds show a background with much less "flow," whereas faster shutter speeds might just create a hint of motion in the image

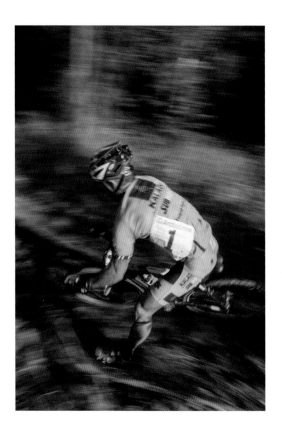

Shot at 1/40 sec. Note how each part of the image varies in sharpness.

Panning is not an exact science, but there are some definite guidelines you can follow. Use too fast a shutter speed and you won't create the feeling of motion, you'll just end up with a slightly blurry background. To the viewer, it will just look like you didn't shoot fast enough. Go too slow and you risk having the entire image be a messy wash.

Lens selection and relative distance also affect the look of your pan. Just as telephoto lenses magnify the image in the viewfinder, they'll also magnify any motion that's going on in your frame. Panning with a 100mm lens at 1/50 sec will give you the same relative blur as using 1/25 on a 50mm lens. You don't need to go as slow with telephoto lenses, and conversely you need to go *even* slower when you're shooting wide angle.

With a 50mm lens, the sweet spot is around 1/8 to 1/30 second if your subject is moving at a moderate clip. With a standard wide angle, I often go 1/4 to 1/8. Again, if they're really flying, you can go a little faster. Also, think about the kind of effect you're going for: e.g., a feeling of slight movement or the impression of a subject that's really cruising through the frame.

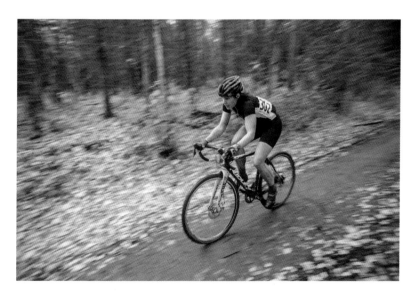

Panning front to back

In addition to the standard side-to-side panning effect, you can also pan front-to-back or back-to-front. This technique is not usually taught in beginning photography books. It's used much less often than the traditional method, but it definitely creates some dramatic effects.

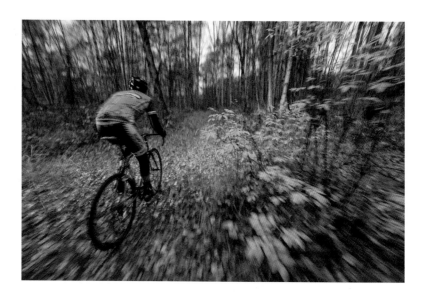

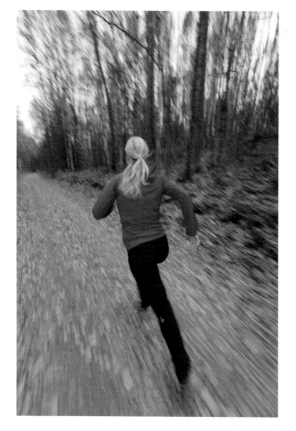

I make heavy use of front-to-back panning in my style of photography, because I feel that it gives the viewer a unique perspective on the subject. Instead of looking at the scene from afar, or off to the side, a front-to-back pan gives them the feeling of being immersed in the scene, at ground level and traveling along with your subjects.

Wide-angle lenses are the preferred glass for this kind of technique. Since they have a broader depth of field, you can fudge the focus more loosely, and they let you impart that right-in-the-middle-of-the-action feel, which is essential for this technique.

Panning from behind is relatively straightforward. You slap on a wide-angle lens, set your desired shutter speed, and then shoot away as you walk, ski, ride, or otherwise propel yourself right behind your subject while they're in motion. This way, your apparent motion moves *through* the frame, instead of *across* it. (You can get a similar effect if you attach the camera to a moving object or vehicle.)

When panning this way, you can look through the viewfinder, but I wouldn't recommend it. That can

be a little dangerous, especially when you're walking on a rocky trail or trying to ride a bike. I won't be held responsible for any damage you do to yourself or your camera if you go stumbling head first while panning, so please be careful and look where you're going.

Usually when doing this technique, I'm shooting from the hip so that I can pay attention to my surroundings. This is one area where mirrorless cameras rock, since they have high quality LCD screens on the back. Tilt screens are even better, because they make it easy to hold the camera at low angles and still see what you're shooting.

As we saw in the vantage point section, shooting from lower angles can get you some very dynamic results, because we typically don't view the world from six inches to one foot above the ground. By the same token, if you can somehow get your camera up into a high vantage point, your front-to-back panning will take on an even more dynamic look.

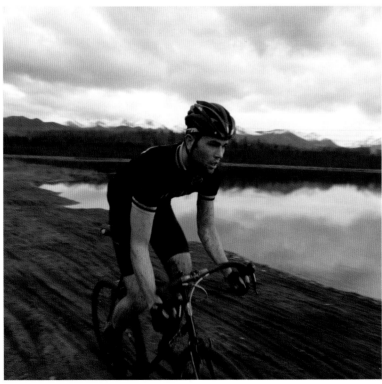

Sharp vs. blur

Contrasting sharpness and blur within the image

In many ways, the concept of focus is the single most important aspect of image making.

Think about it.

We FOCUS on our subject with a LENS and use an aperture that gives us a certain DEPTH of FIELD, which may or may not give us a SOFT BACKGROUND, and then we set a shutter speed that will either FREEZE or BLUR the image.

We're often impressed when our subjects are TACK SHARP against a field of beautiful BOKEH. When we edit, we quickly delete images that are FUZZY or OUT of FOCUS, choosing only the SHARPEST selects for output, posting, or delivery to the client. Landscape photographers strive to create images that are SHARP from front to back, while portrait and closeup photographers go for a SHALLOW FOCUS look with their imagery.

See what I mean? Focus is everything in photography, or close to it.

Focus

When we look at a photograph, our eyes tend to lock onto whatever part of the image is rendered with clear, crisp focus. Whether it's cultural training or instinct, we're conditioned to deduce that the sharpest thing in an image is the main subject. Naturally, we're drawn to this area of the image like it's some kind of visual bullseye. In most cases, this part of the photo not only introduces us to the subject, it provides us with the starting point for our eyes.

After we lock onto that point of sharp focus, we will start to explore the rest of the image and follow the lines, shapes, and colors that the photographer has laid out for us. However, no matter how far we stray, we'll always and inherently be drawn back to that point of sharp focus.

There are a number of ways that you can use focus in your photography in order to increase the impact of your images. As with any technique, how you use focus largely depends on how you want to present the subject matter to your audience.

When shooting landscapes, we're usually taught to use wide apertures and hyperfocal distance in order to achieve maximum edge-to-edge sharpness from front to back. This technique works so well with grand vistas that are shot with wide-angle lenses. By using a tripod and stopping the lens down, you're able to create images where everything is sharp.

Create visual pathways through focus. Our eyes lock onto the point of crisp, sharp focus of the biker's front, then drop down to the trail where they flow back to the other cyclist in the background.

These types of images can be very compelling, but since there is no single point of sharpness, you must rely on other compositional techniques in order to bring in the viewer's eye and lead it around the frame. Effective use of lines and color, as well as subject placement, can dictate the likely path a viewer might take when they explore the different areas of your image.

A wide depth of field can be used to great advantage in other areas of photography as well. It's a very useful technique for shooting from the hip

or from different vantage points, or when you just don't have time or accuracy to nail exact focus.

However, if you only shoot images with a wide depth of field, you're missing out on one of the most creative possibilities that photography offers, selective focus, or in other words, a shallow depth of field.

Selective focus

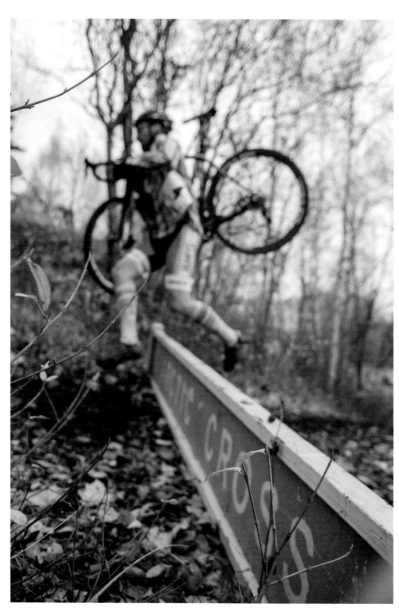

Using selective focus is a great way to alter the mood of your imagery. Once you break out of the subject-in-focus box, you open up a wide variety of creative options.

Even though camera lenses behave much like your eye, we humans don't usually perceive the world with selective-focus vision. When we're looking at an object, we're usually too focused on the thing itself to notice the depth field that our eyes are giving us at any given time. And even if we do stop and pay attention, it just doesn't look the same as it does in a photograph. (You just did this with your finger in front of your eyes, right? If you didn't, go right ahead . . . I'll wait.)

Using a shallow depth of field allows you to isolate your subjects in sharp focus against a soft background of out-of-focus elements. That blurred background acts as a frame in which to place your subjects instead of just hanging them out there in space, and it can give the image a sense of place and context within the frame. By using selective focus, you can build a picture that actually tells a story instead of just featuring the subject matter.

Focusing with a shallow depth of field on the climber's hand brings us right into the excitement of the image. Her face becomes less important than the immediate task at hand, which mirrors her own experience in the moment.

What if, instead of focusing on the athlete, we focus on a completely different element in the frame? The feel of the photo changes, but the story remains the same.

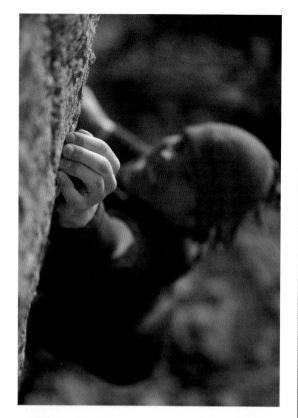

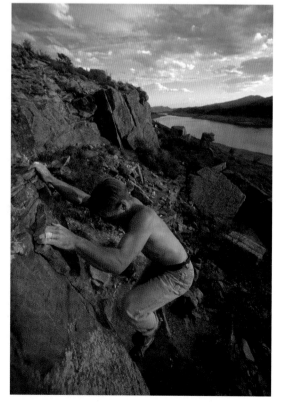

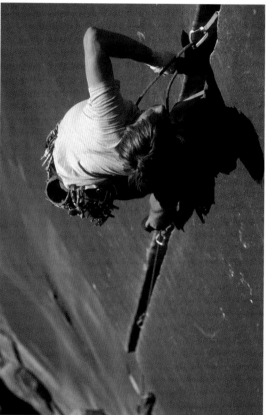

Focus doesn't always have to be saved for the main subject. By using selective focus, you can tell the same story with a different twist.

The three images on the facing page have similar views and vantage points, but by using different focusing techniques, we can create three very different looks.

The amount of depth you create in your image is partly up to you, but it's also determined by your lens choice and how close you are to your subject. The longer your lens and the closer you are, the more shallow your field of focus will be. Conversely, if you put on a wide-angle lens and/or back up, your depth of field will increase, even if you open the aperture on your lens all the way.

Selective focus and shallow depth of field work great for portraits (you always* want to focus on the subject's eyes), but it also works well for sports, wildlife, and even landscapes, where you can isolate individual subject elements.

*Remember, when I say "always" I mean "most of the time," because rules are meant to be broken. Besides, we're artists. We don't follow rules.**

**Sometimes we do. But only when it serves the purpose of creating a great image.

Regardless of what kind of focus technique you use, your goal is to build relationships between the different subject elements in your frame and tell the story of your subject matter as it exists within the environment of your image.

Sometimes the autofocus locks onto big snowflakes instead of the subject. It's not something that you can always control, but I love when this happens; it imparts a really cool feel to the image.

Your viewer's eyes don't have to go there first, but if your subject isn't the sharpest thing in the frame, you've got to set it up so that their eyes go there second. You don't want to let your viewer loose in the frame and have them wandering around, searching for the main subject. It's got to be apparent on the first or second glance. Either their eyes go right to your main subject, or the first thing they notice leads them right to it.

Showing people

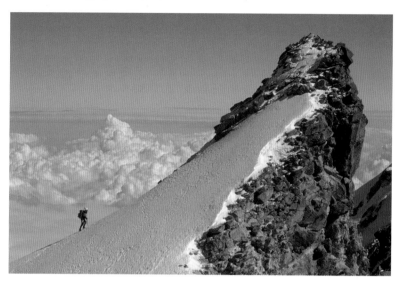

Adventure photography is about telling stories of struggle, challenge, determination, exploration, inspiration, courageous endeavors, and epic journeys. In other words, it's not so much about the place as it is the people. Your job is to make your viewers relive those magnificent journeys and imagine what it must be like to brave such fierce challenges.

Our universal fascination with this type of imagery stems from the connections we draw with the subject matter, often because we're inspired to see those place with our own eyes, or because we could never imagine struggling through such harsh conditions ourselves. Perhaps the story gives us a familiar view of a summit we once stood on with our own two feet.

In any case, the allure of adventure photography revolves around the notion that we're all explorers at heart. The human story is rooted in adventure, and regardless of how far we're willing to push our own physical limits in the outdoors, most of us share a common excitement for active discovery. We all desire to take part in grand expeditions, even if it's from the armchair.

While dramatic photos of mountains and far-away lands can certainly ignite those fires of adventure in our souls, it's the photos of people that speak to us most. Those are the ones that hold the strongest connections and bring us most deeply into the scene. Those are the ones that most effectively communicate those concepts I described above.

There are an unending number of ways to show people in the world, but here are the two most common techniques that I use in my photography.

Middle of the action

Want to knock your viewer's socks off? Hit them with hardcore, in-your-face action photography. Immerse them in the scene with you. Drop them right alongside your athletes and let them feel the burn, taste the fear, and share in all the fun, just as if they were there too.

Nothing creates more mind-blowing, jaw-dropping excitement and tension in an image then letting the viewer feel like they're right there in the middle of the action. If you do it right, they won't just see the image, they'll hear it too. I do anyway, and sometimes it's deafening.

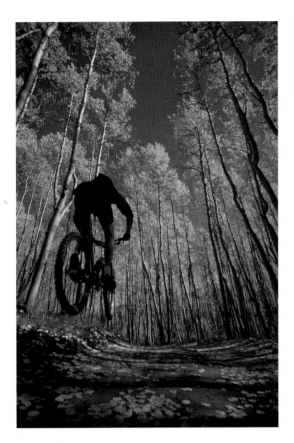

I love shooting this way, because it gives the most raw, intense point of view. I can show the grit, the grime, the sweat, the rain pattering on helmets, the dust being kicked up on the trail, and the mud flying out from under the tires.

In this style, I'm almost always shooting with wide-angle lenses. As far as I'm concerned, the wider the better. This gives you a dramatic, in-your-face perspective, because as we saw in Chapter 2, these kinds of lenses not only have a spacious viewpoint, they have a broad depth of field, and they blow out perspective in ways that your eyes cannot see. Inherently, they impart a very characteristic look to your imagery.

My Nikon 24mm lens is probably the most used lens for shooting in this style. In fact, if I leave the house with my Nikon, my 24mm always goes with me. I also have a Nikon 14mm. Although it lets me get even closer to my subjects, it's a much heavier lens, so I don't always take it into the backcountry. With my Fuji X cameras, my favorite wide angle is the XF

Shot with the old standby—the Nikon 24mm f/2.8

14mm, which equates to a 21mm angle of view when compared to standard 35mm.

My technique for this style is simple: I put the camera on autofocus and jump right into the scene. I try to get as close as possible, while looking for specific details that I can hone in on that help to anchor the image. Oftentimes I'll accentuate the foreground, which might be a climber's hand, an ice axe, or a pronounced looking rock.

This is where good vantage points really count. Scouting and finding the best location can be the most crucial aspect to this kind of photography. Work hard and put your camera into the least likely place that it would normally be. The more wild and out-of-the-way your vantage point is, the more you'll pique your viewer's interest.

When I'm shooting climbing, I'll use ropes and rig myself up on the wall right above or next to my subjects, which is somewhere the viewer would NEVER be, unless they've actually been on that particular climb.

Similar to the front-to-back panning technique I discussed earlier, I often like to get right behind or in front of my subjects and follow their own motion with the wide-angle lens. This means firing short bursts while running backwards if I'm following them from the front.

Don't try this unless you're willing to lose control and go crashing to the ground. You're almost guaranteed to trip over something while doing this, but it's easily worth ending up in the dirt if you get a great shot. It happens to me all the time. Just remember to save the camera.

As with panning front to back, it's pretty hard to look through the viewfinder while following like this, so when I do this, I'm often shooting from the hip. I'm holding the camera with one or both hands away from my body and just pointing it towards the subject with blind aim. You can get away with this when using wide-angle lenses, especially if you stop down, use autofocus, and burn lots of frames.

This is where mirrorless cameras have an advantage because you can shoot at arms length while keeping an eye on the nice, clear LCD panel. With a DSLR, you can try shooting in Live View. I never do, though, I just do sweeps with the camera on continuous shooting mode.

You can apply this first-person shooting technique to just about any kind of subject matter. Try it with a variety of subject matter and see what you come up with.

Little person in the big world

Another approach to photographing people is what I call the "little person in the big world" technique. This is where you back up and tell the story of how they interact with the greater scene. By including a small human element within a powerful landscape, you create a photo that visually connects us to nature. It has much more depth than a simple landscape and it creates a powerful visual target that draws your viewer in and immediately connects them with the scene.

I love making photos like this because I love shooting landscapes. However, it's pretty tough to make a living as a straight landscape photographer. Add that little person in the frame, though, and you add tremendous marketing potential to your imagery.

From this standpoint, unless it's a really spectacular scene, I tend to look at shooting landscapes more as fun than as work. While I do license the occasional landscape image, I'm always looking for ways to include people in my nature scenes. This makes them way more usable as stock, and great additions to the portfolio. Sometime if there's nobody around, I'll jump into the scene myself.

When shooting photos like this, your primary concern is nailing the landscape. Strive for a unique and compelling composition and wait for truly magical light. Surf around on www.500px.com to see the caliber of modern landscapes. That's how good you want your scenes to be. If you

can shoot photos like that and include people, you'll have a winning combination.

In this kind of image, the location is what grabs your viewer, so it's got to be as powerful as you can make it. A good approach is to pretend there's no person in there. Shoot like you're trying to make a Sierra Club calendar image, because if you don't have a dramatic background, the image won't hold up.

Even while you gauge the landscape, try to plan out in advance where you'll put your person. Look for other elements in the scene to give you an obvious starting point, like a trail or the fall line of a ski slope. You might have a number of options of where to place the person along that path, so narrow it down to a specific location within that line by using the Golden Ratio or the Rule of Thirds, or else balance them against another element in the frame.

Vary the size of the person in the scene. They don't always have to be tiny, but if you have an exceptional background or superb light, don't make them too big or you'll take away from the natural setting. Remember, with this type of image, it's more about the feel of the setting rather than emotion and grit.

The key is to create a balanced image that *seems* unbalanced. You want your viewer's eye to keep tracking around the frame and exploring all of the different elements you've placed in there. As I pointed out earlier, if you make it too easy for them, your viewer will quickly grow bored and move on.

Adding a little person in the big world brings dynamic human interest and life to an already powerful landscape.

Mountain bike touring in Denali National Park, Alaska. Little person in a very big world. Nikon 24mm f/2.8.

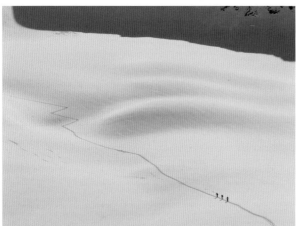

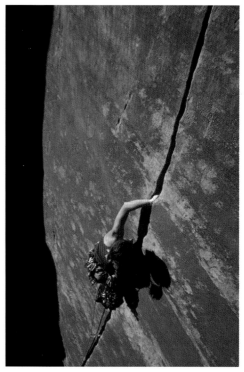

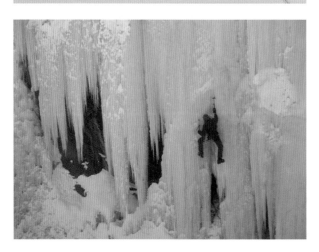

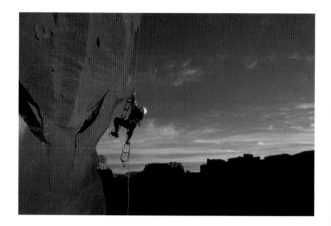

Portraits

Compelling portraits are a great way to tell the story of adventure. After all, it's the people who are out there pushing the limits of their skills and endurance, battling their fears, braving the elements, carving that last turn, craning their necks to keep a careful eye on their partner above, and exerting every last ounce of energy to pull the final move over the lip.

Maybe they're simply reveling in the wonders and excitement of being outside in a beautiful place. You know: having fun. In the end, they're just people, like you and me. Sure, some of them are pretty extraordinary folks, but they're still made of flesh, blood, and emotions. If you don't see an enormous blank canvas of opportunity with that concept, then pay close attention.

People ALWAYS make for good subject matter, and if you do it right, adventure photos of people have the power to wow your viewers even more than dramatic, in-your-face action. People relate to other people, and showing the inner human side of adventure can make it all seem that much more amazing.

A good portrait drags the viewer right out of his or her comfort zone and forces them into a face-to-face confrontation with their own imagination, fears, and excitement. Whether it's intense suffering, careful introspection,

Shooting portraits from a slightly low angle gives you the "Hero Look."

or the elation of personal success, if you capture the right moment, your viewer will have no choice but to be drawn into the shot.

Shooting portraits while the adventure is happening will certainly test your skills, but they payoff can be huge. Expect lots of bad frames, especially in the beginning. Know that it's worth trying over and over again, because if you get that one great image, then you've done your job.

What's the ideal lens for shooting portraits? As far as I'm concerned any lens is a good portrait lens. The wide ones let you get in close and still show a lot of the environment around your subject. This helps you create a broad narrative of your scene.

The medium ones have a nice shallow depth of field, which helps make your subject stand out better. They're not so narrow that you can't also include some secondary elements when you back up a little bit.

With the long ones, you can zoom right in and paint your subject against a soft out-of-focus background. This makes them pop, and anything else you add to the frame will sit there silently and obediently lead the viewer's eye towards your main subject.

Here are some techniques that I often use when shooting portraits in the outdoors.

1　**Watch for the moments**: No, better yet, anticipate the moments. This is where it counts, because a good portrait is all about expression, and expression is all about moment. If you can predict when those moments might happen, you'll be able to get yourself into position to grab them just as they occur.

2　**Use continuous high**: Motor drives aren't just for action. With fast, continuous shooting, you can capture those slight expression changes that usually happen in between shutter cycles. You never know, one of them might be the one! Depending on the scene, you might get it by watching, timing, and then snapping off a single shot at just the right moment. Either way, timing is everything.

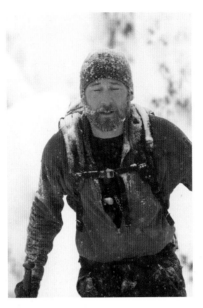

3 **Change it up**: People pictures don't have to be straight, "eyes on you" head-and-shoulders shots. Vary your angles. Shoot loose. Shoot tight. Shoot really tight. Shoot from the side. Shoot all the expressions. Shoot wide. Shoot long. Shoot medium. Shoot low and get the hero shot. Be serious. Ham it up. Freeze the moment. Interact with your subject and create a moment.

4 **Nail the focus**: In most cases, it's got to be on the eyes, unless you're backing up and featuring something else in the foreground that leads up to your person. As I said earlier, it's OK to drop your main subject out of focus but you'll need to make it up by creating a workable visual pathway back up to them. If your subject is moving and hard to keep track of, consider using Face Detection mode. It's not just for family portraits.

I shot this with the Fuji X20, using the screen of a laptop for additional lighting and catchlight in the eyes.

Landscapes

Despite everything I just said about the increased marketability of people shots, let's not forget that what usually draws us to our adventures is the landscape itself. I don't know about you, but I lie in bed at night dreaming of long alpine ridges, perfect hand-sized granite cracks, desert towers, broad tundra valleys, open chutes filled with fresh powder, and endless trails that zigzag up and down mountain slopes and disappear over the horizon; you know, the places where we go to forget about mundane life and let our true selves flourish.

Landscape imagery is synonymous with the idea of adventure. It's always been that way, ever since people first roamed with cameras, sketchbooks, and portable painting kits. Landscapes ignite our imagination, and they make us yearn to explore and see what's around the next bend, over the next pass, and on the other side of the world.

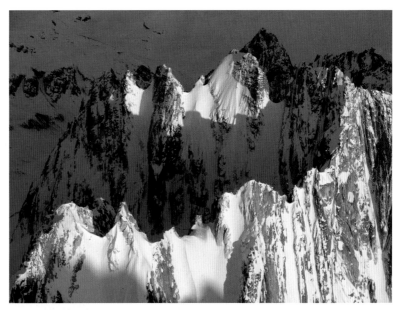

When I look at a powerful landscape photo, say the top of a granite spire that's poking up through the clouds and turning pink from sunset, my mind makes up its own soundtrack for the scene. I hear wind. I hear music. I hear the fleeting tones of nature and the rush of excitement, whatever that sounds like. A great landscape has the power to kick my mind into overdrive and transport me out from behind my desk and away from my comfy office chair. Is it the same for you?

Many of us first discovered our love for photography by shooting landscapes. That's how we honed our skills, so I would never advocate giving it up. Even though people photos will usually earn you more money, this doesn't mean that once you turn pro or aspire to be a pro you shouldn't concentrate on shooting landscapes. Quite the opposite. Shoot to your heart's content. Chase light over the mountains. Stay up late. Miss dinner. Head out there all by yourself. Spend as much time as you possibly can photographing the natural world. Even if you never sell one of those images, it won't be time wasted.

I won't pretend that this is an authoritative guide to shooting landscapes. These are only some of my ideas and approaches. There are countless

books and eBooks by experts like Galen Rowell, Ansel Adams, Ian Plant, David duChemin, William Neill, and many others that you could read forever, but here are a few pointers and ideas to get you started.

Location

Location is everything. Obviously, the more stunning the place, the more stunning your photos can be. With that in mind, the best thing you can do to make great landscapes is to put yourself into the magical places of the world. Make the effort. Don't spend all your money on gear, save some for gas and plane tickets because there is no substitute to actually being there.

This doesn't mean you can't take great photos close to home. Sometimes we get so fixated on our dreams of distant lands that we forget what's in our own backyard. It's true that some of us have more dramatic backyards than others, but there's beauty to be found everywhere: you just have to walk out your door and go look for it.

Shooting landscapes will make you better at shooting adventure. Sometimes we get so caught up in the action part that we forget about the place, which is what often sets the tone for the image. Landscape photography is also a great process for scouting locations. Go back through some of your favorite landscape photos and imagine where you'd stick people in them.

It's easy to imagine where a runner or cyclist would go in this scene. Do this exercise for more of your landscapes.

Light is everything

Did I say location is everything? I meant to say that light is everything. As we saw earlier in this section of the book, good light always makes any subject look better. There's a reason they call it magic hour. Not only does the color of the light matter, there's an element of work and dedication here as well. It takes forethought and commitment to chase the light. That alone will make your pictures better.

If you're hunkered next to your tripod in a great vantage point while waiting for the light, you've got two things going for you. First, you made the effort,

and second, you either have a long walk back in the dark or a night out in your tent, which means you'll have lots of time to think and reflect on what just happened. Thinking is learning. Taking the time to mentally process your methods and experiences will make you better at everything.

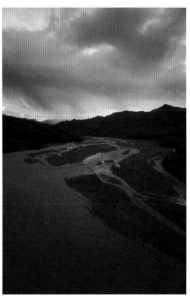

Foreground

The best landscapes portray simplicity in their subject matter. Usually, this means focusing on one important element in the scene, which is often your foreground. Better yet, focus on the relationship between two or three different elements. Even though you'll often want to focus on the main subject, give it room to breathe so that it doesn't lose the sense of place. The key is to accentuate the subject, whether through effective use of your lenses or through placement of the subject in the frame. Use other elements in the photo to draw your viewer's eye around the picture.

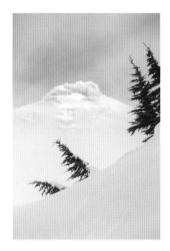

Convergence

Some of the most dynamic settings happen in the places in the world where elements converge: where sky meets earth, land meets water, warm meets cool, or different types of terrain come together. These locations offer excellent possibilities for creating images that show relationships in nature, because they give you multiple elements that play off of each other within the scene.

Examples of this can be reflections of colorful clouds in a pond, a rushing stream next to the still grasses on the bank, the warmly lit ridge of a mountain range jutting up into the cool sky or where brilliantly colored clouds meet the shadowed horizon.

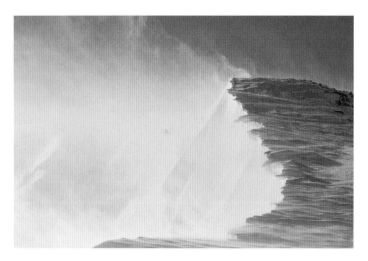

Thinking outside the box

Photography as an art form reflects the ideas and methods of the creator. In the end, there are no rules, only guidelines, and experimenting with original approaches and non-traditional techniques will push the boundaries of your creativity and allow you to come up with a unique style of imagery.

Here are a couple of the approaches that I apply with my own photography.

Being in shape

Adventure photographers must be in good shape. This is pretty much a prerequisite for the job. Not only do you need to keep up with your athletic partners and models during extended hours over varying terrain, while lugging the extra gear, you'll often want to sprint ahead to set up when you spot a good vantage point off in the distance.

In short, adventure photography is about putting yourself in the best locations in the best moments. If you're in great shape, you'll be get to more places faster.

Experiment with your equipment

Camera gear isn't exclusive in how it's supposed to be used. Forget "supposed to." Want to break out of a rut? Grab that lens you never use and leave the old standby at home. Bring flash to situations where you wouldn't normally think of using it, or where it's highly impractical. Impractical conditions necessitate new creative solutions.

Shot with an 80mm Lensbaby. Manual focus and manual exposure means working harder but it also means getting unique results.

Renting new gear is a great way to break out of a creative rut and give your photos a fresh look without overdoing it. I shot this with a rented 45mm Nikon tilt shift lens.

To create this image, I lugged a battery-powered strobe and 36-inch soft box out onto the trials when it was about 10°F.

Telling the story

When I critique student images in my photo workshops, I often see pictures that have great potential, but that don't quite knock it out of the park. There are usually two main reasons why a photo falls short.

The tendency for many novice photographers is to either focus too much on a singular piece of subject matter without giving it compelling narrative, or else they bog the image down with an overabundance of information. Either the photo fails because it doesn't say enough or because it tries to say too much.

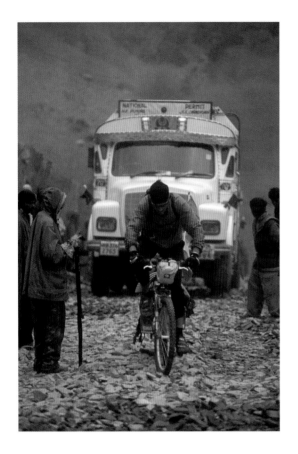

Relationships

You create narrative in your images by adding additional subject elements to your composition. These secondary elements build context and define the relationship between your subjects and the rest of the world outside the frame. Without these relationships, you just have a picture of a thing, and that's not a photograph, that's just a snapshot.

The elements you include in your composition reflect your own creativity and how you see the world. Sometimes these secondary elements might be highly conceptual or symbolic, oftentimes they're the things that make up your background. It could just be the way the light, shadow, or fog accentuates or highlights your main subject.

These relationships tell the story of the greater scene and answer questions such as *where*, *why*, and *how*. They give the photo a sense of place and build the elements of mystery and forceful impact that a powerful photograph carries. They give your photo flavor. Without flavor, you have bland, and when it comes to photography, no one wants to look at bland.

A compelling photograph is like a hit song. They both tell a story in a very simple yet effective way. They both get you in the door quickly, build interest and intrigue by exploring contrasting tempos, lyrical content, instrumentation, foreground elements, backgrounds, focus, color, tone, etc . . . and then get you out before things get old.

The trick is packing just enough information into the piece to engage the imagination of your audience and then leave them wanting more when it's over. With a song, you want them humming or singing the chorus long after the song is over. With an image, you want them to remember and think about the visual story that they've just seen.

Simplicity and perfection

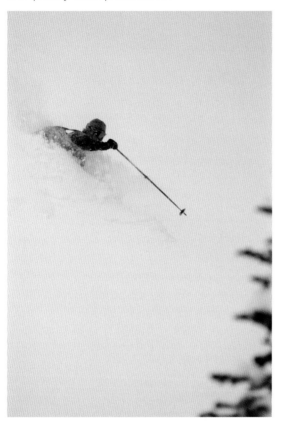 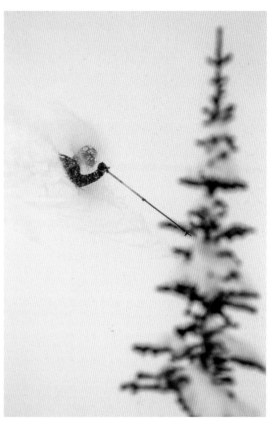

Although these photos were taken less than one second apart, the second shot has the right amount of relationship and moment to make it stand out as a more powerful image.

The strongest images not only capture our attention in the moment, they embed themselves in our minds and are remembered long after the initial viewing. They don't distract or overwhelm the viewer with too much information and they don't try to say too much. They're simple. They follow that time-tested rule of *less is more*.

As a photographer, you have complete power over what goes into your frame. Think of the viewfinder as your canvas. You have final say about what goes into it and what stays out of it, and this is usually the more important decision. Compose your shot so it contains only the most important subject matter, and then include one or two other elements that help flesh out the story of the main subject.

After you've established what the picture is about, think about what it's NOT about and remove any distracting or unnecessary elements from the frame by zooming in, waiting for few seconds, minutes, or hours, or by simply moving to a new vantage point. You should aim for a scene where every single element in the frame is related in some way. Each element should either complement or contrast the others. If it doesn't do either, get rid of it. Be ruthless. Edit before you take the shot. I guarantee, it will save you lots of time later.

After you've narrowed down your scene into one important visual element and one or two relating elements, ask yourself the following question:

"What's the picture about?"
More than any single piece of gear or technique, this simple question is your most effective tool in the image creation process. If the answer isn't immediately apparent, you run the risk of making boring, cluttered, distracting pictures where nothing interesting stands out in the frame. If your viewer can't immediately determine what they're supposed to be looking at, they'll quickly move on and will remember very little about your photo as soon as it passes their eyes.

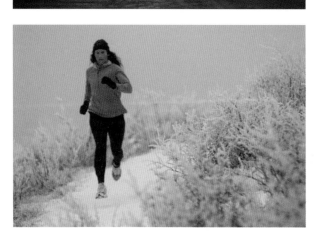

What's the picture about? This question helps dictate the story or the narrative on which your image is built. It provides essential information about what's going on within your frame and defines the relationships between all the elements that make up your photo. It doesn't need to reveal the entire story, and in fact, it should leave enough room for the viewer's imagination to run amok. Remember, your goal is to evoke an emotional response from your photo, not to give them everything.

What's the picture about? ensures that your photo has legs to stand on and room to breathe. It makes the images strong enough to throw a punch and nimble enough to dodge the unnecessary clutter that overwhelms lesser pictures.

If you're unsure about what should or should not go into the frame, you should ask yourself this all-important question, because if you don't know what the picture is about, then your viewer won't know either and that's a very bad thing.

Be deliberate

The best adventure imagery combines explosive action with bare-bones simplicity. When composing your shots, you should strive for the perfect balance of mood, relationship, and moment. You should be deliberate about the entire process and, above all, remember that good photographs do not simply happen. They're crafted with a solid infusion of technique, creative vision, and the ability to anticipate and react to everything that's going on around you, all while being actively engaged in the adventure yourself.

By keeping alert, I recognized the much more powerful moment when it unfolded.

Show the rest of the story

Don't forget to show elements that illustrate the environment, mood, location, details, and people surrounding your adventures. It doesn't always have to be about the hardcore action, sometimes it's about the downtime.

Alter your presentation

Think of new and non-traditional ways to present your work. Whether it's for display, selling prints, or self-promotion, a little creativity after the photo has already been taken can go a long way. I like to create diptychs that show the close and far views of my subject matter.

Abbreviate your subject

I've long been fascinated by sketching. In my mind, it's one of the simplest art forms there is. Pencil, paper, a few lines, some scribbles, maybe a bit of shading and you're done. You don't need very much detail: in fact, the less you show with a sketch, the better it tends to look.

One of my favorite travel books is a collection of short stories called *The Back of Beyond*, by David Yeadon. Each of the tales is illustrated with a single pencil drawing, and despite the simplicity of Yeadon's style, his sketches do an amazing job of bringing you into his world.

Whenever I visit local art galleries I'm often intrigued far more by the drawings and paintings than by the photographs. I used to wonder why this is. As a pro photographer, am I just too jaded by commercial work to appreciate "art" photos? Am I too elitist to be able to admire simple pictures of the natural world?

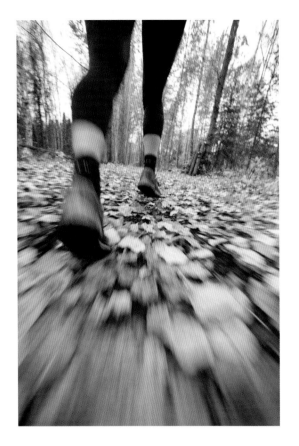

No, that's not it. What defines the issue for me is the fact that as photographers, we often struggle with the concept of creating vs. capturing. Photographs vs. pictures. Art vs. real life.

Art is not about *reproducing* your subject, it's about *representing* your subject. It's about abbreviating the scene and presenting a distinct sliver of the world to your audience. Sketch artists and painters are forced to work within this severe creative limitation, because the simple fact is that these mediums will never look exactly like real life.

With the exception of a few realist painters, artists don't set out to replicate real life; they strive to create visual representations of real life, while imparting a specific and unique flavor to their work. Even realists choose parts of the scene to reproduce in such a way that they can impart their own take on the subject matter.

Photographers are not bound by these representational limits. With a camera, we can capture real life and show the world in perfect detail, which is what many beginning photographers tend to do.

However, accuracy alone doesn't cut it. REAL isn't necessarily ART. We see it every single day, and just repeating it all again doesn't move us. What excites us is seeing an abbreviated idea of the world that sparks our imagination, or seeing specific details presented in a way that we might not have noticed as we sped through the scene ourselves.

What moves us about a good photograph is the way that a few subjects interact and relate with each other within a set of small yet very defined borders. We're inspired not by the exactness of a subject, but instead by the way the light plays off of a subject in a way that only a few people ever get to see. Or by a fleeting expression that communicates emotion and drives our hearts.

The most compelling photographs only show part of the subject, which forces our brains to imagine the rest. Throughout this book, I keep stressing the notion that any time you invoke the viewer's imagination, you've gone a long way towards creating a successful image. You can tell the same

story with a wildly cluttered photo that you can with a simple, abbreviated photo. Which one do you think will be more engaging to look at?

Although we can show whatever we want in our imagery, we owe it to our viewers to trim down the fat and show only what's necessary to tell a powerful story. Don't give them the whole meal, give them snacks. Bits and pieces. Details and ideas. Give them the bare bones. A smattering of real life. Play a game with yourself and see how little you can include in your imagery and still get the narrative across. I guarantee, if you incorporate this practice into your photography, you'll begin to create much stronger imagery.

Need a little extra help? Go to the art gallery and study some paintings and drawings. Pay careful attention to how little the good ones show and HOW they show it. Go one step further and pick up a pencil yourself. Try to draw something using as few strokes as possible. Get a feel for how abbreviating a subject will entice your mind to fill in the rest. This helps you see more creatively, and it will make you a better photographer. Besides, sketching is fun, and experimenting with different mediums will stretch your creative muscles.

Remember the idea here is not to *capture*, but to *create*. You'll find that the more you abbreviate, the more your viewers will be drawn to your imagery.

Post production

I'll fix in post.

First and foremost, I'm a photographer, not a computer guy. Don't get me wrong, I know my way around a Mac and consider myself quite adept at programs like Photoshop and Lightroom. However, I would rather spend my time taking pictures than sitting in front of the screen processing them.

My mentality with photography is to get it right the first time and I always strive to create a perfect image in the moment, or as close to it as I can manage. To me, the act of assembling my subject elements in the frame and then nailing the right exposure just as the action is exploding in front of me is an irresistible challenge. It's what drives me, and I'm proud to say that I'm good at it.

That said, I'm not perfect. I blow exposures. I miss the crop. I don't get it exactly right every single time, but let's be fair here, neither does the camera. Sensors have limitations and, besides, they don't really know anything about photography. All they know is ones and zeros. On off. Red, green, blue. That's not an image, that's just data.

Whether it's me or the camera that comes up short, most images need at least a small degree of tweaking in post. I try to make it minimal, usually just a bump in exposure, rescuing the highlights, adding some vibrancy, lightening up the shadows, stuff like that. Each image requires a different set of adjustments, and, of course, each person will have their own ideas about how the final image should look. In the end, your goal is to create a photo that has the most visual impact possible. You want it to pop.

In this section, I'll cover the typical adjustments that I make to my photos. Please note, this is not a comprehensive guide to postprocessing, just a tip sheet to get you started.

The histogram

The histogram is a graph that shows the brightness values of all the pixels in your image. From left to right, it represents the darkest black shadows to the whitest highlights, with the height of the graph showing how much of the image falls at each brightness level.

If any portion of the histogram is pushed all the way to the edge at either end, it means that your image has exceeded the maximum level of brightness that the camera or software can record as discernible detail. In other words, it's been "clipped." Information that's been clipped will show up as a uniform level of white or black, and any detail that's lost can't be recovered, at least in the dark end.

A well-exposed image will produce a histogram that gradually falls off in a smooth curve at both ends. The exact shape of the curve will vary with each image, and it depends on the overall brightness or reflectivity of your subject matter.

When editing images, you use the histogram as your guide. Every adjustment you make will be visibly represented in the graph. Most digital cameras also give you the option to display the histogram as you shoot, which can be a very helpful tool. You should get in the habit of glancing at the histogram when you're taking photos, especially if the lighting changes, as it can serve as an immediate indication as to whether your scenes are over or underexposed. Plus, it's much more accurate than the JPEG preview that you see on the LCD screen.

Basic image editing

Since I use Adobe software, here are the adjustments that are found in Lightroom and Photoshop, in the order I like to apply them, starting with the **Basic** Tab. Most other programs have adjustments that are very similar, even if they're not called the same thing.

White Balance on the camera gives you a ballpark starting point for color temperature, based on the lighting conditions in your scene. Most of the time I trust Auto White Balance to get it right, but there are times when it's not quite there.

For example, images shot in the shade or under overcast skies will have a pronounced blue cast. Since our eyes and brain compensate for this

blue cast in real life, moving the Temperature slider towards a higher value (towards the yellow side) will warm up the image and make the shot look a little more natural. Adjust the slider until you achieve the desired result in the overall warmth or coolness of the image.

Tint controls color casts in the green and magenta realm. I find that the Tint slider is rarely needed for outdoor photography, but I'll use it occasionally to bring out the green in grass and foliage. You'll find that certain photos taken under indoor and fluorescent lighting may require some Tint adjustments.

Exposure

As we saw in the metering section in Chapter 3, digital camera sensors are far more sensitive to bright light than dim light. Since half of the color and brightness data in a digital image is contained in the far right side of the histogram, you'll want to adjust your images so that the histogram spreads out smoothly all the way to the right, but DOES NOT clip over the edge. Whereas with film it was OK to underexpose your images, with digital, if you're not right on, it's much better to overexpose a little but then go under.

With this in mind, let's start in the Tone Panel with **Exposure,** which adjusts the overall exposure or brightness of your image. This is arguably the most critical adjustment, so if you only do one thing to your images, it should be this. It's fairly straightforward, simply move it back and forth until the right side of your histogram falls as close to the edge as possible. This alone will go a long way towards improving the overall quality of your shot.

Contrast is probably my least used adjustment in this panel. It controls overall contrast in the image, with greater effect in the midtones; I find that if I do a good job with Exposure and the other main controls that I'll cover, I rarely need to touch this slider at all. It's there if you need it, though, so experiment as necessary.

Highlights is used to bring back blown-out highlights and whites that have fallen over the right side of the histogram. It's often the first adjustment I make on an image. You'd be surprised at how much bright information you can bring back from a slightly overexposed RAW file. However, if the image is completely overexposed, then no amount of highlight recovery will help.

With some images, only one of the three channels might be clipped, even though the histogram won't always indicate as such. In these cases, the Highlights slider can help bring back some of that "lost" data. To use this adjustment, simply adjust until the histogram shows as little clipping as you can possibly get. I like to use **Exposure** and **Highlights** together, finetuning between the two until you get the best possible results.

Shadows can help you bring out darker details that are lost in the shadows and lower midtones, such as a face in the shade. Again, you'd be surprised at how much shadow information you can rescue from a RAW image,

which is why you should use the JPEG preview on the back of the camera as a guide, not as a critical evaluation of the image.

Be careful with this adjustment, though. As we saw above, there is much less data in the shadows than there is in the brighter areas, and bumping this up too much will quickly lead to distortion and grain that you will easily see in your image.

Blacks controls your darkest tones. It basically does for the left side of your histogram what Exposure and Highlights do for the right. You'll use it one of two ways: either to bring back clipped information from the left edge, or to increase contrast and bring your histogram even further left in the case of low-contrast images.

Once you have rescued your clipped information, how much you adjust is up to you and the type of image you're working on. Most of the time I

like to slide it so that the histogram falls all the way left to get maximum tonal information in my image, but this may not be the best for lower contrast scenes, such as images shot in the fog. Note that any time you're making adjustments, you can hold down the Alt/Option key while you're making changes to see any clipping that you may have in your image. You can also see current clipping by pressing the J key.

Moving on to the Presence Panel, **Clarity** increases edge contrast, but only in the midtones. It's actually a very useful control that adds a subtle depth and dimension to your images by crisping up the edges. I find that adjusting Clarity somewhere between 15 and 40 can really make your photos pop. This slight boost in contrast also makes eyes and eyebrows appear a little sharper and more defined.

Negative Clarity will help soften skin texture in portraits. Sliding Clarity all the way right is a very quick and dirty way to get instant HDR. Sliding it

all the way left gives you soft focus. (See examples below.) Experiment with this adjustment and view at 100 percent until you start to see halo effects around edge detail, then back off a bit. Another trick with skin tones is to blend a little bit of positive and negative Clarity.

One trick with portraits is to give the overall image a bit of negative clarity to soften the skin, then paint in some positive clarity over the eyes and mouth using Lightroom's Adjustment Brush. This gives an overall look of smooth skin with added sharpness where you want it.

Saturation modifies the overall color intensity of the image by saturating all colors equally. **Vibrance**, on the other hand, also increases saturation, but only on colors that are already less saturated. This reduces the potential for clipping and also prevents skin tones from becoming oversaturated. Using a combination of these two adjustments can really make your images pop and give them that Velvia look, especially when you add in some Clarity.

Clean and straight

No matter how good your color corrections are, you don't have a great image unless it's clean and straight. You could be the world's best color and tone guru and a true master of the histogram, but if your photo has dust on it, or if the horizon is slightly skewed, then it just looks sloppy. Fortunately, most imaging software comes with the tools to fix these small imperfections.

You should always be diligent about keeping a clean camera, but the truth is, if you shoot outside, and especially if you use interchangeable lenses, sooner or later you'll get dust on the sensor. You'll see the worst dust when using wide-angle lenses and when shooting large areas of dark blue sky at small apertures. Fortunately, you can get rid of these nasty little dust spots in post by using the **Spot Removal** tool.

Even with tripods and electronic grids in our viewfinders, we all occasionally shoot photos with slightly tilted horizons. You can use the **Straighten** tools to fix this and make your photos perfectly level. You'll notice that straightening the image automatically crops it by default. Sometimes you'll find that using the **Crop** tool to tighten up the image even more will help give it more power. (Left).

Remember, any changes that you apply to an image in your RAW conversion software program don't affect the actual file, they're saved as metadata in the sidecar .xmp file that's attached to your RAW image and are applied the next time you open the file, providing you do not delete the .xmp. This is probably the BIGGEST TIME SAVER in digital photography.

In depth with color and tone

With all the possible variables in lighting and color, sometimes the basic corrections aren't quite enough to give the image its best look. Learning how to recognize when you need to make additional adjustments will help increase your efficiency and improve your output. I haven't included all of the panels, just the ones I use most frequently.

Now that we've covered all the adjustments in the Camera RAW **Basic** tab, let's move on to the **Tone Curve** tab. Adjusting tone curves can be intimidating, even for those who consider themselves Photoshop adept. Fortunately, ACR gives us two easy workarounds. The **Parametric Curve** tab gives you the option to make simple yet effective adjustments with four sliders—Highlights, Lights, Darks and Shadows—and three region

points below the histogram that allow you to expand or contract the effective range of each slider.

You won't want to make the drastic changes here that you might in the Basic exposure palette (you'll definitely destroy the image if you do), but that's not what tone curve adjustments are for anyway. This tool will help you refine the tonal range of your image by adding or reducing a little bit of contrast or bringing certain parts of the image into a more workable range for printing.

Both tools work extremely well and you'll find that using this panel is a great way to bring up those shadowed skin tones a little bit more without degrading the image too much, or to give the image just a little bit more 'pop' by adding subtle contrast. If you find yourself making drastic moves here, it means your exposure was too far off. Getting it right in-camera will save you time later.

The **Point Curve** tab lets you increase contrast with two different presets— Medium and Strong—and it also gives you the option to plot individual points along the curve and adjust as you see fit. If you're comfortable with using curves in Photoshop, go ahead and make some of your curves adjustments here. The same guidelines for making subtle, not drastic changes apply here as well.

HSL

Next we come to the **HSL** tab, which stands for **Hue, Saturation,** and **Luminance**. You'll find this to be a very useful palette, especially when photographing people. Due to a number of factors, color isn't always rendered accurately by the sensor or your RAW conversion software. You'll see this most often with red, magenta, and purple, occasionally with trees and foliage, and especially with colors that are very bright or saturated.

So where do people fit into this equation? Simple. Their clothing. Shoot enough jackets, backpacks, tents, and outerwear and you'll begin to love the HSL tab. It also comes in handy with dealing with sunset light.

For any color that seems a little off it's best to adjust the **Hue** first to achieve your desired color accuracy, then adjust the **Saturation** and **Luminance** to bring clipping under control to achieve a workable level of contrast. With some scenes, the greens of nature are often rendered more yellow than green. You can use adjust the yellow sliders to bring these colors into line. I often use **Saturation** and **Luminance** in the blue slider to darken blue skies. Don't go overboard here or you won't just increase the blue, you'll increase the noise as well.

You can also use the **HSL** tab to create black-and-white images. Simply click the **Convert to Grayscale** tab and then adjust the sliders as if they were colored filters in the black-and-white darkroom to control tone and contrast. For an even more artistic black-and-white image that has a selective color effect, uncheck the grayscale box, and slide all of the saturation sliders down all the way left. Then bring up one or more colors to add color to one or more elements in the photo while keeping the other elements grayscale. You can adjust the **Hue** and **Luminance** of each color to achieve your desired result.

I won't cover **Split Toning**, since it's not a commonly used tool. It's more of an artistic effect, used to colorize black-and-white images and add retro effects like sepia toning and cross processing. Go to town with this one. Have fun. Or not.

The **Details** palette is where you increase sharpening and noise reduction. These two adjustments can be quite useful, but they work against each other. Moving up the **Luminance** slider will reduce digital noise and grain, but too much will make the images softer. Likewise, sharpen too much and you'll start seeing more noise. You'll need to walk a fine line between these two adjustments.

Again, if you hold down the Alt/Option key as you make these adjustments, you'll be able to see a grayscale preview of only the sharpening/noise effects that you're applying with each tool. This gives you more control because you'll be able to see what's actually going on as you make the changes.

Next is the **Lens Correction** tab. This is where we correct for **Chromatic Aberration**, which sometimes happens when the lens fails to focus all color wavelengths to the same point. These optical errors can occur with all types of lenses, but you'll find that some are worse than others. The visible effect in an image will be a colored halo or fringe around defined edges, which can be perceived as a loss of sharpness. You also have a set of **Defringe** sliders which can help you finetune your Chromatic Aberration adjustments.

You can also correct for (or add) vignetting effects here. Vignetting can sometimes be present if you've used filters on a wide-angle lens or a hood that's too long for the lens. Conversely, slight vignetting can be a nice effect to your image, especially for portraits, since it accentuates the center of the frame. Experiment as needed and you might be surprised at the results.

Finally, we have the **Camera Calibration** tab. I won't go into too much detail here, but if you shoot RAW, this is where you can apply any number of different color profiles to your image. Profiles offer a quick way to adjust to a desired look, and the profiles you'll have available in this menu will vary depending on what camera you use. For example, if you shoot with Fuji X cameras, this is where you can apply any one of their Film simulations to your file. Nikon has their own set of profiles, and so forth.

In practice

As with any skill, getting better at color and tone correction just takes practice. The benefit to shooting RAW is that as you gain more experience, you can always go back and finetune your images.

Be sure and check the histogram as you work, but try to use your eyes and trust what you see as well, providing you use a calibrated display. In the end, it's your eyes that matter most, so if you're going for a certain look and don't care about a few blown-out highlights or lost shadows, then don't worry about clipping the histogram a little bit. Remember, there's no right or wrong. It's YOUR imagery and you have final say.

I don't spend a whole lot of time tweaking every single image. When I find a potential keeper, I flag it in Lightroom and then do a very quick adjustment. Usually, all I do is make sure the temperature is right, then I bring the exposure, highlights, and blacks under control, open up shadow detail a bit, add a touch of clarity and vibrance if necessary, and call it good. I can always go back and refine the image later, but this "quick fix" helps add life to the original RAW file and gives me a good starting point for my keepers.

In these two examples, you can see the exact adjustments I made in order to refine these particular shots.

Lighting

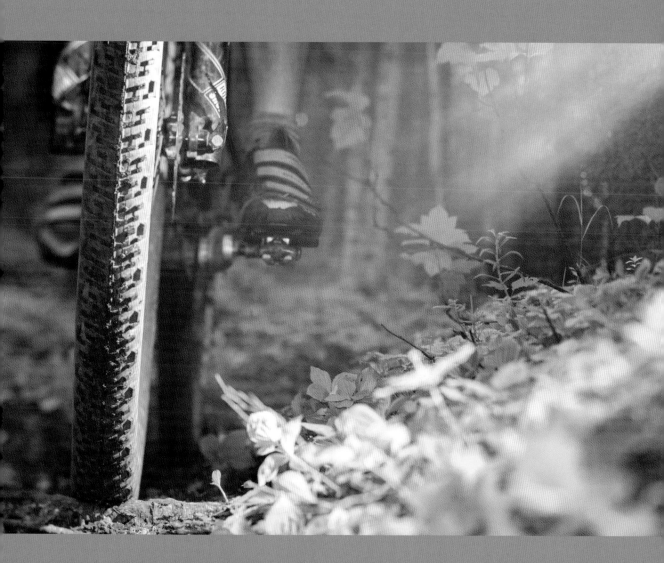

Using flash outside

In this style of photography, you could go your entire life without using any external lighting and still get incredible shots. After all, when we're outside, we've got the best strobe of all: the sun. It gives us bold, beautiful light that's better, more powerful, more consistent, and more reliable than any flash gun. Using flash outside can be problematic. It only has a limited range. It doesn't recycle fast enough for long bursts of action, and when you get it wrong, it looks horrible. Plus, who wants to deal with all that extra gear when you're trying to have adventures?

However, as we all know, the best light outside can also be the most challenging. Let's be honest, the sun isn't always the friendliest light for photographing people. If it's out front it makes them squint, and if it's behind them, it casts their faces in shadow. That's where flash can make a big difference in your imagery. Use it right, and flash allows you to elevate your photos to a whole new level of professionalism and creativity.

Using flash allows you to take a great subject that's lit with challenging light and turn it into a great photograph that's lit with the remarkable light it deserves. It adds depth and allows you to take control during those times when you don't have the luxury of great natural light.

In addition, knowing how to effectively use flash adds a whole new dimension to your style and it enhances your skill level, your creativity, and your marketability as a pro. Even if you end up only using flash 5 to 10 percent of the time, the gear and knowledge will pay off, because it will let you create imagery that you'd never be able to get without it.

Don't get me wrong here. I'm not saying that you have to lug an entire bag full of lighting gear into the field. Quite the contrary. Sometimes all it takes is one well-placed strobe to make or break the shot, and since a flash takes up no more room in your bag than the average-sized zoom lens, there's no reason that you can't take one into the outdoors on a regular basis. You may not need it, but if the right situation arises, you'll be ready.

The key is learning how to put together a small, bare-bones lighting kit that gives you enough control without encumbering you too much. I call this approach "going fast with light."

In this section, I'll lay out a selection of flash equipment and light-modifying tools and show you a few fundamental techniques that can help you get started off using camera flash in the outdoors. I'll show you that good light doesn't have to slow you down.

Small flashes

A good outdoor lighting rig revolves around a selection of handheld flashes and a few lightweight, portable, and durable lighting tools. Whereas there is no limit to how big, heavy, or delicate a studio photographer's equipment can be, in the outdoors weight and durability is everything. If it won't fit in my pack or withstand being dropped into the dirt once in awhile, then it's not a very practical tool for me and I won't use it.

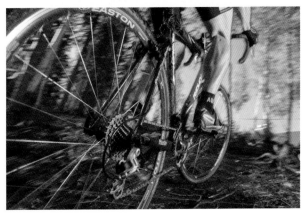

The main ingredient of a small lighting kit is, of course, the flash. Most camera companies offer a selection of handheld flashes that are designed to work with their respective camera systems. The higher end models are more powerful and have a full array of features, including fully rotating/bounce heads and the ability to function as wireless commanders or remote slaves.

There are also a number of third-party-brand flashes from companies like LumoPro, Nissen, and Vivitar that work with any camera system. Many of them operate only as manual flashes, but, as we'll see, this works fine for most off-camera flash work.

Which flash you buy depends on your needs and your budget. I recommend buying at least one high-end, dedicated flash for your camera system because it will give you the most features, light output, and control, especially if you want to shoot fast action or do more complicated lighting setups that involves multiple strobes. If you need more, you can always fill in your kit with some of the lower end or third-party models.

For my Nikons, I have the SB-900 (now the SB-910), which is the flagship model in the line. I also have a few older, discontinued SB-800 units. The more budget-friendly Nikon flash is the SB-700. Don't discount the 700 though; it offers the best of both worlds between the 910 and the 800, and if you're just getting into flash, this is the one I'd recommend. The most basic Nikon flash is the SB-400. It doesn't have any of the fancy features of the higher end lights, but if you need a simple light to fill in small shadows, this one will do the trick.

Canon also has a comparable set of flashes, including the 600EX, 430EX, and the budget 270EX II. Most of the mirrorless camera companies also have dedicated flashes, and while they're usually not quite as advanced as what you get with a DSLR compatible flash, you can still get good results. For my Fuji system, I've got the tiny EF-20. It works pretty well for portraits, but as I explain later in the flash section, I often use my Nikon flashes with my Fuji cameras.

Light-shaping tools

The trick to using flash effectively is to make it look invisible or, at the very least, subtle. Most of the time, you're trying to accentuate your subject, not light them up like they're in a police lineup. To reign in the direct, harsh quality of straight flash and soften the effects of the flash, I often take along a few simple diffusion tools and portable soft boxes. Not unlike the diffusers that most portrait and product photographers use in their studios, these are small enough to fit in most backpacks and you can use them by yourself in the outdoors.

Unlike the studio world, where everything is deliberate and controlled, the outdoors can be quick and chaotic. When you're standing at the top of a peak, sometimes the last thing you want to do is deal with another piece of gear. It does take a little bit more time to use these kinds of devices, but if you learn to be fast and efficient with your lighting gear, you'll find that it's worth the effort.

Small soft box

Soft boxes and diffusers work by spreading the light over a larger surface area; they allow the flash to deliver a more even pattern of illumination,

which lowers contrast and reduces shadows. The basic rule of thumb when using any kind of diffuser is that the larger it is, and the closer you place it to your subject, the softer the light will be.

My favorite small soft box is the Lumiquest Softbox III. It's very easy to use in the field and increases the surface area of the light from a regular flash by 20 times, so it's great for location portraits. When not in use, it folds flat into an 8" x 9" plastic rectangle that slides right into most packs, camera bags, and laptop cases. (I usually keep it stuffed in the outer flap of my Lowepro photo pack.) It's pretty durable, but also relatively inexpensive (around $40), so you don't have to worry too much about beating it up too much. Mine's got a few tears and holes, but it still works fine.

I often use the Softbox III by fixing it to a flash that's attached to my camera with a sync cord. I'll hold the flash off to the side in my left hand and shoot one-handed with a wide to normal lens. This setup is by far my easiest, fastest lighting rig, and I can get it up and running in less than a minute. Maybe two if I'm not in a hurry. Sometimes I attach the flash and Softbox III to a light stand or clamp and trigger it wirelessly.

If I had to recommend only one piece of lighting gear, this would be the one. If I leave the house with a flash, then this goes with me every single time. If I don't use it, it's light enough that I'll forget I even have it with me. Other choices in this area include the Honl Traveller 8 and the affordable 12" soft box made by Fotodiox.

Larger soft boxes

I've also got a couple of medium-sized soft boxes, but since they're a little bigger, I only pack them when I'm sure I'll be shooting flash or if I'm not traveling too far from home. This size still fits in my bigger packs (or straps to the outside) and

The Lumiquest SBIII and makeshift light stand.

The Lumiquest SBIII in action. Photo by Jim Kohl.

Large soft box: Shot with the Photoflex Octodome NXT

does an excellent job of softening up the light, even better than the SBIII. If you're willing to find a way to work them into your outdoor photo shoots, you'll get great results with the larger diffusers.

Keep in mind that the bigger the soft box, the more likely it is to get blown over by the wind if you're using it on a stand. On the plus side, it might cushion the fall so that your $400 flash doesn't slam into the ground. Believe me, I've watched this happen more than once. It's like a crash pad for your speedlight. You can increase stability by filling your pack with rocks and anchoring to the stand.

Photoflex OctoDome

This is my medium-sized soft box of choice. The small 36˝ dome dishes out beautiful light, but it's kind of a specialized item. I use it extensively for assignment work and shooting stock in my local areas, but I almost never take it on my regular adventures. The smaller OctoDome NXT is much more portable. It sets up in about two minutes, and the 18˝ eight-sided dome design wraps the light quite well, especially up close.

The Photoflex OctoDome NXT. A portable, durable, and effective light-shaping tool.

It's essentially a small soft box that longs to be a bigger soft box.

The smaller OctoDome NXT comes complete with all the necessary attachments and the whole kit weighs less than two pounds. If you add a swivel bracket for a light stand, maybe two and a half.

Another excellent choice for a packable small and medium-sized soft box is the Lastolite EzyBox. It comes in a few different sizes—8˝, 15˝, and 24˝ square—and while I haven't used these boxes, I've seen them in action and would highly recommend any of them.

Flash settings

In its basic form, the light from a flash is hardly beautiful. Nor is it subtle. It's harsh, invasive, and can be even more unflattering than having the sun directly overhead. Hit your subject straight on with direct flash at full power and you probably won't like what you see. It's no wonder many outdoor photographers are intimidated by flash, especially since we're used to dealing with the beautifully diverse hues of natural light.

In that way, I like to compare flash to salt. You'd never eat a bowl of salt, but if you use it sparingly, blend it with the other ingredients, and create unique recipes, it becomes a valuable and flavorful item in your kitchen.

Same thing goes with flash. If you learn how to shape and blend it with natural light, you can achieve fantastic results. Before you can do that, though, you need to understand the basic principles of how flash works. Here are the basic settings that are found on most flash units.

Through the Lens Metering (TTL)

In TTL mode, your camera and flash both evaluate the scene and share critical information about the current lighting conditions with each other in order to determine proper camera and flash exposure.

It works like this: as soon as you press the shutter button, your camera tells the flash to send out a nearly imperceptible "pre-flash" that briefly lights up your subject. (This happens faster than you can see.) The camera's exposure meter reads the light that's reflected back from the subject and compares it with the results from its own meter readings of the scene.

Armed with this information, the camera then sends a message back to the flash, telling it exactly how far away the subject is (based on the AF setting) and how much light is needed for a balanced exposure. Then the shutter fires and the flash pops with just the right amount of light. Perfect results every time!

OK, it's not quite perfect, but it's usually in the ballpark. You still need to follow a basic flash workflow and make some specific decisions about how you want your photo to look, but for the most part, modern, dedicated TTL technology makes flash photography a relatively easy process.

Auto (A)

Auto mode lets the flash itself take control of the flash exposure. A sensor on the front of the unit reads the light output and adjusts accordingly. I never use this mode, because the sensor can be fooled by too many factors such as backlighting, light falloff, and exceedingly bright ambient light. In most cases, you're better off going with TTL and letting the flash and camera work together to achieve proper exposure.

Manual (M)

In Manual mode, the flash puts out a fixed amount of light, which you can control on the unit itself or by way of a wireless commander. Power output is set in full-stop increments, i.e. 1/1 (full power), 1/2, 1/4, 1/8 all the way down to 1/128 power. Some flashes let you adjust in 1/3 stops.

When shooting in Manual flash mode, you set the background exposure on your camera (using any exposure mode), put the flash on full power, and shoot a test photo. If it's too bright, you dial down the flash output until it looks right. Once you're there, it's time to shoot for real.

Sync speed

While using flash, this is the fastest shutter speed you can use without running into synchronization problems between the camera shutter and the flash. Sync speed on most cameras is 1/250, although some models vary from 1/160, 1/180, and 1/200. If you try and shoot with shutter speeds faster than your sync speed, the shutter won't be finished opening and closing when the light from the flash is done firing and you'll get uneven light coverage or dark bands on the top or bottom of your photo.

You can always use a slower shutter speed and, in fact, using slow shutter speeds with flash on moving subjects often leads to some interesting effects. Since the actual duration of the flash itself can be well over 1/1000 sec, you'll often get sharp, selectively or ghostly sharp subjects against a blurred background.

High Speed Sync (FP mode)

Some camera and flash combinations allow High Speed Sync mode, which lets you shoot shutter speeds above the standard Sync Speed. Instead of sending out a single burst of light, the flash emits a series of repeating pulses across the entire shutter cycle. The tradeoff is that flash power is reduced.

One way to get this power back is to use a second flash, which gives you an extra full stop of light. This is useful when shooting in extremely bright light outside, when using very long lenses, or if you need to light a subject that's far away. Another benefit of using multiple flashes is that you greatly reduce your recycle times.

Note, however, that in order to double the power, you need to double your number of flashes. So, while going from one flash to two gives you one full stop, in order to gain another full stop, you'd need to go up to four flashes, etc. Pro sports shooter Dave Black has a portable flash rig with eight SB-900s on a stand, which lets him light up subjects that are over a hundred feet away and achieve lightning-fast recycle times. Eight lights sounds like a lot of power, but in reality, though, it only gives him three more stops of light than a single flash would produce.

If your camera or flash has a High Speed Sync mode, I'd recommend leaving it enabled all the time. This way, it will automatically kick in when you need it.

Slow/Rear Sync

Normally, the flash fires when the shutter opens. In Rear Sync, the flash fires at the end of the cycle, right before it closes. This gives a more "realistic" effect when using slower shutter speeds, especially with moving subjects, because it leaves light trails behind the subject instead of in front of the subject. I recommend keeping your cameras set to Slow/Rear Sync all the time.

Master/Remote/Slave

Some flashes can function as a wireless commander, or Master, which lets you control remote flashes with it. In addition, a Master flash can also be set to fire as a regular flash, even if it's controlling other flashes. If you don't want it to add any light into the mix, you can set the Master so that it doesn't put out its own light. Conversely, if you're using a flash as an off-camera slave, then set it to **Remote** or to **Slave** mode.

Using Remote flashes

If you're using your camera's dedicated flash system, you can only have one **Master**, but you can have virtually any number of **Remotes**, or slaves, each of which you assign to one of two or three groups, depending on the capabilities of your camera or Master flash unit. Each group, whether it's a single strobe or fifty, is given a specific operating mode (TTL or M) and a flash exposure value, which determines flash output for every flash in the group.

For example, let's say you designate one remote as your main fill light and another as your secondary fill or key light (explained in the next chapter). You might set your main fill light to be Group A and your secondary light to be Group B. Using the master, you control how much light each flash is adding to your scene. After some experimentation, perhaps you determine that proper exposure requires your A flash to fire at full power and your B flash to fire at, say, 1/16 power. You can control those values from the master flash unit, or from your camera, if it has those capabilities.

If you're using flashes in **Optical Slave** mode, every flash will fire as long as it can see the light from another flash. This is explained more in the next section.

Triggering the Flash

Many beginning photographers think that flash is harsh and unflattering. If you fire the flash from its traditional location on the hot shoe, then yes, it can be extremely unflattering. That's when you get red eyes, ugly contrast, and that horrible "deer in the headlights" look that straight-on flash usually gives.

By contrast, the light from a flash that's directed off-axis from the camera's view will ALWAYS be more dynamic, interesting, and pleasing. Directional light creates shadows, accentuates textures, shapes, and form, and gives the subject a more three-dimensional look. Off-axis flash can greatly enhance the visual appeal of your imagery. For this reason, I almost always use my flashes as off-camera light sources, and so should you. It just looks better.

The main issue with using off-camera flashes is figuring out the best way to trigger them. Here are the six methods that I typically use:

1 Sync cord

This is the easiest, cheapest, and most reliable way to get your flash off-camera. It's pretty much foolproof, unless you cut the cord or break the contacts. You don't have to worry about losing a wireless signal or having communication problems between the camera and the flash, and it doesn't require batteries.

You just plug one end onto the hot shoe, the other end on the flash and fire as normal. As far as the flash is concerned, it's still on the camera and will work with full TTL capability. When you're done using it you just coil it up, stow it away, and forget about it.

The main limitation with sync cords is range, although you can daisy-chain up to three 9 feet cords together and still retain full function. Sync cords work great for handholding the flash, but if you don't have a spare hand, you can always put the flash on a light stand, clamp it to a tree or post, or have an assistant or friend hold it for you.

You should have a sync cord. Period. If you don't have one, get one. They're cheap. Nikon and Canon both offer dedicated cords, and companies like Opteka and OCF Gear offer third-party cords that work with most camera systems, including Fuji, Olympus, Sony, and Pentax.

2 Pop-up flash

Most higher end DSLRs allow you to control remote flashes using the pop-up flash on camera. You have full TTL function with your dedicated flash units, and you can even trigger third-party flashes to fire manually in Optical Slave mode. It works as long as the infrared sensor on the flash can "see" the camera flash.

I use this method all the time with my Nikons, and it works quite well, even outside. It's also an ideal solution for going ultralight. The limitations are distance and line of sight, although I've triggered flashes that are behind me while shooting inside. On most cameras, you can only control up to two groups of flashes, but oftentimes, that's all you need.

This method doesn't work very well for shooting closeups or portraits. The monitor pre-flashes from the pop-up flash are still picked up by the camera,

and they can make your subject blink, or else they show up in your photo. The workaround is to cover the camera flash with your hand or a piece of cardboard so that it triggers the slaves but doesn't light up the subject. Nikon actually makes a small accessory (the SG-31R) that attaches to the camera hot shoe and shields the built-in flash from the front.

If your camera has a pop-up flash that doesn't function as a master, you can still use it to trigger other flashes in optical slave mode (see below).

3 Using another flash as a master

You can also use a regular flash to trigger your remote units. This works just like the previous method, except that you have more control than if you used the pop-up flash. A dedicated unit that can function as a master flash controller allows you to trigger multiple slaves in different groups.

You can also rotate the flash head to point directly to the sensor on your remote flash and zoom your master to get increased range. The obvious disadvantage is that you eat up one of your flashes by using it as a commander. You can still use it as an on-camera flash/commander combo, but as I mentioned above, straight-on flash rarely looks very good, so you're severely limited in the quality of light that you can shine on your subject.

However, you could put your master flash on a sync cord and have it fire an off-camera flash that controls the other off-camera flashes as well. We're already back to the sync cord. See how useful it is?

I like using this method, but it means I have to carry at least two flashes, which adds weight and takes up a little more space in my bag.

4 Wireless commanders

A dedicated wireless commander like the Nikon SU-800 and the Canon ST-E2 will allow you to trigger an unlimited number of remote flashes and control them in up to three separate groups. This solution is considerably less expensive than buying a radio system, and since it's infrared, it solves the blinking problem for close portraits. Also, you don't have to burn one of your flashes by using it as a controller.

Inside, these devices rock. I have the Nikon SU-800 wireless commander and its signal will bounce all over the place; it will even travel around corners. With an infrared commander, you can trigger flashes that are not in the line of sight or that are even in the next room.

Its powers are a little more subdued outside. Since there is nowhere for the signal to bounce, it has to be within sight of all the other units. If your flashes are off axis from your commander, you might have to fix it using a sync cord to a light stand in order to signal to point your commander the right way. In really bright sunlight, you often need to shade the unit with your hand or tape on a piece of cardboard to shield it from the direct sun.

My thought is this: if you shoot off-camera flash inside, or if you shoot macro photography, then it's a no-brainer. Definitely consider the SU-800 or the S2-E2. It will give you excellent versatility at a reasonable price and it's great when photographing people.

However, if you shoot primarily outside, then you should weigh your needs and your budget. You might think about a radio-controlled system instead.

5 Radio triggers

PocketWizards and Radio Poppers offer incredible versatility for off camera flash work, because you have vastly increased range, they transmit signals for hundreds of feet, and you don't need line of sight. They allow you to stick remote flashes just about anywhere.

The downside to radio systems has traditionally been expense. You need a transmitter that goes on the camera and a receiver for each flash unit. However, prices have come down in recent years. I bought my first pair of Pocketwizard Plus radios for $270 each. Today, the Plus III model costs almost half that, and you can pick up the intro model Plus X triggers for only $100.

The main limitation with the basic Pocketwizards is that they only work in manual mode. They do make a series of TTL compatible

The Pocketwizard Plus III is one of the newest generation models of wireless camera/flash triggers.

radios like the Flex and Mini systems that work with Canon and Nikon, but these are much more expensive. I've tried them with great results; but I think for the price, you can't go wrong with the simple Plus series, especially if you're just starting out. Cactus triggers are also a good budget option.

I haven't used any of the RadioPoppers, but I know a number of pros who do. They have the same limitation of only being able to trigger flashes in manual mode, but again, I don't see this as a real problem.

Keep in mind that you can't combine radio triggers with your camera's dedicated wireless TTL systems, because the monitor pre-flashes that your cameras sends out to evaluate the scene will throw off any remote flashes that aren't on the same dedicated network. For example, you can't trigger one flash with Nikon CLS and one with a Pocketwizard. However, you can combine radio systems with flashes that are set to fire in optical slave mode (see below). I do this all the time.

When using radio triggers, your creative boundaries become greatly expanded. Imagine the possibilities. Essentially, you can light multiple subjects and background elements that are very far away from each other or that are hidden from your line of sight.

6 Optical slave mode

Any flash that operates wirelessly can be triggered in what's known as optical slave mode. In fact it's the only way that some of the third-party flashes can be fired when they're off-camera. When set to optical mode, or SU-4 mode in the Nikon world, the flash will fire when it sees the flash of any other lighting unit, even if it's a different brand of light.

The advantage of using optical slaves is that you can cross brands and methods. For example, with this mode, I can trigger my Nikon Speedlights with my Photoflex battery-powered strobe or with my Fuji X camera. I could even trigger a Canon or LumoPro flash with a Pocketwizard on my Fuji which would, in turn, fire a Nikon flash as well as my Photoflex strobe. Theoretically, you could daisy-chain as many flashes as you wanted, providing that each unit can see the light from at least one other flash.

In order for this to work, though, all flashes and strobes would need to be in manual mode. This means you'd have to go over and change the output setting on each and every flash if you wanted to change your lighting.

Using flash—addressing problems

Even though your flash is technically smarter than you, it has no idea how you want to light the scene. You need to give it some direction. Before blasting away, you need to ask yourself a few basic questions about how you want your photo to look.

Here are the five main concerns that you need to address when going into any scene where you intend to use flash. I've included some image examples to see how you can address specific problems and turn them into solutions that give you a final, workable image.

1. **Background**: How bright or dim do you want your overall scene to be? Do you want your subject to be lit up against a dark background or against a field of white? You control the background by raising or lowering the overall brightness of the ambient light with your camera exposure, using ISO and shutter speed.

I want a slightly darker, more saturated look than what I have on the left, so I'll slightly underexpose the background.

Although my background looks good, I've got too much light, so I'll need to dial the flash exposure down.

2 **Amount of light**: How much light do you want from the flash? Are you going for gentle fill, or do you hope to rescue your subject from the shadows? You control this through your flash exposure and with the aperture value on your camera.

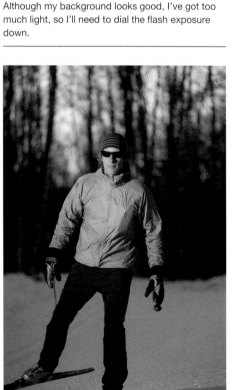

3 **Direction**: Where do you want the light to come from? Are you trying to complement the natural ambient light, or do you want it to shine in from the other side for enhanced effect? Placement is key to great lighting. (We'll discuss this more in a later section.)

In the above shot, the straight-on light is too obtrusive. I'll move the flash so that it gives me more subtle sidelight.

4 **Quality**: Hard or soft light? Close or distant? Small light or big light? You control the quality of your flash with the use of specific light-shaping tools that we discussed in the previous section, as well as with careful placement of the light.

5 **Coverage**: Will you have enough coverage with one flash? Is it zoomed wide enough to throw even light on your subject? Unlike the sun, light from the flash falls off drastically with increased distance, which makes for that "obvious flash look." To prevent this, you may need a wider zoom setting on your flash, a second light, or a larger diffuser or soft box.

In order to make the flash more invisible, I'll add a CTO (Color Temperature Orange) warming gel to match the evening sunset light.

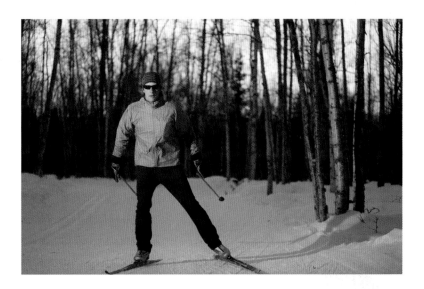

To avoid the obvious light falloff effect when shooting too wide, I'll move in close and eliminate the ground from my shot.

Once you've established these simple parameters, you need to set proper exposure. Although TTL usually does a pretty good job of balancing flash with the ambient light, it's not a failproof system. Remember, it's based on the values of reflected light, not on your creative desires. More often than not, you'll need to make adjustments to the flash and/or the background exposure in order to achieve a look that matches your own personal vision.

Basic flash workflow

So, once you've completed your checklist, follow this basic flash workflow. As you become more experienced, you'll develop your own workflow and learn when to deviate as needed.

1 **Set your camera exposure**: Meter on the background and set your camera exposure as desired. You can use an auto exposure mode, but the advantage of using Manual is that you can dial in your exposure for the background and keep it locked in. As long as your ambient light doesn't change, your exposure will stay the same regardless of how you light your subject.

2 **Place the flash**: Position the flash where you want it to go and modify it as needed, based on the direction, coverage, and quality of light that you're going for.

3 **Choose your desired flash mode**: Either choose TTL or Manual. Remember, with TTL the camera is controlling the amount of light that's being emitted by the flash, based on the information it gained from the flash right before the shutter opened. With Manual flash mode, the flash puts out a fixed amount of light that you control by adjusting the value.

Either mode will give you good results and which one you use may ultimately come down to preference. I probably use TTL at least half of the time and go to Manual when I've got a little more time to set up the shot and dial in the exposure or when I know the overall lighting scheme of my scene will not change. Ultimately, Manual gives you the most control.

4 **Set your flash exposure**: Even though straight TTL flash exposure may be "correct," it doesn't always look right, and it may not be exactly what you're going for. Chances are it will still be too bright, so you'll probably want to dial it down.

Under normal circumstances, dropping flash exposure by about one and a half stops generally gives you good results. Depending on your scene, you may find that dialing down anywhere from _.3 to _3.0 stops on the flash gives you the best look. However, if you're underexposing the background, you might even need to compensate on the plus side, especially if you're using an auto exposure mode. Remember, flash output is factored into the camera's auto exposure setting.

In Manual flash mode, you simply dial down through the different power settings until you get the desired look. No matter what mode you use, in addition to the specific flash setting, the actual amount of light that hits your subject is also affected by distance to the subject, aperture, and ISO.

5 **Do a test shot**: Fire away and then study the results. You should be able to quickly determine if you need to change your camera exposure, adjust the light output, or move the flash. Make your changes quickly and then do another test shot. Once you've got the right look, take off the training wheels and go for the money shot.

Like everything else, this all just takes practice. As you become more proficient and confident, things like flash placement, metering, and exposure compensation will become second nature.

Keep in mind that although I list the specific gear and setup that I used for some of these shots, they're by no means the only options, or even the best options; it's only what I chose at the time. In some cases, I might have been limited with gear, time, or even the forethought to try something else. You might choose a different way to photograph any one of these subjects, and that's OK, as long as you get a great shot, or as long as you learn something in the process.

Here is another series that shows the evolution of the flash workflow and the final image.

Flash in action

Filling in the shadows

As a tool, flash helps you reduce contrast, and the most common contrast problem you have is filling in the shadows. If your background is lit by the sun and your subject is not, no amount of pixel wrangling is going to let you rescue the shot. If you expose for the background, you'll lose your subject in shadow. Conversely, exposing for the foreground subject will just blow out your background, and that won't look very good either. This is when you need a little help from a handheld flash.

The first example was shot without flash, and as you can see, it doesn't work at all. By bringing in the light from a single off-camera flash and portable soft box, I'm able to bring the subject back from the realm of darkness. For the second shot, I set my background exposure in Manual mode for 1/250 @ f/9 with a 24mm lens.

For the light, I used an SB-800 inside the Lumiquest Softbox III, which I held outstretched in my off hand; a sync cord ran behind my head from the camera to the flash. This simple approach totally rescued the shot. Without it, I would have had to come back and shoot in different light.

Gear used in this photo: a Nikon DSLR, one lens, one flash, a sync cord, and one small soft box that folds flat and fits in my camera bag.

Shooting at Sunset

Here's a very common situation where fill flash can make a big difference: shooting portraits in late afternoon or evening light. In this scene, I'm photographing a cross-country skier right around sunset. Although there's enough ambient and reflected light from the snow to keep her from falling too much into shadow, the light quality just isn't anything special. If I don't use flash, I get the first picture, which severely lacks life.

To solve the problem, I put the camera in Manual mode, slightly under-exposed the sky by about one stop, and lit my subject with a handheld flash. The strobe was connected to the camera via sync cord and diffused with a Lumiquest Softbox III. It's a very similar approach to the first image.

Holding the camera in my right hand, the flash in my left, I exposed at 1/250 sec at f/9 with ISO 500. My flash exposure was straight TTL, with no compensation. The small soft box softens the light just enough without making it look too obvious. It's got style, but it still feels real. To give the photo even more style, I shot with a 35mm Lensbaby.

Shooting in high-contrast locations

Oftentimes, forest scenes make for a great deal of contrast, especially when it's sunny outside. With all the uneven lighting, it's almost impossible to nail your subject in just the right place in between those thin shafts of light that filter through the trees.

By using an off-camera flash, I've added enough extra light to bring the shot alive. You don't even really notice, but you notice when it's not there.

Gear used: one flash, one small soft box, and one small light stand that straps on the side of my photo pack. If I wanted a second light, I could have attached a flash to one of the thin trees with a Super Clamp or a Gorillapod.

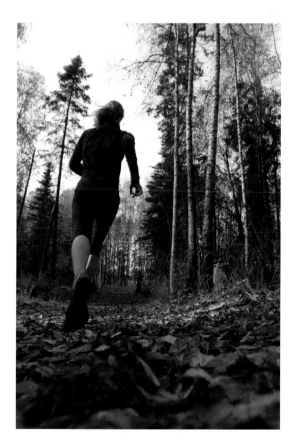
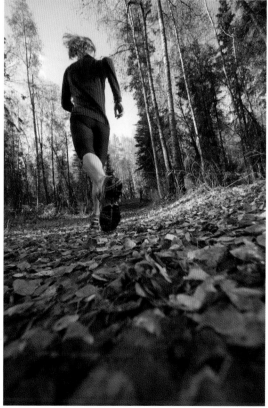

Direction and color

You don't always want the light to come from the same direction. Forty-five degrees off-axis, just to the left of the camera looks good, but it will get old. Sometimes you'll want to move the light and bring it in from a completely different angle, just to vary your creativity and strive for a new look.

I'll often stick one light way off to the side, zoom the head all the way out, and throw hard, direct light at my subjects. Depending on the situation, I might even warm up the light with an orange gel and make it look like a slash of afternoon sunlight. Is this cheating? I say no, especially if it's done right. Your goal is to accent the scene and make it look plausible.

My approach to photography is to create subjective and symbolic interpretations of things, places, and people that excite me. In many cases, what I do isn't so much journalism, as suggestion. It's not just about documentation and truth, it's about inciting ideas and imagination.

While I don't create scenes that are obviously faked, I direct my models and ask them to repeat certain actions so that I can grab just the right moment. I arrange subject matter in the viewfinder as I see fit, and I often use lenses that see the world differently than is recorded by regular human vision. In my mind, don't bend the truth any more than adding some orange light to create the illusion of sunset, as long as it's done in a believable way.

For this shot, I balanced a gelled SB-900 on top of my photo pack, which was on the ground. I used Pocketwizards to trigger the camera to fire as I rode down the trail. It was a fluke that the light turned out like this. A happy little surprise.

That said, make sure you match your warm light to the situation. Nothing will make your photo look more fake than a subject that's lit with warm sunset light when it's obviously midday in the rest of the photo. Pay attention to what the light is doing. Be mindful of how light looks in all seasons and weather conditions and think of all the variables that you can replicate with your flash.

Sometimes the sun gets blocked by obstacles, walls, or buildings and shines only upon a small part of the scene. Sometimes it creeps underneath the edge of a blanket of clouds that might cover the entire sky right before it sets. That's easy to reproduce with a gelled flash, and if done right you can make it look as real as the real thing.

Here are two examples. One is shot with a flash, the other with real sunset light. See if you can tell which one is which.

Placement

Usually, when using directional light, your number one consideration is placement. When you're working with an assistant or on assignment, you often have people to help carry and hold your gear. However, when you're out for a hike in the mountains or on a mountain bike ride with your buddy, your gear allowance is much smaller. You've got to be a little more creative about how you place the flash. This is where a little ingenuity goes a long way.

I've clamped and gorillapod-ed flashes to bike frames, seat posts, sign posts, ski poles, tree branches, and just about anything else I can think of. On many occasions, I've simply placed them on the ground using the little plastic stands that come with the flash.

If you're not using radio triggers, your main challenge with using remote flashes is making sure that every flash sees the signal from the master or from another slave. You'll need to position and rotate the heads in such a way that all of the optical trigger eyes are facing the right direction. You might even need to rotate or zoom the master so that it sends the signal out to the appropriate units or reposition your off-camera flashes. If you're trying to trigger lights on either side of you, point the head on the master straight up and put on the dome diffuser. That will create an omnidirectional light signal.

By the way, on the previous page, the second photo was shot with flash.

Using a second light

You can use the light from a second flash to add additional interest to the scene. This is commonly referred to as "accent" or "key" lighting. Used correctly, accent lighting can transform an average photo into a great image. If you study professional photos that are made with flash, you'll often see that the difference between an amateur image and a professional quality image lies in the effective use of key lighting. Well-done accent light is something that you may not even notice at first glance, but if you were to remove it, you'd definitely see the difference.

For these photos, in addition to the main soft box flash off to the side, I placed a second flash about 15 feet away and slightly behind. This side splash of light makes the shots much more three-dimensional.

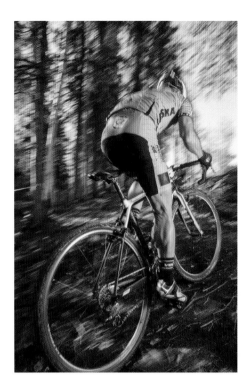

Here I used a shutter speed of 1/80 sec and shot as close as possible with a 24mm lens.

Flash with motion

Using flash is an excellent way to add a more dynamic component to your motion photography. By combining rear sync flash with a slow shutter speed, you create a blur effect across the frame with a defined, hard-edge subject that's lit up by a microsecond burst of light right at the end of the shutter cycle. Add a panning effect or move the camera during the exposure and you create an even more dynamic look.

There is almost no limit to the kinds of effects that you can vary with these techniques. I use them all the time in my photography, sometimes with soft boxes, but usually without.

You should experiment with all approaches, gear, and flash settings. Since you're using the flash more as an effect to stop the action and not as a main light, you can also use it on-camera and still get great results. Play around with shutter speeds and placement as well.

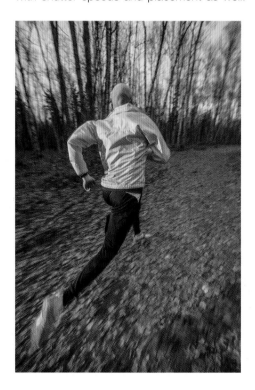

For this shot, I went even wider: 14mm lens with 1/80 sec shutter speed and two flashes, one on each side of the subject, triggered with a third flash on the camera.

Bigger lights

If you end up becoming a heavy flash user, you might consider upgrading to a battery-powered strobe. They're a little heavier and more expensive, but they offer two main advantages over traditional handheld flashes: the bigger lithium ion battery packs last a lot longer than the AAs in your handheld flash, and they have much shorter recycle times.

Run a couple hundred pops through your handheld unit and you'll find yourself waiting progressively longer for the capacitors to fill back up. Depending on your power setting, a battery strobe will fire for hundreds or even a few thousand cycles on a single charge, and as long as the battery still has juice, the longest you'll ever have to wait is a couple seconds.

Battery-powered strobes are extremely useful for shooting everything from fast action to locations and portraits. I like them for assignment work because they recycle quickly. Try explaining to the art director that you missed the shot because you were waiting for your flash to recycle. If you're getting big money for the job, you should have at least one powerful light.

The Photoflex TritonFlash battery-powered strobe on a light stand

The TritonFlash head, battery pack, 18" soft box and speedring, packed up and ready for transport inside my backpack.

My main strobe is the TritonFlash made by Photoflex (www.photoflex.com). For how much light it puts out, it's surprisingly portable. It sets up in less than five minutes, and when disassembled, it fits with the speedring in a medium-sized photo pack along with my camera gear and a small soft box. I typically use it on a lightweight light stand, which I strap onto the side of my pack, but since the battery pack is light enough to wear around my neck, I can also use it handheld when I'm on the move.

The TritonFlash set up with a 24" Photoflex WhiteDome soft box.

When set to a low power, it will keep up with short bursts of up to 7 frames per second. Even at full power, it's always ready in less than a second. It has high speed sync mode, an optical eye that allows me to trigger it with other flashes, and it works with Pocketwizards.

1/200 second exposure with light from a Photoflex TritonFlash battery-powered strobe through an 18" Octodome. A 200mm telephoto zoom helps isolate the subject even more.

The other comparable model out there is the Elinchrom Ranger Quadra (http://elinchrom.com). It's got a smaller light head, but a bigger, heavier battery pack. In use, it performs very similar to the Photoflex light. I know a number of pros who use the Quadra with excellent results.

Going wide with the lens and bigger with the light: 14mm lens with 1/80 second exposure and a 36" soft box over the TritonFlash.

Final thoughts

Using flash outside will certainly affect your approach to shooting, because it has limitations that are not present in traditional outdoor photography. Between the time spent dealing with the extra gear and waiting for your lights to recycle, you may not be able to shoot everything on the fly as quickly as you're used to.

This isn't a bad thing, though. The added effort helps you identify the vision that you have for each particular shot and forces you to slow down and take a more active, deliberate role with your creativity and your technique.

As you become more confident with using flash in the outdoors, your efficiency with the entire process will increase. And even though you still may not be as quick as you are without it, don't think of flash as being a slower style of photography, instead think of it as a more focused one.

Start small. Start easy. Get yourself a basic flash rig and play around with position, distance, and exposures. You'll be surprised at how good your photos will look with a few simple tools and techniques. Consider renting from a place like BorrowLenses.com so that you can try out some different flashes and light modifiers.

Most importantly, have fun experimenting!

Going Pro

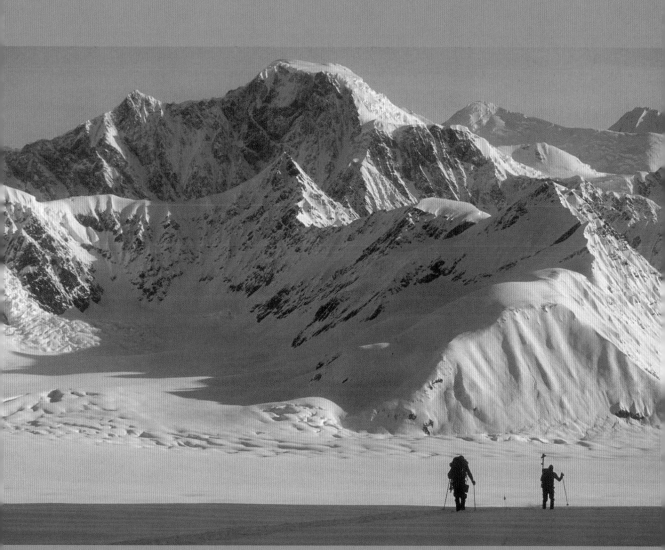

Going pro: what does it take?

So, you want to be a pro outdoor adventure photographer and make a living playing outside and doing something you love? Who doesn't?

Don't worry, I won't try and talk you out of this crazy dream. I might even get you in trouble by encouraging you too much. I've been known to do that. I turned pro in 1996 as a green-eared kid in my twenties with only a few pieces of camera gear, a couple of credit cards, and no real prospects; and yet here I am now, with almost twenty years worth of tear sheets behind me, a long list of clients, and no end in sight. The way I see it, if I can find success in this business, then so can you.

By no means am I the most successful adventure photographer around, but I continue to earn a living with it and watch my business grow every year as I learn new things and expand my skills. I've faced my share of professional struggles, and I still do, but I wouldn't trade my photography career for anything.

You should know that photography is, and always has been, a very tough field. Especially outdoor photography. Especially right now. Magazine photographers are getting lower day rates today than they did back in 2008. Newspapers all over the country are cutting entire photo departments and giving their reporters iPhones. The basic laws of supply and demand have wreaked havoc on the stock photo industry, and with modern globalization, there is stiffer competition than ever before.

Despite those tough realities, I feel that it's also a very exciting time to be a pro photographer. The advent of digital imaging technology, lighter cameras, the internet, the iPad, self-publishing, new media, and an enormous worldwide appetite for images means more opportunities for photographers than at any other time in history. However, those opportunities don't come easy; you still have to work just as hard, if not harder, to find them—or better yet, to make them.

Do you have what it takes to be self-employed?

Wanting to be a professional photographer is easy. Creating a successful freelance photo career is a lifelong, never-ending process that will always require a great deal of creativity, risk, mental energy, and above all,

perseverance. You must have a true sense of adventure, a dedicated and unwavering belief in yourself, and the willingness to stick it out even through the most challenging times.

It also requires a no-nonsense evaluation of your own skills, as well as your acceptable level of risk. You must possess an incredibly strong drive to learn so that you can adapt to changing circumstances. Finally, you must be willing to put yourself out there in the world with the confidence to say "I can do that" and the skill to back it up.

Being a self-employed photographer means that you are your business. There is no clocking out and forgetting about it until the next day or week. It's always on your mind and you never stop thinking of new ways to advance your creativity and your business.

Plus there's lots of overtime. As much as you want, in fact, and I don't just mean spending the entire weekend in the mountains with your camera. I mean the extra hours you'll spend in front of your computer editing photos, blogging, processing RAW files, tweaking your website, or writing copy for your next promo piece when you'd rather be outside.

You don't think twice about doing the work, though, because to you, it's not work. You'd do it even if you weren't getting paid. Besides, you love what you do, and you know that there are plenty of other shooters out there who will work just as hard as, if not harder than, you will to get ahead.

Here's an example. It's a beautiful sunny afternoon, and I'm sitting inside working on the last chapter of this book while my friends are out hiking and running in the sunshine. I'd rather be outside having fun too, but I have a deadline to meet for my wonderful editors at Focal Press. Plus, the sooner I get it done, the sooner I can go play!

Last week, I was up until well past midnight every day editing and backing up assignment images, which put me behind on both sleep and other tasks. My schedule often changes multiple times each week, and sometimes each day. I even had to postpone a long-planned bike trip this month because I got a call to shoot a big job for a new client.

Don't feel too bad for me, though. There are plenty of days when I'm off hiking, skiing, or flying my little Cessna while my friends who have day jobs are sitting in their cubicles. When you're self-employed, you don't have to work 24/7 at your business, but you must want to.

You should also have strong support from your family if you're not single or living by yourself, because your photography business will consume you. At the same time, you will need to learn how to deal with the stresses and find balance with the other people in your life, because despite what you think the entire rest of the world doesn't revolve around your photography business.

On the other hand, if you're someone who prefers strict schedules and regular paychecks, then being self-employed is probably not for you. Better keep it a hobby.

Making the jump

Quitting your job is always a risky proposition. It's better to get downsized like I did, because at least then you get a severance package or unemployment benefits. However, if you wait for the perfect time to start your photography business, you might end up waiting your whole life away. At some point, you just have to jump. Before you muster the courage to make that leap of faith, you'll need to make some brutally honest

assessments about your life or else you'll fall flat. At best, you'll prolong your own success.

- **Your talent and skills**: How good is your work? Is it pro-quality? As I pointed out, photography is a very competitive field, and if you're not able to produce great work, then you have no business trying to charge for it. You don't have to be the best (you might never be), but your imagery should at least be close to that of other photographers within your chosen field.

- **Your bank account**: Think photography is an expensive hobby? Try it as a profession. Besides cameras, lenses, software, and computer hardware that you'll need to purchase and continually upgrade, it costs money to produce great imagery and market it to the rest of the world. Don't forget about food, gas, rent, mortgage, health insurance, and the rest of life's monetary necessities. You'd better have a decent-sized nest egg, a stack of credit cards, and/or a VERY supportive spouse/partner to keep you afloat until you can start earning money.

- **Your niche**: Adventure photography is a very broad term. Specializing in a specific sport or genre can help make you more attractive to certain types of clients. At the same time, concentrating too much on one sport could limit the type of jobs that you're offered. I see it both ways here. It's good to specialize, but I feel that having a diverse set of skills will ultimately get you more work and keep things fresh for you in the long run.

 More importantly, you should pick a style and stick with it. If you want to be an adventure photographer, then only put that kind of work on your website. Don't fill it up with lots of different styles and subject matter. This makes it hard for clients. I'm not saying you can't shoot baby portraits and weddings on the side if you enjoy the work, just don't mix babies and climbing on your website. If you do shoot more than one style, then make a different site for each one.

- **Your level of risk**: What are you willing to give up in order to finance your business and weather the economic realities of being self employed in a tough creative field? Are you ready to put your heart and soul into this, even though it might be really hard? Think about how long you'll be willing to stick it out.

 Or not. I tend not to overthink things or plan too far ahead. When I was let go from my day job back in October 1996, I jumped into this with both feet and kept plugging away, one day at a time.

For me, it's always been about passion and perseverance. I never wrote up a business plan, I just started taking pictures, building up my portfolio, and contacting prospective clients. I've weathered two big dips in the economy, and at no point have I ever considered quitting. To me, failure is simply quitting too soon.

Is this the best approach? Maybe not. It's worked for me, but I tend to live life by the seat of my pants. If you feel that it would help to create a more detailed plan, then carefully evaluate all of the factors at stake before you proceed.

Full time vs. part time vs. no time

Even if you want to try and make money at photography, nothing says you have to do it full time. Maybe you're not ready to quit your job and give up a steady income. Maybe you've got financial obligations that make this kind of move unrealistic right now.

That's perfectly OK. In fact, there are certain advantages to having a day job and doing photography on the side. For one, you can enjoy most of the fun and few of the stresses. You don't have to constantly hustle for work. You don't have to worry about where your next check will come from. You can still shoot small jobs on the weekends, sell prints, or license your images through a stock agency. Besides, if you've got a great job with good benefits, you might even have more money to travel.

Maybe you don't even want to try and make money from your photography. That's OK too. Photography is a wonderful hobby and a great creative outlet, and even if you never earn a single dollar from your work, it doesn't mean that you love photography any less than I do. In the end, it's your life and it can be whatever you want it to be. If that means being a pro, then go for it. If not, then at least you were honest with yourself, and that's a good thing.

If you decide to make the jump, your first assignment is to learn everything you can about photography and the business. Read more books. Spend time online. Talk to other shooters. Join a professional organization like ASMP, and of course practice your craft as often as you can. Explore your creativity and pursue nothing short of technical excellence.

Be patient, though. If you dedicate yourself to your craft on a regular basis, you will improve. I promise you that.

The key to success: Diversify

The key to remaining successful in this business is to build multiple revenue streams which include a few sources of passive income. Diversifying helps "recession proof" your business and it keeps the money flowing across different seasons and during economic slowdowns. It's unwise to rely on just a single category, just in case that sector drops off or if a particular project doesn't pan out.

Even the most in-demand niche shooters have incomes from a variety of sources. The more streams you can get going, the better, as long as you can mange the workload. You don't want to spread yourself too thin or you won't do anything well.

Depending on your interests and talents, here are some common models that could be part of your overall business plan.

- Assignments
- Stock
- Portrait and/or wedding photography
- Writing articles and books
- Blogging
- Self-publishing (eBooks, calendars/paper products)
- Teaching (photography workshops, online tutorials/webinars)

Marketing

I could write an entire book on marketing. However, this is not it, so I'll be brief and just give you the bullet points.

Some photographers cringe at the mere thought of marketing, which is odd, because we're good at being creative and solving problems when it comes to making images. Marketing is nothing more than finding creative ways to solve one very simple problem that can be expressed with the following question:

How can I get people to hire me?
Marketing is finding creative ways to get your brand in front of potential clients enough times so that they remember you and, eventually, use your services. It's laying a foundation that you build through continuous contacts, whether by phone, email, direct mail, or in person.

The general rule of thumb with marketing is that it takes seven impressions before someone

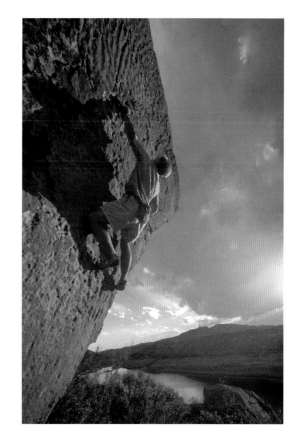

remembers you. It might take more, or you might get the call after someone sees your work for the first time. You won't know when it will happen though, so you've got to keep promoting yourself in fresh, original ways. Remember, there might be a thousand of you all fighting for the same clients. If your work and your marketing efforts don't stand out, you'll be lost in very big shuffle.

Your website

In this day and age, you have to have a website and it has to be great. End of story. In most cases, your website represents the first time potential customers will see your work. It's your first chance to make a visual impression, so it needs to look great.

I'm amazed at how many photographer's sites I visit that just aren't visually appealing or that are cluttered with so much stuff. Flash, music, or other distracting add-ons make a site look like it was built by an amateur. Don't make that be yours.

Your website should look professional. It should reflect both you and your brand. It should be easy to navigate, consistent in design, and consistent with your print marketing. It should present a clear impression of who you are, what you do, and what kind of imagery you make. It should also be search-engine friendly. If you don't know much about SEO (search engine optimization), get a book or look it up on the web. I know photographers who shoot great work whose sites will never be found because they're not search-engine friendly.

If you do not have the skills to make a professional-looking website, then you should either hire someone to build it, use a pre-made Wordpress theme, or else use one of the online services like Photoshelter, aPhotoFolio, Livebooks, or Smugmug.

Depending on what kind of photography you do, your site can either be a simple and stunning visual impression of your work or it can be a feature-rich online store where customers can purchase and download stock, view portrait albums, or place orders with full e-commerce capabilities. That's up to you and your budget. If in doubt, start simple and build from there. You can always change it later.

Print and email marketing

In addition to an awesome website and professionally made business cards, you should also create and mail print pieces to your potential and

established clients on a regular basis. These act as little "reminders." The idea is that your card and e-promos will land on an art director's desk just at the right time. With print marketing, it's a numbers game. Send enough reminders, and someone is bound to call you.

Of course, your print pieces have to be eye-catching. Imagine the hundreds of promo cards that land on the desks of photo editors every week. How will you make yours stand out from the crowd? Chances are, it will be bundled together with all the other cards that showed up in the mail that day. The editor will probably give it a quick glance, because, believe it or not, editors are always on the lookout for new creative talent. If your card doesn't immediately intrigue their visual senses, though, it will likely end up in the recycle bin without a second look.

If you don't have the ability or design sense to create a great-looking print piece, then hire a graphic designer. Better yet, barter with one. After all, designers need imagery and trading for services is just one way that photographers can be resourceful.

Social media

Social media is nothing more than a modern form of marketing. However, many photographers simply don't know how to use it in the most effective way. Not that I'm an expert, I'm learning more every day just like many of you, but I've stumbled on a few basic rules that seem to make sense.

There's a reason it's called *social media*. It's all about people interacting with each other as they share ideas and content. The operative word here is *interacting*. The people and companies that run successful and effective social media campaigns are those who are good at this kind of interaction. They listen to, respond to, and communicate with the people on the other end of the keyboard. They don't hold up a virtual sign and then sit back while they wait for the traffic to come in.

Unfortunately, that's how many photographers use social networking sites today. They post links to their work and expect that all their followers and fans will simply drop everything, go check it out, and then share your content with all of their followers as well. Somehow, they think, this will eventually get them some work.

We've all done it that way on occasion, but social media doesn't quite work that way, UNLESS the content you post is absolutely stunning, which brings me to my next point. You have to give people a reason to follow

or like you. Great content is certainly one reason, but more often than not you also have to give them something else. Something they can actually use, whether it inspires, intrigues, educates, informs, or helps them, or simply makes them laugh. Never underestimate the power of humor.

Engage with your social media friends and followers. Bring them into the discussion and share their content and ideas as well. Listen to them and actually be a real person instead of a page. You'll find that the more you interact with your followers, the more impact you'll have on any platform. In that way, social media is just like life—if you want the love you've got to give it.

Relationships

Social networking is no different than any other kind of marketing. It's all about building and maintaining lasting relationships with your customers. Your goal is to show people that you can provide them with a valuable service and also give them a reason why it should be YOU they hire and not someone else.

You do this by being personable and easy to work with AND, of course, by going the extra mile to give them the finished product that ends up being better than they expected. If you do that on a consistent basis, you'll not only get the call, you'll get referrals, which are worth more than gold in this business.

A few months ago, I spoke with a potential new client who told me, "a lot of the photographers I've hired are not very easy to work with . . ."

Did I hear that right?! Not easy to work with? You should be VERY easy to work with. You should be downright ENJOYABLE to work with. So much so that they can't wait to hire you again and, better yet, go out for a beer with you after the shoot! That's what we call "networking."

Be yourself. Be positive. Be easygoing. Be interested in who they are as well. Remember, editors are people too. The most successful photographers work hard to maintain their professional relationships through regular contact and interaction. Don't just put your work out there, put YOU out there. In the long run, that's what people will respond to the most.

There are lots of great books and resources out there on marketing, networking, and social media. *The Linked Photographers' Guide to Online Marketing and Social Media* is an excellent and very up-to-date book that shows photographers how to get the most out of social media and online sites and create a successful online marketing campaign. It covers how to use Facebook and Twitter to your advantage, and it even has a section that covers SEO, which will show you how to create or modify your website so that it will actually be found.

The Photographer's Guide to Marketing and Self-Promotion by Maria Piscopo is another great, all-around guide to marketing and networking that I'd highly recommend to anyone who wants to ramp up their photo-marketing plan.

The author, who is a professional photographers' rep, shows you how to define the type of work you do, how to build and present an effective portfolio, and how to create and run a successful marketing campaign that includes print, email, newsletters, and more.

In short, marketing is all about coming up with creative ways to get your name and your work out to prospective clients. There's no "right way" to do this, but before you start marketing yourself, you should be able to

answer the following questions. Hopefully, you'll keep finding new and creative solutions to these problems throughout your career as a professional photographer.

• What products or services do I have to offer?

• Who are my potential customers?

• How can I let them know who I am and what I can do for them?

• Why should they hire me instead of someone else?

• How can I communicate that to them?

• What are my strengths?

• Is my website design fresh and is the content up-to-date and eye-catching?

I'd like to say one last thing about marketing, and about your career in general. For most people, me included, there is no such thing as "overnight success." Rarely is there a single "big thing" finally that causes you to "make it."

A successful photography career is built with small steps and constant maintenance over many years. Every project, assignment, marketing idea, and investment helps push you further along, and while some steps are bigger than others, don't rely on any one of them to push you to the top.

Instead, rely on your own stamina to keep plugging away, even when things are tough. Even if you look around and see other photographers achieving successes that seem greater than your own, remember this:

Your business is not about them. It's about you.

So don't worry about the other guy, worry about your own skills, ideas, and relationships. That's what leads to success.

The business of photography

Most of us love adventure photography because we love the creative process of telling a unique visual story about the outdoors and our place in it. When we first start out, things are usually pretty simple: we're drawn by the excitement and challenge of capturing those dynamic moments that are so integral to us and our friends at the time. Think back to those

early shots when it all started to come together for you, both creatively and technically. There's magic in those frames. Don't ever forget them!

The trouble starts when we decide to make it our profession. Photography is largely a creative, right-brain activity. When we shoot photos, we tend to focus on the whole picture first and then break it down into subjective, random, visual, and intuitive abbreviations that suggest the greater scene.

Business, on the other hand, is analytical, sequential, verbal, and it focuses on the hard details. These are all left-brain ways of thinking that sometimes clash with what may come more naturally to us as creative types. The result is that photographers don't always make the best business people, at least when we start out.

That's not to say that all photographers are right-brain people and can never become good at business. In fact, I would argue just the opposite. Photography is a very technical craft that requires significant left-brain functions, like calculations, numerical values, and estimations. It attracts all kinds of left- and right-brain predominant people. It's no wonder that so many doctors and lawyers take up photography as a hobby; it probably allows them to be creative while still using the kinds of exacting analytical aspects that are so familiar to them.

Running your business

Once you decide to make photography your business, you need to establish that mindset. You don't have to go and change your entire personality and start wearing a tie every day, but you do need to conduct yourself as a professional.

This means acting the part. You may have gotten into this field because you love tromping around in the outdoors with your gritty garb and trail-weary backpack, or because you love to focus on the extremely introspective aspects of making perfect images. That's probably still how you create your best imagery, but when it comes time to deal with those clients that you found by marketing yourself, you need to put on your game face.

This means being on time, acting and speaking like a professional, wearing khakis and a button-down shirt instead of dirty mountain pants and a polypro top that smells of past expeditions, and establishing proper etiquette, not to mention staying organized.

When you work in this way, there will be many aspects where your life and your photography business are intertwined. (This is one of the things I like about what I do.) However, you should try to separate out some of the business parts, when necessary, especially the money.

I won't tell you how to budget your finances or how to allocate your incoming and outgoing dollars, that's for each person to figure out for themselves, but you should get yourself a business bank account, credit/debit card, and a business line of credit as soon as possible.

A credit line is helpful because oftentimes you'll have to front-load assignment expenses and buy gear that may take a while to pay off. You may not want to use available cash for these types of expenses, because as you'll soon learn, it often takes weeks and months to be paid. Many clients pay on a 30–60 day cycle. That is, when they don't lose your invoice or shuffle it around to different departments before finally submitting it to accounting. And that's when the 60 days officially starts.

You'll probably want to use your own name as the name for the business, and you may also want to consider what type of business category you'll use. Many photographers are sole proprietors. Oftentimes, photographers who have studios will go the LLC route (Limited Liability Company), which offers the business owner more liability protection from claims and debt.

Some photographers even establish corporations for their businesses, although most are either SP or LLC. Check with an attorney or business advisor for more information. The Photo Attorney® website (http://www.photoattorney.com) has lots of resources and legal info that's geared specifically towards photographers.

Insurance

Adventure photography can be a dangerous business. At the very least, you'll want to have a heath and/or accident policy for yourself. Fortunately, with the recent changes in healthcare laws, it's now easier for self-employed people to find affordable insurance.

Depending on what type of work you do, you may also need business insurance. If you do assignment or location work as an independent contractor, you probably want a general liability/injury policy. You may also want a policy that covers lost, stolen, or damaged equipment. Note that a homeowner or renter's insurance policy may not cover your gear if you're using it as a professional.

Taxes

Welcome to self-employment, your taxes just got more complicated! If you earn over $600 per year, which will hopefully be the case, you'll need to pay taxes on your business income. You'll also have to file some additional forms, such as a Schedule C and Schedule SE, and possibly do depreciation as well.

On the plus side, you just gained a whole new set of deductions. As a working photographer, you can deduct any business-related expense you incur, including office and studio space rental, office supplies and equipment, computers, software, iPads, all your photographic gear, gas, travel, airfares, hotels, National Park entrance fees, lunch with your models, and anything that you use in your business.

In order for this all to be legit, though, you'll need to keep accurate records of all your income and expenses and save all of your receipts. You might want to check with an accountant, because there are some very specific rules about how you deduct and depreciate certain types of rent, travel expenses, and equipment costs. Or, get the business version of Turbo Tax. It will answer most of your questions, show you exactly what forms you need, and costs less than visiting a tax accountant.

Record keeping

This is where things get a little challenging for some photographers. We're not all hard-nosed business people, but we do need to bid for jobs, negotiate prices, keep track of our money, and get paid. To start off, you'll need to establish a system for keeping accurate records for client contacts and management, scheduling, and expenses tracking.

At the very least, you'll probably want to get Quick Books or use an online solution like Wave (http://wave.com), a free web-based alternative accounting solution that allows you to track expenses and sync all of your bank accounts.

You may also want a dedicated photography business program. FotoBiz and Blinkbid are the two choices that are the most relevant to stock and assignment photographers. They both offer complete photography business solutions that help you manage contacts, log submissions, and generate estimates, invoices, and payments.

Pricing and negotiating

You'll also need to know how to price your work and negotiate appropriate fees for your services. This is often the hardest part of the business for many photographers, because there is no master price list that tells you how much to charge for each job. There are guidelines, but they're not set in stone. Plus, every project comes with a different budget and specific set of parameters. The same can be said about licensing stock images.

In the past, photographers charged a flat "day rate" for shooting jobs. The industry is moving away from that these days, because it's not the most accurate method of pricing. It doesn't take into account your creative and technical expertise or factors such as image placement, size, circulation, region, and duration of use.

To illustrate why the day rate model doesn't work very well, consider two different assignments, both of which will take a single day to shoot. Let's say you charge $2000 as your day rate. So, for one day of shooting, your pay for each job will be $2000.

Now consider the end use of each job. The image for Job A will be used as a local ad that will run three times in a small, regional publication. The image for Job B will be featured in an ad that runs on the back cover of *Outside Magazine* every month for six months. Do you see the problem here? If you don't factor in usage rates, you're not getting what you're worth. In this game, the exposure of an image can represent much more value than the number of hours it took to create it.

In other words, clients don't pay for your time, they pay for your talent AND for the exposure of your images. Instead of charging a day rate, you should charge a creative fee that reflects your skills, as well as your overall cost of doing business.

On top of that, you charge usage fees that reflect how the clients will use the images you produce. Some photographers just bundle this together with the creative fee.

Unfortunately, what we want to charge and what clients want to pay doesn't always match up. This is where your skills as a negotiator come into play. Negotiating involves identifying what each party needs and establishing a middle ground where each party communicates and compromises, until both parties agree that they're getting a fair amount for what they're giving.

It takes practice to become a good negotiator, but the important thing for photographers to remember is this: don't just give your work away. Also, don't just cave because the other side doesn't want to pay what you're charging. Finally, don't be the guy who undercuts everyone else. You're just hurting the entire industry, which you are now part of.

If a client balks at your fee and you decide to come down a bit, make up for the reduction in price by changing the perceived value of the job in your estimate. You can do this by modifying the specifications of usage, such as duration or size, or by reducing the number of final images you'll deliver.

Don't give away something for nothing; in the negotiating process, everything has value. Learn to be firm with your price, and, more importantly, learn to say no. Sometimes it's better just to walk away from a bad job than to deal with all the headaches it involves, especially if you're not getting paid very much.

The most important thing when pricing jobs is to gather all the information possible from your client and then get back to them later with your price. This gives you time to collect your thoughts, analyze all the factors, and even ask another photographer for advice. It's in your benefit to keep in

Further reading

There are so many good resources on the web that can help you run a more successful photography business. Check out the Black Star Rising blog (http://rising.blackstar.com) and John Harrington's book *Best Business Practices for Photographers*. It's one of the best and most relevant books on the subject. This up-to-date and comprehensive guide has everything you need to know, from pricing to copyrights, IRS stuff, and contracts. He even has a chapter on how to balance the personal and professional aspects of your life. (We could all use a little help with that.)

The ASMP Guide to New Markets in Photography is another book that should be on the shelf of everyone who's working in the field or thinking about getting into photography as a career. A modern manual that explores where the industry is headed today, it addresses the changes that photographers face in the current climate, whether they revolve around marketing, licensing, or how to adapt to new technology. It also profiles how a number of successful photographers have transformed their own business models to meet the demands of today's photography industry.

Also check out Bill Cramer's Real World Pricing & Negotiating worksheet (http://blog.wonderfulmachine.com/2013/02/real-world-pricing-negotiating/). It's a highly relevant aid that will help you price assignment work.

Finally, I would strongly recommend that you consider joining ASMP. They have chapters in most areas around the USA, and its members represent a wealth of information that can be helpful to you as an emerging photographer.

touch with other shooters, because in order for all of our businesses to survive, we all need be on the same page with consistent pricing models.

The most important thing to remember is this: YOUR WORK HAS VALUE, even if you're just starting out, so price it as such.

Blinkbid and fotoBiz are two software titles that are geared towards helping photographers price their work. I've used both of them and would recommend either program. In addition, check out the *ASMP Professional Business Practices in Photography* book for more comprehensive help in this area.

Working with clients

As with any business, a large part of being a professional photographer is building and maintaining lasting relationships with your customers. Once you get a client, you should do everything possible to keep them. You need to show them that you can provide a valuable service and give them a reason why they should hire *you* again and not turn to someone else next time.

Here are some ways you can display professionalism with your clients.

1 **Be organized:** No matter how chaotic or messy you are in the rest of your life, when you're dealing with clients, you should be organized and on top of things.

2　**Be easy to work with**: I know I already said it, but I'll say it again. Also, learn to be diplomatic, because there will be times when it's your client who is not very easy to work with. At some point in your career, you'll have a client who has unrealistic expectations about the shoot or who is just hard to satisfy, no matter how much effort you put in. In these cases, exceptional people skills will be just as important as good picture-taking skills.

Remember, it's not just your work that you're putting out there, it's you as a person. In the long run, that's what people will respond to the most.

3　**Be confident**: You should always inspire confidence when dealing with clients. After all, they hired you because you're an expert, so you should act like one. However, make sure you don't cross that fine line between confident and cocky. If you do screw up, admit your mistake and be humble. You're only human and the client knows that. They're more likely to cut you some slack if you take responsibility and work hard to fix the problem.

4　**Be professional**: There's also a fine line between being personable and being professional. Know when and where that line is. It's perfectly OK to joke around with your clients, especially if you've already got a good relationship with them. However, there's a time and a place. Don't get too lax or carried away. You're not there to amuse anyone, you're there to take great pictures. Too much clowning around gets old fast.

5　**Don't share job images too soon**: This tip is especially important in our instant social media planet. Your clients might be spending a lot of money on the project you're shooting, and the last thing you want to do is jump the gun and show those images to the world before they're officially unveiled by the client. No matter if it's advertising or editorial, concepts like "launch," "timely," and "exclusive" are extremely important in the professional realm. Make sure you get the OK as to when you can share images from the job.

This also goes for posting shots while you're working. It's bad form to spend lots of the client's time posting pictures of your assignment on Instagram and Facebook in the middle of your shoot. That's not to say you can't do this on occasion, just don't go overboard. Do it during short breaks and make sure you don't say or show anything in your posts that might compromise your client's exclusivity, unless they say it's OK. In fact, you might be encouraged or even expected to share behind-the-scenes images as part of a broader social media campaign. When in doubt, ask.

6 **Communicate and find solutions**: There will be times when the client wants something that you can't do in the specific way they want. It might be for a technical reason. It might be because you don't want to risk breaking your neck. Even though the client hired you to do a very specific job, they're probably not photographers and so they may not fully understand the realities or dangers involved in getting a specific shot.

Working with models

In adventure photography, your models are your lifeblood. Without the people who plow through the snow on their boards, drop class V rapids in their kayaks, climb sheer granite faces hundreds of feet off the ground, hike, run, cycle, explore, sail, swim, surf, and do everything else exciting in front of your camera, you'd just be shooting landscapes.

In other words, your entire business depends on your models, so whether they're your friends or sponsored athletes, you need to treat them right. That means listening to them, respecting their space and their comfort level with the situation, and knowing when to put the camera away. Above all, you need to be mindful of their safety 100 percent of the time, even if they're not. Keep the "Kodak courage" in check and make sure that nobody does anything stupid.

You also need to make sure they're dressed and outfitted appropriately for the situation, even if it means supplying some of the gear yourself. The proper equipment and clothing is integral to producing relevant and marketable imagery, and it's up to you to make sure everything looks right.

Unless you have someone else on location who can pay attention to that stuff, you'll also have to take on the role of product stylist. Ultimately, it's your job to make sure that everyone has the right look before you click the shutter. That's as important as making sure you have the right lenses.

Last but not least, whether you use paper copies or a mobile app like Easy Release, don't forget to get signed model releases from everyone!

Communicate with them. Show them that you're willing to go above and beyond to get the shot (within reason, of course), but if there's something you can't do, don't just make excuses, explain your position and work to find solutions to the problem. In the end, you want your motto to be "CAN DO." Get the job done and you'll get the call again.

Professional profiles

I'd like to close by profiling a handful of contemporary pro adventure photographers. I include them to show you the variety of styles and imagery that exists in the industry today and also to remind you that each person follows a unique path as they forge their own career. Although they have different levels of experience, all of them are very talented, accomplished, and hard-working shooters who have found their own level of success in a very competitive field.

With the exceptions of Trevor Clark and Jay Goodrich, whom I've only communicated with online, I know all of these people personally and would

attest that they're not only great shooters, they're great people. I feel fortunate to have them as my peers, and I'm very grateful for the time and effort that each of them took to contribute their insight and imagery to this book.

I have great respect not just for these seven people, but for anyone who's working as a pro photographer today: the longtime shooters, because I came up through the ranks with them and I know what it takes to build and sustain a career like this; the younger shooters because they represent the future of this industry. It's amazing to see how much further ahead some of these younger photographers are with their skills and talents compared to where I was 15 years ago. Not only is the gear better now, there are so many more great resources for learning than when I started out. If I could only go back . . .

Perhaps the coolest thing is that some of the very same people who have learned from me during the past few years are now working right alongside me in the industry. If you're one of them, know that I'm as inspired by you and your energy as I am with the guys who have been shooting for 20 years. I look forward to following your work and careers during the coming years.

Thanks so much for reading.

Dan Bailey
July 29, 2014
Anchorage, Alaska

Photographer Profiles

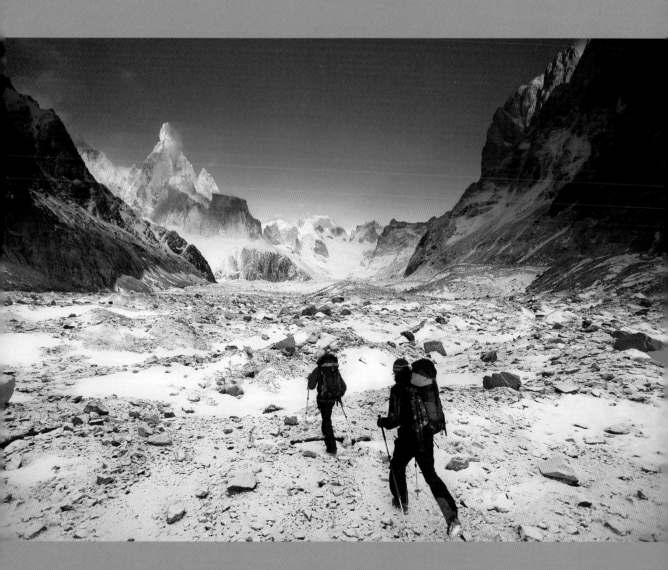

All of the images in this chapter were shot by the respective photographers.

Corey Rich

1 How long have you been a full-time pro photographer?

Over 20 years. Before that I worked for newspapers and shot news, sports, features, and portraits. I worked for *The Antelope Valley Press* in my senior year in high school and then *The Modesto Bee* for nearly two years while in college at San Jose State University. After that, I dove head first into the world of adventure photography and have never looked back!

2 What specific sports or activities do you primarily shoot?

Outdoor adventure, outdoor lifestyle and travel photography, and tons of video storytelling. I love to document adventures in wild places where I am photographing my friends and travel companions pushing the limits and exploring new places. Also I am most creative when I am a part of the adventure, a participant. The best adventures are when the outcomes are uncertain.

3 How did you break in? How did you get your first clients?

Almost two decades ago, as extreme sports entered the American mainstream, I was there to tell the stories of athletes like climbing legend Chris Sharma, kayaking pioneer Eric Jackson, and world champion surfer Lisa Anderson. Editors at *National Geographic Adventure*, *The New York Times Magazine* and *Sports Illustrated* regularly turned to me to bring them startling, memorable images from the world's wild places.

4 What do you feel were the circumstances, events, or actions that led to your first successes as a pro?

In the mid nineties, while I was a student at Fresno State, Brian Terkelsen at Quokka Sports saw one of my photos in a Patagonia ad in *Outside Magazine*. The dot-com boom was right in its prime. And Terkelsen had just helped launch a new online venture, Quokka Sports, with lofty ambitions of being the world's premier digital sports media company. Quokka's websites were cutting-edge in terms of functionality and design. They covered everything from climbing on Trango Tower, to the America's Cup, to even the 2000 Olympics in Sydney.

Quokka hired me to shoot a 30-day adventure race in Morocco. When I got home, I took that money I made and bought my first house. And while I ended up going back to school for a bit, it was short lived. Three classes shy of a degree, I dropped out. I didn't have time for school because I was already doing the job I was studying to do.

5 What's the most, or one of the most, memorable shoots you've done?

There is no single "most" exciting assignment, and all hold a special place in my memory. The key to doing this job is being in the moment, creating memories associated with each and every project. The beauty is enjoying the place and somehow capturing it in still images and motion footage.

6 What marketing tips or career advice would you offer to beginning or emerging photographers who aspire to turn pro?

Simple. Go on adventures and shoot great pictures! It is that easy. If you are making great photos you will have no problem finding a home for them. Every industry is always looking for great photography and video content. Believe it or not, great content (pictures, video, writing) is in short supply. You need to prove to magazine editors that you can do it and that you are motivated.

Get used to hearing the words, "on spec." At first you need to make it happen on your own. That is to say, no one is going to pay you to make cool pictures on assignment straight out of the gate. After proving yourself, then you might expect to receive assignment work if you are easy to deal with as a person and a solid photographer/filmmaker. But at the beginning

you need to fund your own shoots and rely on the stock sales. It can be a long road.

The other advice that I like to give is to shoot subject matter that you know and love. One key to success in photography is to know your subject and your market.

The best way to gain exposure is by getting published in national magazines and newspapers (big newspapers) and websites. Start building a social-media presence for yourself. The more editors and people in general who see your work, the more they will begin to recognize you as a player in the photography/video industry.

David Clifford

1 How long have you been a full-time pro photographer?

I've been a full-time pro photographer for 20 years.

2 What specific sports or activities do you primarily shoot? How has your style or subject matter evolved since you first turned pro?

I shoot anything that moves. Skiing, climbing, running, biking, and BASE have been my go-to sports to shoot for the last seven to eight years.

3 How did you break in? How did you get your first clients?

There were so many factors involved in my early success as a pro. I would have to say that the photo workshops I took from Rich Clarkson, Chris Rainier, and David Hiser were very important.

4 What do you feel were the circumstances, events, or actions that led to your first successes as a pro?

I've mentored many of the best outdoor photographers in the world and there is a lot of street cred that comes with that distinction. I would say that being able to shoot stills and video in any condition and the toughest situations and constantly deliver excellent results is one of the reasons, but the truth is that it is the personal connections that I've made that have really made the difference.

5 What creative methods or techniques do you feel best represent your photographic style?

My style is very real. Whether I am shooting commercial or editorial, I make sure the moment is very real and authentic. Whether I am shooting a highly produced big-budget commercial shoot or a lower budget editorial shoot I constantly push myself to over deliver and be as creative as possible.

6 What's the most, or one of the most, difficult shoots you've done? What big challenges were involved in getting it done?

Every shoot has its own challenges. I recently shot the 2014 Marmot catalogue and we had to shoot five categories over six days with three days of heli-skiing. We hadn't had snow in two weeks and the conditions were not ideal to sell the dream. We rose to the challenge and managed to make some amazing imagery across the board. The client was AMAZED. We just really made the conditions look far better than they really were. We also managed expectations and communicated very well with the client. On top of that we worked our asses off and never stopped working on making the best possible imagery we could.

7 How do you use social media in your business?

I use Facebook, Twitter, Instagram, Tumbler, and LinkedIn. I am not as engaged as many photographers who hire people to manage their social media and ghostwrite their posts. I do try to keep my followers up to date with what I am up to but NOT spam them. It's really a full-time job in and of itself, which makes it tricky, and I can see why other photographers outsource their SM.

8 How has motion and video played a role in your business? What percentage of your professional work these days is stills vs. motion?

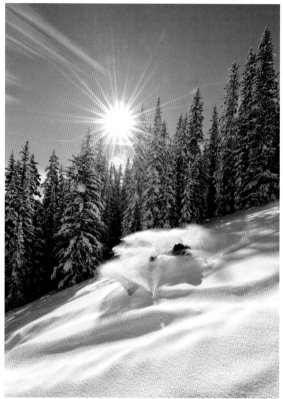

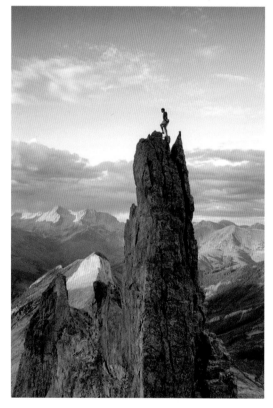

I would say motion is extremely important. Most of my clients expect me to deliver both. In fact, I expect that within a few years it will be mostly motion based. I don't view it as stills vs. motion but really stills + motion. Doing both well is the new norm.

9 What marketing tips or career advice would you offer to beginning or emerging photographers who aspire to turn pro?

Tips: Learn how to edit video. Be hungry. Don't be an ass. Work hard. Show up. And communicate well.

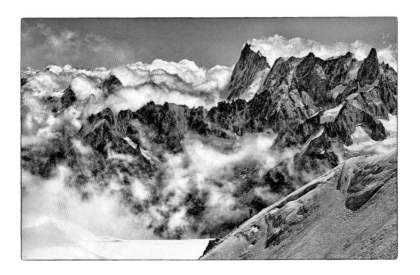

Dan and Janine Patitucci

1 How long have you been full-time pro photographers?

Since 1999.

2 What specific sports or activities do you primarily shoot? How has your style or subject matter evolved since you first turned pro?

Climbing, trail running, trekking, ski touring, road biking, mountain biking, travel, lifestyle. Our subject matter has really stayed the same all these

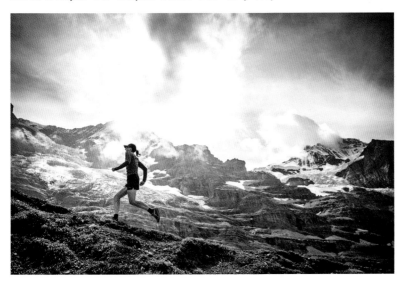

years as they are the activities we are passionate about and do ourselves. We don't often shoot what we don't love to also do.

3 How did you break in? How did you get your first clients?

We lived in our VW Westfalia for two years when we first started and just shot shot shot. We traveled around meeting clients and showing them what we were up to—and we just stayed out and visible with constant check-ins about our plans and schedule.

4 What do you feel were the circumstances, events, or actions that led to your first successes as pros?

In 2001 we came up with the idea to climb and shoot all of California's 14ers in one summer, and by technical routes if one existed. For the project we got sponsors and some work to shoot their products during the trip; it was an all-around huge success. We ended up doing a multimedia show of it, getting it in *Rock & Ice* as a feature, and made a lot of the partnering brands happy. But the project also gave us a focus to stay out and shoot for so long—and from this we learned what to shoot that sells and is of interest to the brands and magazines.

Also, being two people working was a big advantage. We could do twice the work and we always had a model for when we were just out on our own. We could shoot all the time.

5 What creative methods or techniques do you feel best represent your photographic style?

All these years we have been all about simplicity. We don't use flash, filters, tripods, or much of anything beyond a couple of lenses. We are all about the experience—being sure we are just out and getting the image, not at all focused on much else in photography. We have found that fitness and the skills to perform the sports you are shooting go further in this industry than playing with gadgets.

But we do put color to use: we love shooting colors and working with bold, graphic elements and big landscapes.

Overall, I think our style comes from what we love and are passionate about—being fit and moving amongst big, beautiful mountains and landscapes with friends.

6 Aside from your photographic skills, what unique styles or personal traits do you feel you offer your clients? Why would they hire you over someone else?

We have spent our lives in the mountains, as athletes and photographers. We live in them, the Swiss Alps, and are literally out and about 340 days a year, doing the very sports we photograph. We understand the sports, and what it is about them visually that most viewers want to see. We feel that we understand the emotions that go along with doing the sports, and this comes out in the images. We also know the outdoor industry and what sort of images many brands require. There is a certain level of authenticity that comes from our images because so often they are just that— shot during real moments.

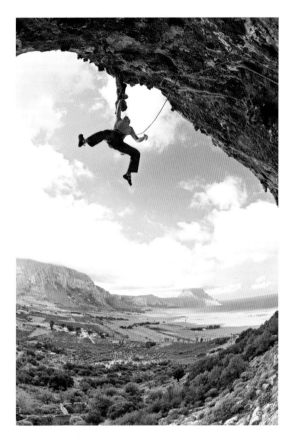

7 What's the most, or one of the most, difficult shoots you've done? What big challenges were involved in getting it done?

I don't think we have ever had a really tough shoot. We have had difficulties with weather and conditions, but no truly disastrous shoots. The closest thing to disasters have been clients needing certain conditions and they just don't happen for all the days of work, and you only have that one opportunity. This is where really understanding the client's needs can help—what else can you do to get some images, something to save the shoot.

One tough experience was shooting Ueli Steck on Annapurna. This was both one of the best experiences and one of the most frustrating. Ueli is a very close friend of ours and he asked us to join him on the trip. Once there, I missed the acclimatization trip due to respiratory infection. Shortly after, conditions were perfect and we headed up to the wall. I was supposed to join him to at least where the first camp would have been, but it was clear I was too slow, the rapid ascent was too much. This killed me, to not be able to go and shoot, all I could do was watch him climb away. But in the end we successfully documented the experience, which is considered one of the great feats of alpinism, but I'll always wonder what I could have shot of his first hours on the route.

8 How do you use social media in your business?

We share what we do as we do it. Fresh images go online as we make them. I try to maintain quality, but with the addition of more personal or humorous stuff, it's a fine balance to not turn people off. I don't want to just be "dig me, dig me," but to truly provide something useful to people, be it inspiration, a tip on a great place, or a funny moment. And ultimately, to engage people using our images, experiences, and stories. People seem interested in seeing what goes into photography, and of course the end product; social media is a great way to share this stuff.

9 How has motion and video played a role in your business? What percentage of your professional work these days is stills vs. motion?

Ninety-nine percent stills, one percent video. We basically don't shoot video. In 2013 I had to shoot a lot of video of Ueli Steck on our Annapurna trip that ended up at Swiss TV, for Ueli's shows and Sender Films. But I truly love stills and only see video as a requirement of some work.

10 What marketing tips or career advice would you offer to beginning or emerging photographers who aspire to turn pro?

Shoot what you love, what you are passionate about—it'll show in your work. This is so obvious and a cliché, but many drift and so too their careers. Also, come to really listen to and understand what a client needs. If you want to be a pro who's around for awhile, you need to make images that make your clients happy, coming back, and new ones contacting you. It's a business, not a hobby. Think long-term, think like a business.

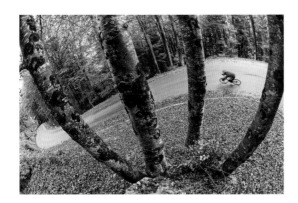

Matt Trappe

1 How long have you been a full-time pro photographer?

Two years. When I first left my corporate career I took a part-time job working retail in addition to my photography business. That helped make the transition more gradual financially. After a while I no longer needed the part-time job and jumped into the photo business full-time.

2 What specific sports or activities do you primarily shoot? How has your style or subject matter evolved since you first turned pro?

I started with trail/ultrarunning as my niche because I love it. I think it's really important to specialize at least initially because it helps you differentiate. That has since expanded into hiking, camping, fly fishing, and other outdoor mountain sports.

3 How did you break in? How did you get your first clients?

I made contacts at trade shows, events, and through friends and then targeted those clients. I would go buy their products, grab some friends, and plan a shoot that I could send to them. At first they'd like one or two but then they started calling me when they needed images. I'd then take my work from those projects and use it to sell myself to other similar clients. After a while it starts to snowball.

4 What do you feel were the circumstances, events, or actions that led to your first successes as a pro?

I don't think there was any sort of silver-bullet action or one specific event that shines as "the first success." It takes a lot of confidence and courage

to do your best work and throw it out there for everyone to see. Do it as much as you possibly can. Shoot what you love, what you know, and what you want to be known for. You'll often get ignored or turned away but you've got to stay confident and keep moving forward.

5 What creative methods or techniques do you feel best represent your photographic style?

I only use artificial light if it's absolutely required and I often shoot into the sun at non-traditional angles. My images tend to be either glowy/airy at one end of the spectrum or be strong and contrasty at the other. It depends on the mood that I'm going for with that particular image and moment.

6 Aside from your photographic skills, what unique styles or personal traits do you feel you offer your clients? Why would they hire you over someone else?

A couple reasons: 1) I have a strong business background with a graduate degree in marketing. That experience helps me to "talk the talk" with

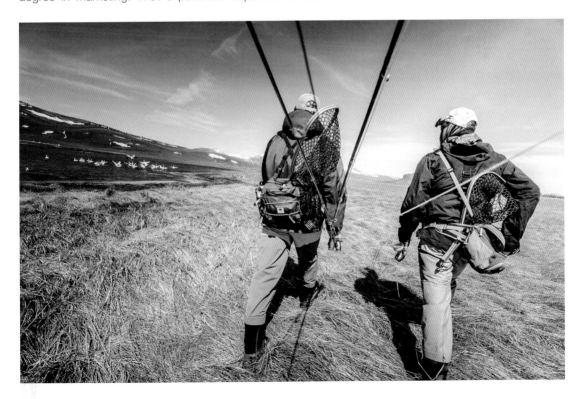

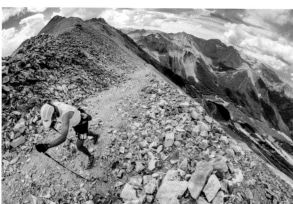

marketing teams. 2) I run ultramarathons and just love going for 10+ hours at a time in the mountains here in Colorado. So I'm very willing to load up, get out there, and keep up with most people.

7 What's the most, or one of the most, difficult shoots you've done? What big challenges were involved in getting it done?

The most difficult shoots for me are the ones with very specific instruction on the types of photos required. The more specific the more difficult. It seems counterintuitive, but I say that because when there are a lot of parameters to work around the images begin to look more staged and less authentic. Authenticity is paramount. I am constantly improving at coming away with authentic images when the creative brief leaves less room for creativity.

8 How do you use social media in your business?

Social media is an outstanding way to get yourself on a client's radar. I am always on Facebook, Twitter, Instagram and Tumblr sharing new work and letting the world know what I'm doing. It's part of not being afraid to show everyone your best stuff. The pay off is when you introduce yourself to a client for the first time and they say "I have seen your work on Instagram." Right there you have a foot in the door.

9 How has motion and video played a role in your business? What percentage of your professional work these days is stills vs. motion?

It is a huge part. I have talked with clients that only hire photographers that can shoot both. I started about a year ago by agreeing to a project that required video having never done it before. That took guts but for me it's the best way to learn. Now roughly a third of my work is from motion projects.

10 What marketing tips or career advice would you offer to beginning or emerging photographers who aspire to turn pro?

My advice is that you have got to want it—badly. You have to be up early and out late. You can't bat an eye when you get ignored or hear the word "No." Let go of all inhibitions, get after and tell the world about it. Buy a good camera but better lenses and then push yourself creatively to shoot new things and the rest will fall into place. Oh, and be very careful about providing work for "credit." I still get asked all the time and the answer is always "No." It's the quickest way to put it.

Trevor Clark

1 How long have you been a full-time pro photographer?

I've been working independently as a full-time photographer for about six years now. Before that, I was working part-time as a photojournalist for a few newspapers while also working part-time in another photographer's office and assisting him on shoots as well.

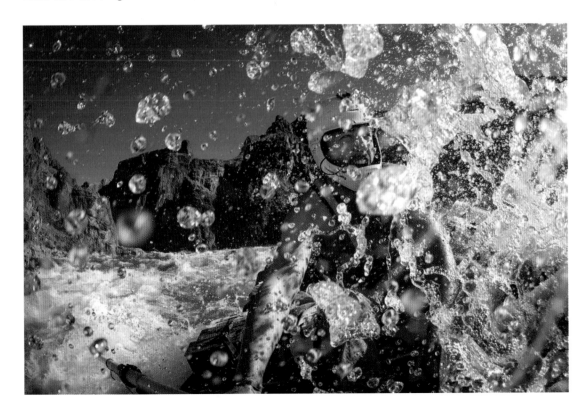

2 What specific sports or activities do you primarily shoot? How has your style or subject matter evolved since you first turned pro?

I shoot a lot of water-based adventure sports because I love the water and I participate in most of those sports as well. That said, I also love to mountain bike, ski, and snowboard, so I shoot those too.

I would say that a lot has evolved since I first set out on my own. In this journey, everything changes over time, from the perspective you bring to the camera to the subject matter you want to capture and put out into the world. I started out just trying to get any image I could that would show that I CAN do this and that people SHOULD hire me to shoot their assignments. Now, I have a much more methodical approach and direction in what I would really like to be shooting.

3 How did you break in? How did you get your first clients?

Like most photographers, I broke in with the help of others. The photo industry is tough and lots of things are against you in the beginning and throughout your career. I have worked as hard as I know how to, but sometimes it really takes someone in the industry to vouch for you before you are offered assignment opportunities. It all makes a ton of sense when you think about it. Whoever assigns you a shoot is taking a risk, so they want to be sure you can do it. You can't fault the people hiring for wanting to cover their bases.

4 What do you feel were the circumstances, events, or actions that led to your first successes as a pro?

As I mentioned before, it mostly comes down to a lot of hard work, being open to opportunities, and making good connections along the way. Most of the work that has pushed me forward in my career was not commissioned or assigned, it was done on my own time and cost me money. I put myself out there, was rejected every time I turned around, and just kept pushing. I'm doing the same thing today.

5 What creative methods or techniques do you feel best represent your photographic style?

If I have any style in particular, I would say it is to just use whatever natural lighting is available and try to find something unique about it. I have certainly played around with artificial light in the adventure photo realm, but I mostly use what is around me with minimal camera gear. In an

industry that seems to be moving more in the direction of the complex, I still prefer to keep things simple.

6 Aside from your photographic skills, what unique styles or personal traits do you feel you offer your clients? Why would they hire you over someone else?

I'm not sure if I offer a unique style or not as I feel I can create whatever the client is looking for, and that is usually paramount. I do work very hard for every client, oftentimes shooting far beyond the expectations of time outlined. I am absolutely honest in my approach and I am truly grateful for every opportunity. I think, and I hope, that shows through in my interactions with the client and in the images we create.

7 What's the most, or one of the most, difficult shoots you've done? What big challenges were involved in getting it done?

Two shoots come to mind. The first was on an exploratory mountain-biking trip in Nepal. I was shooting for a mountain-bike tour company based in Scotland. We were there to scout and shoot mountain biking on old footpaths in the Mustang Valley for a potential trip offering in the future. Unfortunately, I came down with some kind of food poisoning just before we went deeper into the Himalaya and it just took me out. That mixed with riding bikes at 15,000 feet and no medication made shooting really difficult. I actually don't even remember shooting quite a few of the images we got from the trip. I lost about 30 pounds and was never so excited to leave an amazing place.

The second experience happened last year when I took a fall while shooting for one of my ski resort contracts. I exploded my AC joint (where your collar bone connects to your shoulder) and needed surgery to rebuild the joint. Only about half way through my shot list, and not wanting to leave the resort hanging, I sucked it up and shot through the pain with one arm for the next three weeks. Then I had surgery and spent the following nine months recovering and building back my strength. Needless to say, I did get that contract again this year.

8 How do you use social media in your business?

I don't really believe in using social media for social media's sake. I think it is a great tool, but like all great tools, I feel you should use it wisely and have something to say. More than anything, I try to inspire through social media, not promote. There is enough shameless self-promotion going around out there, so I would much rather reach the individual, not the company, who is going to take something away from the message. I really just want to support people who would like to take more of a role in the direction of their lives.

9 How has motion and video played a role in your business? What percentage of your professional work these days is stills vs. motion?

I still shoot primarily still photos. Some people call me crazy, but I never picked up a still camera so that I could one day shoot video. I see the awesome power that video has and I love to watch what people put out there, but it's kind of like apples and oranges to me.

I will say that video does challenge me in new ways, so I do like that, but when you're up against folks with entire crews and seemingly unlimited budgets, it is pretty unreasonable to think you'll be competing for the same jobs.

10 What marketing tips or career advice would you offer to beginning or emerging photographers who aspire to turn pro?

I would just encourage people to always be themselves and be true to their mission. There are a lot of ways you can be talked into pushing your work and career in different directions because someone else thinks it will be good for you. The further you stray from what you really want to be shooting, the less fulfilled you will be when you look back at your work and experiences. If you want to shoot pictures of yo-yos, use that motivation to be the best yo-yo photographer out there and the rest will come.

Jay Goodrich

1 How long have you been a full-time pro photographer?

I have been a full-time pro for almost eight years now.

2 What specific sports or activities do you primarily shoot? How has your style or subject matter evolved since you first turned pro?

I shoot primarily mountain biking and skiing. Throw in some trail running, hiking, kayaking, and now paddle boarding from time to time as well. Essentially my whole career is about photographing how people invest in our outdoors; so as long as I see a potential composition, I will take the picture first and ask questions later.

I began shooting nature, then followed my background in architecture, and have settled in for the long haul with adventure photography. I think it just suits my personality the most. I live to ski blower powder and then can't wait for the summer to ride and work on my bikes. Plus, I love working with people more than just sitting alone in the woods looking for wildlife or waiting for the sun to set.

3 How did you break in? How did you get your first clients?

I requested submission guidelines and began pitching story ideas. Then almost immediately *Denver Magazine* hired me to produce a feature story about roadside wildflowers. I never looked back.

4 What do you feel were the circumstances, events, or actions that led to your first successes as a pro?

Truly wanting to be a photographer. That passion has continued to drive me. It gives me the fuel to continue every day, regardless of setbacks. It also makes me think about how to be different and succeed, regardless of what path the world is taking. That kind of obsession can be felt by others, and people respond to passion. They want to know that you are into what you do and not just following a textbook profit-making model.

5 What creative methods or techniques do you feel best represent your photographic style?

I look at photography a little different. I was formally trained as an architect. With that training I needed to study art, design, painting, and drawing, so my approach to the photograph will typically include knowledge learned from all of those disciplines to search out a unique composition. I want to give my viewer a story, not only in the single capture, but in a set of captures as well. I compose using design concepts and I feel that it

allows for stronger images than if you follow a set of rules, like the Rule of Thirds.

6 Aside from your photographic skills, what unique styles or personal traits do you feel you offer your clients? Why would they hire you over someone else?

I am not afraid to receive criticism with my work. At the same time I am not afraid to offer up ideas; clients saw something in my imagery or they wouldn't have hired me in the first place. I also like to keep a loose and almost Calvin and Hobbes-ish attitude while working and I think people enjoy being around that. Life is serious and if there is a moment in time where we can achieve an objective while actually having a good time we have succeeded tenfold from standard, professional-office, TPS report behavior.

I am pretty good at communicating to achieve an objective as well. I was a shy and quiet guy in college and now I will talk your ear off if given the chance. I think this comes from having to take a client's design idea and translate that to a built structure. You get used to speaking in front of people and it almost becomes obsessive. Creating with photography isn't that different, especially when on assignment, so I am always blabbing with someone to make sure everyone is happy.

7 What's the most, or one of the most, difficult shoots you've done? What big challenges were involved in getting it done?

I can't say that I have really fallen into this situation. Maybe it's luck? Maybe it's planning, but every shoot has special needs

and my job is to get my client's objective regardless. We problem solve one issue at a time until everything is working as best it can. Although shooting outside when it is blowing at 60 mph and dumping 3 inches of snow an hour is pretty hard to make work. So there are times . . .

8 How do you use social media in your business?

We try to highlight new work and new clients as regularly as possible. I personally feel this is a huge time-monopolizer that yes generates aware-ness, but not bankable returns. I go one-on-one with known contacts for that.

9 How has motion and video played a role in your business? What percentage of your professional work these days is stills vs. motion?

It truly hasn't yet, but I see it coming. And I don't think it is going to stop until I have decided to spend more time with it.

10 What marketing tips or career advice would you offer to beginning or emerging photographers who aspire to turn pro?

Make sure your work is the absolute best that it can be. Never stop pushing your own personal creative limits. No job is too small at first. And if you truly want it, don't ever quit because at some point you will become successful.

Index

A

aperture 101–2
art galleries 201, 203
*The ASMP Guide to New Markets in
 Photography* 265

B

The Back of Beyond (Yeadon) 201
*Best Business Practices for
 Photographers* (Harrington)
 265
Black Star Rising 265
Blinkbid 263
business of photography 260–1
 insurance 261
 pricing/negotiating 264–6
 record keeping 263
 running your own business 261–2
 taxes 263
 see also professional
 photographer

C

cameras
 compact/mirrorless 17–27
 creative options 26
 creative shooting modes 147–50
 DSLRs 12–17
 quality 26
 securing 60–1
 drying 63
 keeping dry 62–3
 protecting 61
 in transit 61–2
 technical aspects 104–6
 using two side by side 59
Canon 12, 15, 22, 58, 97, 121, 122,
 220, 227, 228, 230
carrying bags 50–1
 chest/waist pouch 51–2
 dedicated backpack 53–4

fanny pack 52–3
 Lowepro Flipside Sport AW series
 58
Chase, Jarvis 50
Clark, Trevor (profile) 287–91
clients, working with 266
 be confident 267
 be easy to work with 267
 be organized 266
 be professional 267
 communicate/find solutions
 268–9
 don't share job images too soon
 267
 see also professional
 photographer
Clifford, David (profile) 276–8
Clik Elite 53
clothing 64
 base/middle layers 64
 gloves 65
 hat 65
 insulating layer 65
 outerwear 65
color 82
 blue 82–3
 bold vs subdued 88–9
 dark vs light 89
 green 86
 hot 79
 lighting 240–1
 orange 86
 pink 86, 88
 post-production 212
 HSL (Hue, Saturation,
 Luminance) 213–15
 Parametric curve 212–13
 Point curve 213
 Tone curve 212
 primary 85–6
 purple 86

red 83–4
 warm vs cool 88–9
 yellow 84–5
compact/mirrorless cameras
 advantages 11, 17–18
 AF performance factors 120
 capabilities 19
 getting the most out of them
 24–7
 improvements in 17
 lenses 20–1
 price 22
 quality/usability 18, 22–4
 styling 20
Contax rangefinder 17
Cramer, Bill 265
creativity
 abbreviate subject 201–4
 anticipation 155–7
 approaches 132–7
 challenges/techniques portraying
 motion in still image 158
 clean/straight 211–12
 color/tone 212–15
 definition/concept 130
 equipment 155
 exposure 207–11
 histogram 205
 image editing 206–7
 landscapes 187–94
 light 138–44
 luck 155
 methods
 actively created 136
 passively created 135
 snapshots 134–5
 totally previsualized 136–7
 multiple moments in single frame
 162–3
 panning 163–7
 people 174–87

position of sun 145–7
post production 204
process
 fact finding 130
 idea finding 131
 plan of action 132
 problem finding 131
 solution finding 131
sharp vs blur 168–73
shooting different camera modes
 147–50
single moments 159–61
story-telling 194–201
technique 155
types of images 133–4
vantage point 151–4
vision 155
crop sensor 16

D
DSLR (Digital Single Lens Reflex)
 12–13
advantages
 bright/through the lens
 viewfinders 13
 durability 13–14
 fast autofocus 13
 flash capabilities 14
 highest resolution/quality 13
 video 14
AF performance factors 119
buying guide 15
 durability 15
 frame rate 16–17
 weather sealing 16
 weight 17
downsides 15
full frame vs crop sensor 16
lighting systems 14

E
empty/negative space 80–2
equipment
accessories 58–9
camera choice 11–27
carrying bags/cases 50–4
choosing 10–11
clothing 64–5
flash 58
glass-plate cameras 8
lens choice 27–47, 54–8
memory cards 47–50
Nikon 35mm manual cameras 8

outdoor clothing/equipment 64–5
portable camera systems 8
pro vs amateur gear 9–10
scouring the camera 60–4
securing 60–4
typical setups 54–9
EV dial 111
exposure 91–2
+/– EV dial 111
bright/most important subject
 matter 112–13
let shadows drop to black 116
recompose/exclude highlights
 115
wait for different light 113
wait for subject to emerge
 from shadows 114
limitations 103–4
modes 97
 Aperture Priority 97
 Full Auto Mode 97
 manual 98
 Program 97
 semi auto 97
 Shutter Priority 97
overexposure 105, 112
post-production 207
 blacks 209–10
 clarity 210–11
 contrast 207
 highlights 207–8
 saturation 211
 shadows 208–9
 vibrance 211
setting 234
see also light

F
F/Stop 53
film 147–9
flash 218–19
in action
 direction/color 240–1
 filling in shadows 237
 high-contrast locations 239
 sunset 238
basic workflow 231
 amount of light 232
 background 231
 coverage 233–4
 direction 232
 quality 233
final workflow 234

choose desired mode 234
place flash 234
set camera exposure 234
set exposure 234–5
test shot 235
light-shaping tools 220
 medium soft box 221–2
 small soft box 220–1
with motion 244
placement 242
 second light 243
settings 223
 Auto (A) 224
 High Speed Sync (FP mode)
 225
 Manual (M) 224
 Master/Remote/Slave 225
 Optical Slaves 226
 slow/Rear Sync 225
 sync speed 224
 through the lens metering
 (TTL) 223–4
 using Remotes 226
small 219–20
triggering 226
 optical slave mode 230
 pop-up flash 227–8
 radio 229–30
 sync cord 227
 using another flash as master
 228
 wireless commanders 228–9
see also lighting
focus 117
autofocus 118
 Contrast Detection 118–19
 focus tracking 125
 Hybrid 119
 Phase Detection 118
 point selection 124–5
 prefocusing 126–8
 subject in zone 125–6
autofocus modes 121
 AF-C 122–3
 AF-S 121–2
DSLR AF performance factors
 119
mirrorless camera AF
 performance factors 120
selective 170–3
sharpness vs blur 168
using 169–70
FotoBiz 263

framing 73
 composing around AF sensors 75
 empty space 80–2
 hot/cold 79
 keep edges free 75
 leading viewer in, around, out of
 frame 77–9
 multiple subject elements 76
 subject in the center 73–5
Fuji 17, 18, 22, 25, 58–9, 97, 111,
 120, 147, 176, 187, 215,
 220, 230
full-frame cameras 16

G
Golden Ratio 70–2
Goodrich, Jay (profile) 292–5

H
Harrington, John 265
HSL (Hue, Saturation, Luminance)
 213
 Camera Callibration 215
 Chromatic Aberration 214
 Convert to Grayscale 214
 Defringe 214
 Details 214
 Lens Correction 214
 Split Toning 214
Hurley, Frank 3

I
image stabilization 30
images
 abbreviation of subject 203–4
 actively created 136
 basic editing 206–7
 compelling 202–3
 contrived 134
 controlled 133
 creation 132
 drawing/painting 201–2
 found 133
 multiple moment in single frame
 162–3
 passively created 135
 portraying motion in still image
 158
 previsualized 136–7
 representational limits 202
 sharp vs blur 168
 focus 169–70
 selective focus 170–3

single moments 159–61
snapshots 134
tint 207
ISO 98–100

J
Joby Gorillapod 58–9
JPEG 107, 109

L
landscapes 187–9
 convergence 192
 foreground 191
 light 190–1
 location 189–90
 think outside the box 192
 being in shape 193
 experiment with equipment
 193
Leica 17, 22
lenses
 basics 28
 caps 29
 choosing 28
 fast vs slow 30–4
 fixed vs zoom 34–8
 focal length 27–8
 image stabilization 30
 importance of 27
 interchangeable 20
 modern features 28–9
 standard lightweight/add
 telephoto 55
 third lens 58
 trading weight for pro
 versatility/adding telephoto
 zoom 57–8
 ultra lightweight/single lens 54–5
 using 38
 long telephoto 45–7
 normal 41–2
 short telephoto 43–4
 wide angle 38–41, 176
light 138, 190–1
 after sunset 141
 chasing the sunset 142
 cloudy days 142–4
 limitations 112
 magic hour 140
 morning vs evening 141
 quality of 138–9
 tricky light 112–16
 see also exposure

lighting
 backlighting 146
 bigger lights 245–7
 side 145
 silhouettes 146–7
 see also flash
limiting factor 92–7
lines 90–1
The Linked Photographers Guide to
 Online Marketing and
 Social Media 259
location 189–90
Lowepro 53

M
Manfrotto Super Clamp 154
Manfrotto Variable Friction 154
memory cards 47–9
 errors 49–50
metering 103, 109
 center weighted 109–10
 matrix/multi-pattern/evaluative
 110
 spot 111–12
mirrorless cameras see
 compact/mirrorless
 cameras
models 268
Mt Everest 8
multiple moments 162
 moving single image 163
 overlapping time 162

N
Nikon 13, 22, 24, 31–2, 54–5, 57,
 59, 110, 127, 176, 220,
 227, 230
Noel, Captain John 8

O
Olympus 17, 18, 22, 227

P
panning 163–5
 front to back 165–7
Patitucci, Dan and Janine (profile)
 279–82
Pentax 22, 227
people 174–5
 little person in big world 180–2
 middle of the action 175–9
 portraits 183–4
 change it up 186

nail the focus 187
use continuous high
185
watch for the moments
185
Photoflex Galen Rowell-signature
Chest Pouch 51
Photoflex OctoDome 222
*The Photographer's Guide to
Marketing and Self-
Promotion* (Piscopo)
259
Piscopo, Maria 259
post production 204
basic image editing 206–7
clean/straight 211–12
in depth color/tone 212–15
exposure 207–11
histogram 205
practice 215
presentation of work 201
professional photographer
250
being self-employed 250–2
diversification as key to
success 255
full time vs part-time vs no
time 254
making the jump 252–3
bank account 253
level of risk 253–4
niche 253
talent/skills 253
marketing 255–6
print marketing 256–7
relationships 258–60
social media 257–8
website 256
profiles 272–95
working with models
268

see also business of
photography; clients,
working with

Q
Quick Books 263

R
RAW 106–7
advantages 108
shooting with RAW frame of mind
108–9
Real World Pricing & Negotiating 265
Rich, Corey (profile) 272–5
Rowell, Galen 8
Rule of Thirds 70–2

S
SanDisk Rescue Pro software 50
self-employment *see* professional
photographer
sensors 16, 17, 21
shadows
filling in 237
letting drop to black 116
post-production 208–9
wait for subject to emerge from
114
shutter speed 100–1
single moments
blurred time 161
frozen time 159
static time 160
Skoog, Carl 8
social media 257–8
Sony 17, 18, 22, 227
still images 158
story-telling 194
be deliberate 199
relationships 196
show rest of story 200

simplicity/perfection 197–9
what's the story about? 198–9
subject positioning 70–2

T
technique 68
aperture 101
autofocus modes 121–8
camera vs your eye 103–4
color 82–9
composition 69
creating successful photographs
69–70
exposure 91–2, 97–8, 103–4
focusing 117–20
framing 73–82
how the camera works 104–6
ISO 98–100
JPEG 107, 109
limiting factor 92–7
lines 90–1
metering 103
metering patterns 109–12
RAW 106–7, 108–9
shutter speed 100–1
subject positioning 70–2
tricky light 112–16
through the lens metering (TTL)
223
Trappe, Matt (profile) 284–7
tripods 58–9

V
vantage point 151–3
tools 154

Y
Yeadon, David 201
Yosemite 8
El Capitan 8
Half Dome 8